9/14

Great New Buildings of the World

Great New Buildings of the World

Ana G. Cañizares

HARPER
DESIGN

An Imprint of HarperCollins*Publishers*

GREAT NEW BUILDINGS OF THE WORLD: WORKS FROM TADAO ANDO TO ZAHA HADID
Copyright © 2005 by LOFT Publications and HARPER DESIGN

First published in 2005 by:
Harper Design
An Imprint of HarperCollins*Publishers*
10 East 53rd Street
New York, NY 10022
Tel.: (212) 207-7000
Fax: (212) 207-7654
HarperDesign@harpercollins.com
www.harpercollins.com

Distributed throughout the world by:
HarperCollins International
10 East 53rd Street
New York, NY 10022
Fax: (212) 207-7654

HarperCollins books may be purchased for educational, business, or sales promotional use.
For information, please write: Special Markets Department, HarperCollins Publishers Inc.,
10 East 53rd Street, New York, NY 10022

Publisher:
Paco Asensio

Editor:
Ana G. Cañizares

Art Director:
Mireia Casanovas Soley

Layout:
Ignasi Gracia Blanco

Library of Congress Cataloging-in-Publication Data

Cañizares, Ana Cristina G.
 Great new buildings of the world / by Ana G. Cañizares.
 p. cm.
 ISBN 0-06-074792-7 (hardcover)
 1. Architecture, Modern--21st century. I. Title.
 NA680.C275 2005
 725'.09'0511--dc22

 2005004955

Printed by: GRABASA, S.L.
Spain

D.L: B-25084-2005

First Printing, 2005

725
CAN
2005

Introduction

According to the earliest surviving work on the discipline of architecture, claimed to be Marcus Vitruvius' *De Architectura*, a good building should fulfill three conditions: beauty, firmness, and utility. Known today as *The Ten Books of Architecture*, this highly regarded Roman treatise dating back to the first century B.C. still reflects the concepts of contemporary architecture. Today, that balance between beauty, firmness, and utility can be redefined as the aesthetic, structural, and functional considerations of architecture, which, in their correct measure, can lead to the creation of a great building. These considerations, however, encompass a myriad of other criteria—such as context, technology, and representation—that play a crucial role in the definition of a "great building."

So what makes a great building? From ancient structures like the Egyptian pyramids and the Roman Coliseum, to 16th- and 17th-century buildings like Palladio's Basilica or the Taj Mahal, to 19th- and 20th-century constructions like the Eiffel Tower or the Sydney Opera House, great buildings have gone down in history for their ability to synthesize form, structure, and function through innovative means, and for their power to create a deep and direct emotional experience with the people. New buildings today, challenged by an increasingly complex urban context, must carefully integrate their designs into the existing urban fabric through a skillful and sensitive interpretation of the buildings' purpose and relationship with the public. Rather than merely fulfilling an aesthetic purpose, new buildings have cultural, political, and social importance, and only those that succeed in reflecting these values, in combination with a novel approach to the practice of architecture, can be considered as great. In other words, only a select few achieve iconic status.

> "All fine architectural values are human values, else not valuable."
>
> Frank Lloyd Wright

Today, however, the distinction between icons and iconic architecture is often a topic of debate. Ever since the launch of Frank Gehry's Guggenheim Museum in Bilbao, eye-catching, head-turning, and jaw-dropping buildings with curvy shapes, jagged edges, and flashy materials have followed suit and made the short lists for the world's most prestigious competitions. Even architects like Norman Foster, known for his classic modernist style, have joined in with sleek, sexy projects like the popularly coined "Gherkin," a recent addition to London's urban skyline. Regardless of whether these odd-looking buildings are considered to be true icons or merely sensationalistic examples of iconic architecture, there is no reason why they cannot embrace the best of both worlds and express underlying values through visually impressive design.

Precisely because a pretty face is not enough, other factors are equally crucial to the quality and impact of a new building. In an age where environmental considerations are increasingly important and regarded as politically correct, architects are employing the most advanced in green-

technology in an effort to make these buildings as energy efficient as possible. The race for high-tech buildings has also produced a number of projects that incorporate groundbreaking technologies to improve the conditions of those who interact with the building. A unique location—be it alongside a cliff, on top of a railroad track, next to the sea, or in the heart of a historical center—is also a distinguishing characteristic that exemplifies the skill of integration and the sensitivity of the architects in relation to the existing context. Inevitably, this understanding must go hand in hand with an appreciation for the building's function. Given that many large-scale projects are responsible for representing cultural and social values, their creators must communicate these principles through a dynamic design capable of generating a genuine dialogue between architecture, landscape, and society.

> Architecture is the most democratic of the arts, and the buildings that surround us affect us at a deep level. For architecture to be truly great, it has to lift the moods of the people who pass it by, who work within it, who see it on a skyline or at the end of a street…. they push our knowledge and understanding of architecture forward and stimulate and showcase new ideas. —RIBA (Royal Institute of British Architects)

The architects who succeed in encapsulating all these concepts and concerns within a singular physical structure are those who contribute to the architectural panorama, challenge conventional models, and provide cities and landscapes with new landmarks. While many are highly respected within architectural circles, but are less known to the general public, a select handful have come to be known as star architects for their trendsetting architectural styles and the media's constant attention. Their stylistic forms become a personal signature and find their way into some of the world's most significant building projects, raising yet another controversial issue that questions the definition of great architecture in light of the influence that media and institutions have today.

Bearing in mind all these issues and criteria, *Great New Buildings of the World* gathers a discerning selection of contemporary projects completed within the last few years that exemplify the latest trends in the creation of prominent institutional, corporate, retail, cultural, ecclesiastical, and educational facilities around the world. Internationally praised for their contribution to the architectural field and their novel approach to building, these projects not only impress with their unique appearance, but also take into consideration the fundamental aspects of quality and context. Whether they are perceived as icons or as simply iconic, there is no doubt that each of the following buildings aspires to Vitruvius' claim for beauty, firmness, and utility, having won the favor of the public and professionals alike. Challenging and informative, these strong designs by internationally renowned architectural firms offer direction to the profession, as well as provide people and places with lasting icons that provoke sensations and stimulate an interactive dialogue between human beings and their physical environment.

30 St. Mary Axe

Foster and Partners

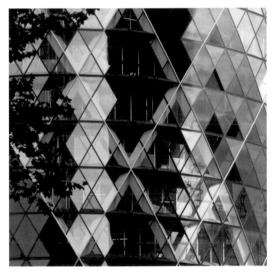 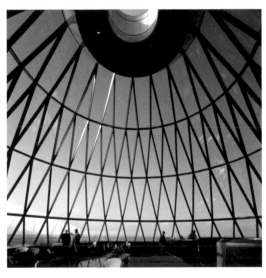 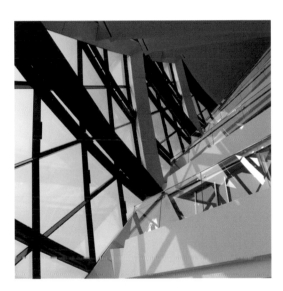

30 St. Mary Axe

Architects: Foster and Partners

Location: London, United Kingdom

Completion: 2004

Photography: Roland Halbe / Artur, Barbara Staubach / Artur, Nigel Young / Foster and Partners

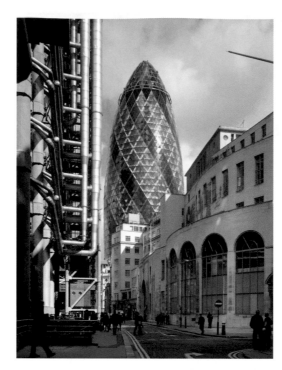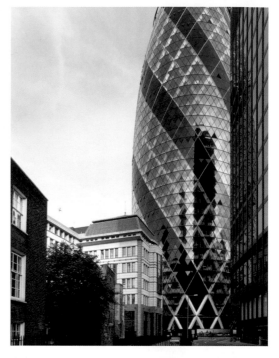

Described as London's first environmental skyscraper and popularly dubbed the "Gherkin," this building by Norman Foster is the winner of the prestigious Sterling Prize 2004. In fact, for the first time in the nine-year history of the award, the judges were unanimous in their decision. Developed on the precedents of green architecture for which Foster's practice is famed, the tower has reached iconic status and become a landmark in Europe's leading financial center.

The tower embodies a highly progressive environmental strategy, taking on an aerodynamic shape to maximize the amount of natural light and ventilation, which significantly reduces the building's energy consumption. A comprehensive range of sustainable measures enables the building to consume fifty times less energy than the traditional major office building. Spiraling atriums naturally ventilate the interiors, while the building's shape maximizes natural daylight and allows views from deep within the building. The balconies on the edge of each atrium provide strong visual connections between floors and create a natural focus for communal office facilities.

A series of complex studies of the local environmental conditions suggested a strategy for integrating the building with its site and allowing it to use natural forces of ventilation. The 590-foot, 40-story tower breaks with the conventions of traditional boxlike office buildings with its circular plan, which enables much of the site to be used as a landscaped public plaza. The building's exterior explores a series of progressive curves with the aid of parametric computer-modeling techniques. The geometry and shape mimic forms that occur in nature; in the same way that the spirals of a pinecone open and close in response to climatic changes, so do the spirals of the building.

As Foster sums up, "30 St. Mary Axe is an embodiment of the core values that we have championed for more than thirty years: values about humanizing the workplace, conserving energy, democratizing the way people communicate within a building, and the way that building relates to the urban realm."

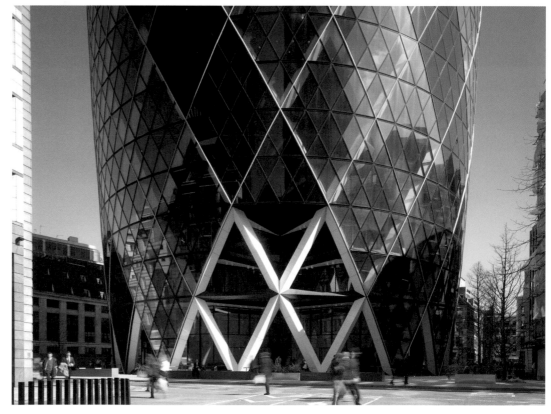

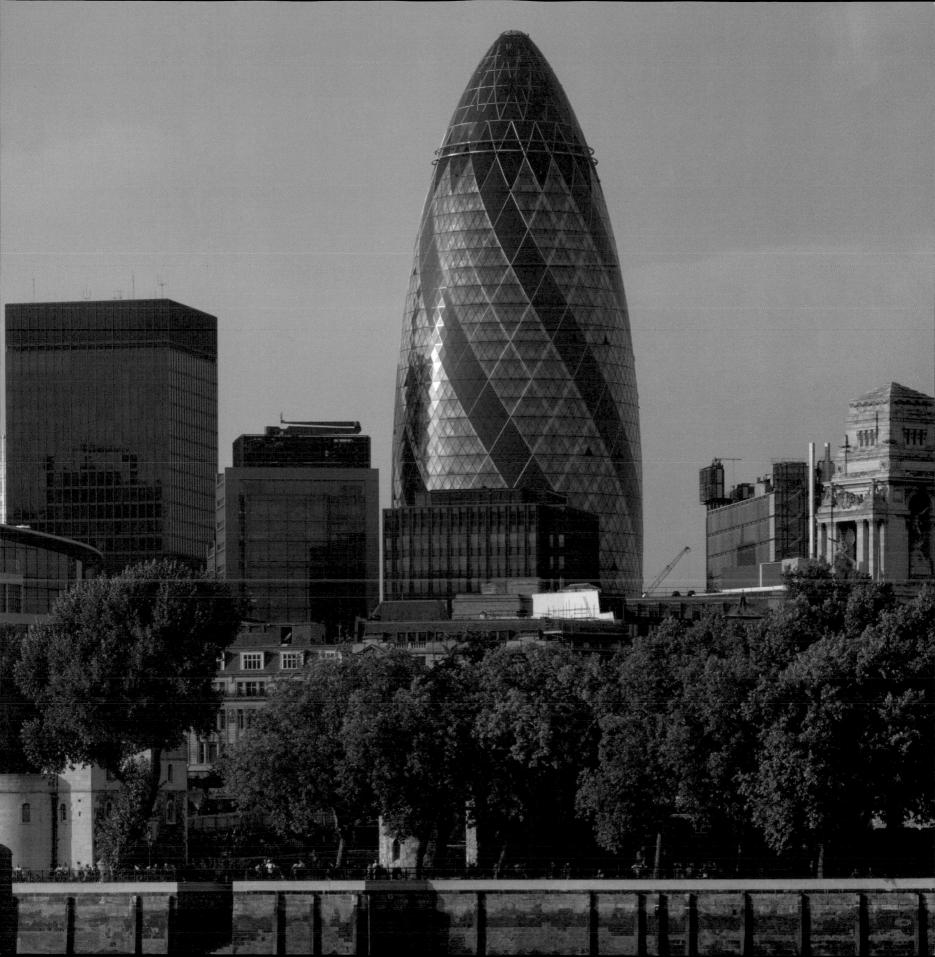

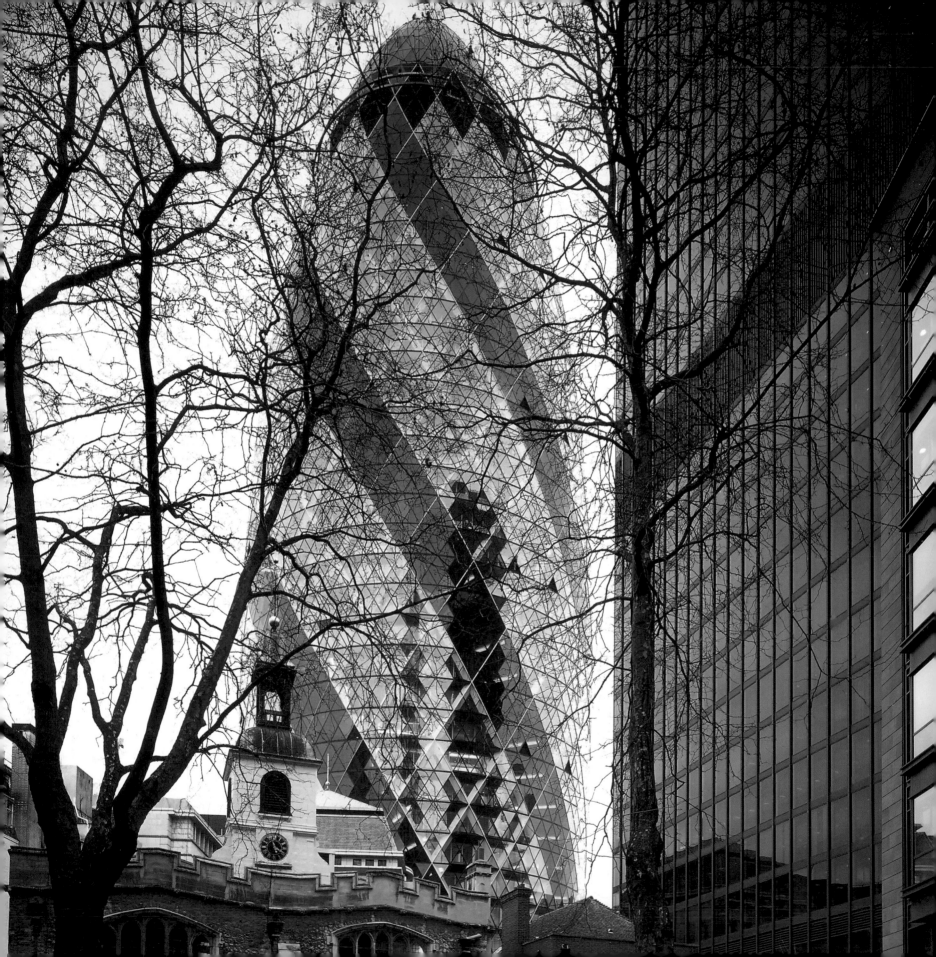

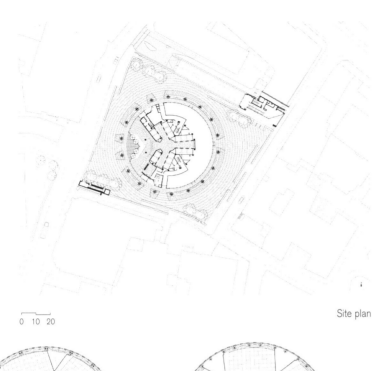

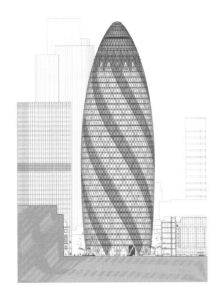

Site plan

Elevation

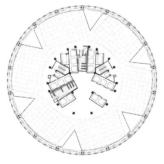

0 10 20

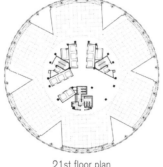

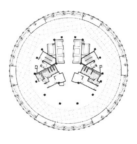

6th floor plan

21st floor plan

33rd floor plan

39th floor plan

40th floor plan

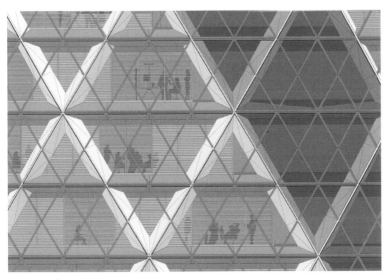

Façade detail

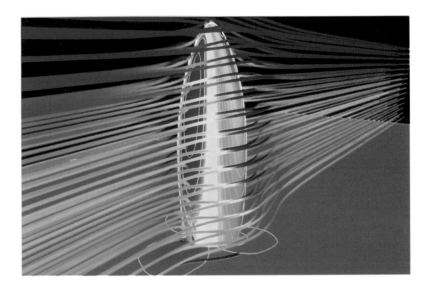

Aerodynamics

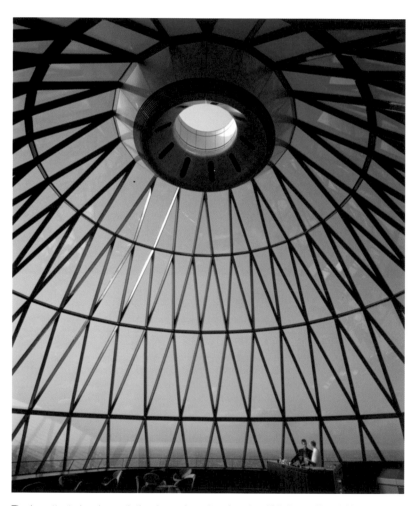
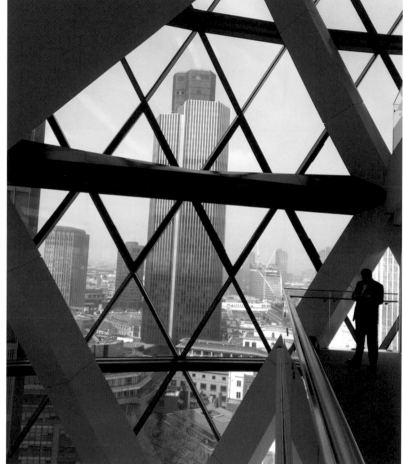

The bar, situated underneath the dome-shaped roof on the 40th floor, offers 360-degree views of London, making it the city's highest occupied lookout point.

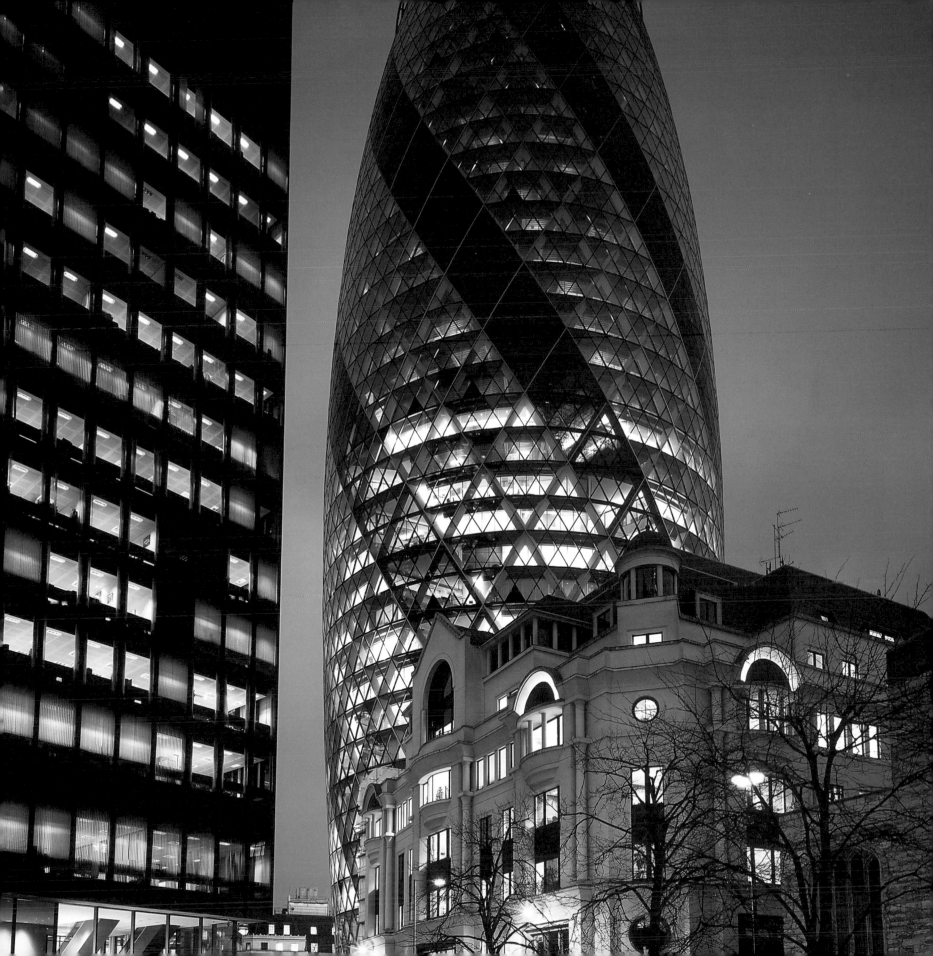

Braga Stadium

Eduardo Souto de Moura

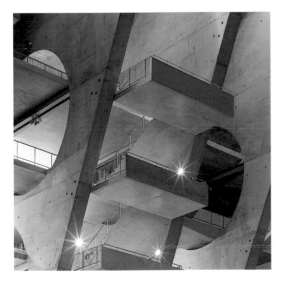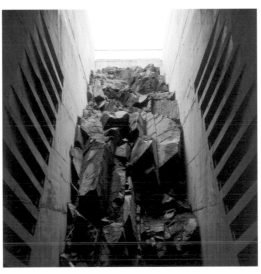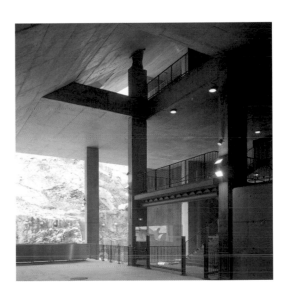

Braga Stadium

Architect: Eduardo Souto de Moura

Location: Braga, Portugal

Completion: 2004

Photography: Christian Richters

As the winner of the competition to host the Union of European Football Associations 2004, Portugal was faced with the construction and remodeling of ten stadiums throughout eight cities across the country to host the international football stage. The new stadiums, all designed by Portuguese architects, generally adhere to the conventional amphitheater model that has persisted since Roman times. Braga Stadium, however, is a stunning exception. Designed by Eduardo Souto de Moura, it grows out of the landscape to form one of the country's most original architectural works.

Situated within the Dume Sports Park on the northern slope of Monte Castro, Moura's architectural feat inaugurates the site of what was planned to encompass a new urban park with a variety of sports and recreational facilities. Mistaken by some as an unfinished site, the construction resembles that of a modern archaeological relic poised in an excavated landscape. The craggy, rugged surface that embraces the stadium on one side, however, is indeed intentional, forming part of the natural landscape out of which the new building seems to have grown.

The 130-foot-tall stadium distributes a total of 30,000 seats across two parallel grandstands with overlapping tiers. The southwest stand, wedged into the hillside, incorporates a labyrinth of stairs, elevators, and concourses set against a backdrop of rock face. The northeast stand, articulated by broad ribs, thrusts out at an angle and features an intricate system of staircases. Inspired by the extraordinary rope bridges built by the Peruvian Incas, Moura joined the sloping roofs with a network of steel tensile cables that hover tautly and gracefully over the stands and field.

Across from the granite cliff, an undulating landscape of grass and trees provides a gentler transition between structure and landscape. With his largest building to date, Moura establishes an austerely striking relationship between architecture and nature that deserves acclaim as one of the most singular structures devoted to the realm of sport and beyond.

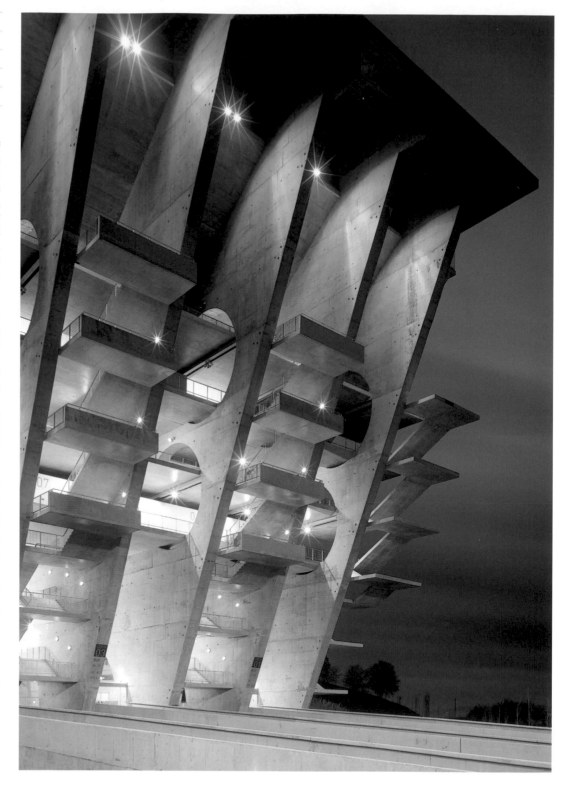

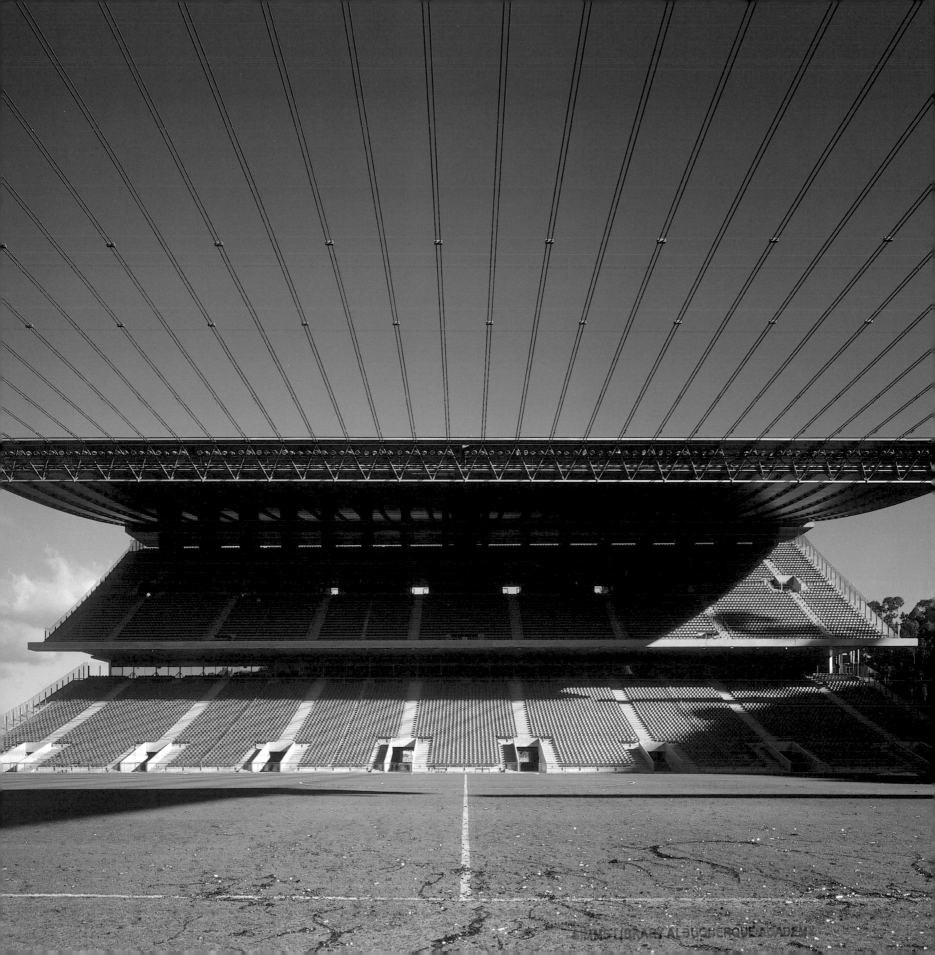

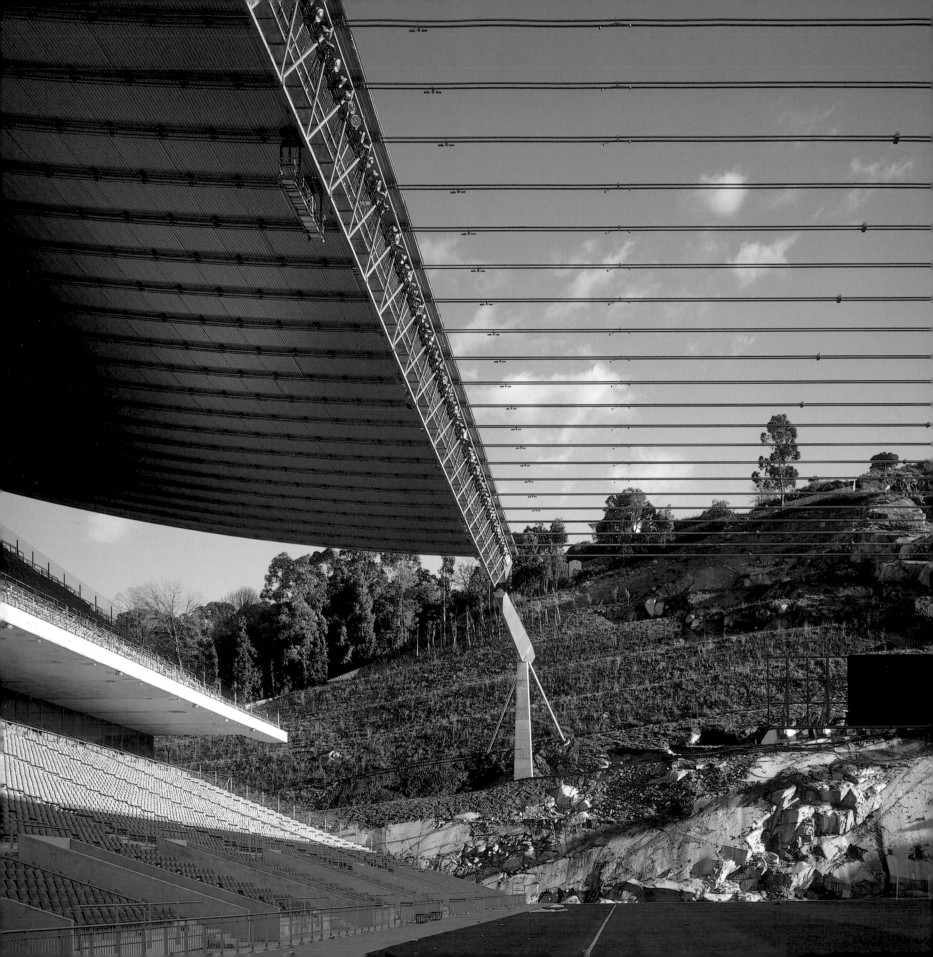

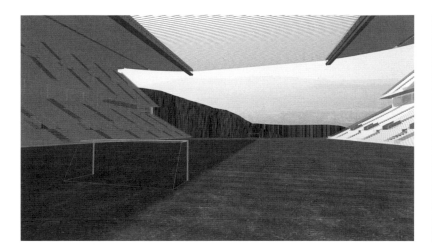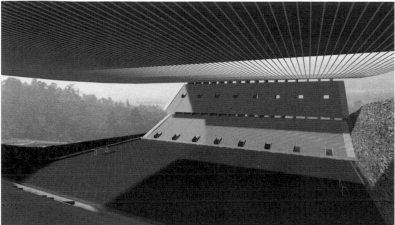

Renders

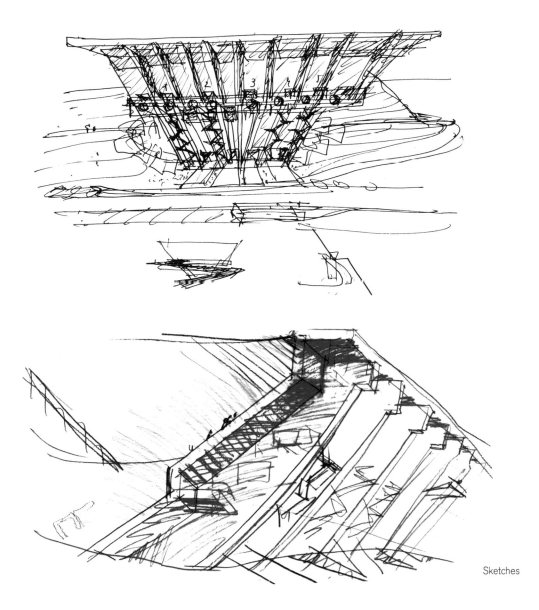

Sketches

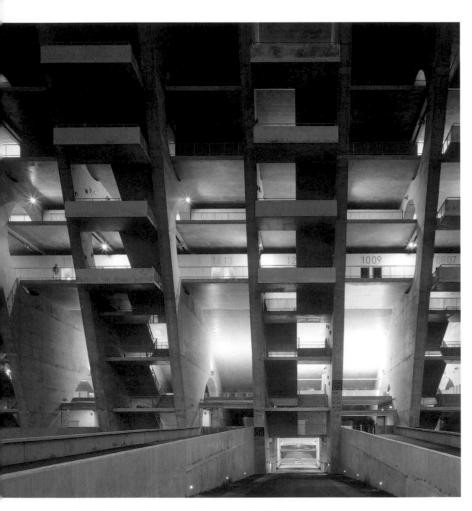

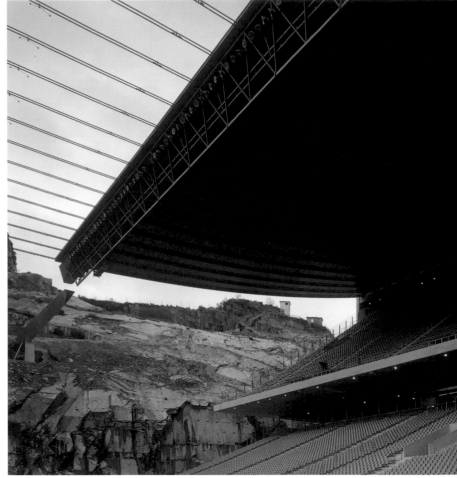

ABOVE: The southwest stand is dug into the hillside to create a series of inclined structures that contain stairs, elevators, and concourses set against a backdrop of living rock. RIGHT: Water is drained off the roofs of the stadium into freestanding concrete troughs perched on the hillside; the cantilevered limbs reach out and stop short of each roof to collect the pouring rainwater.

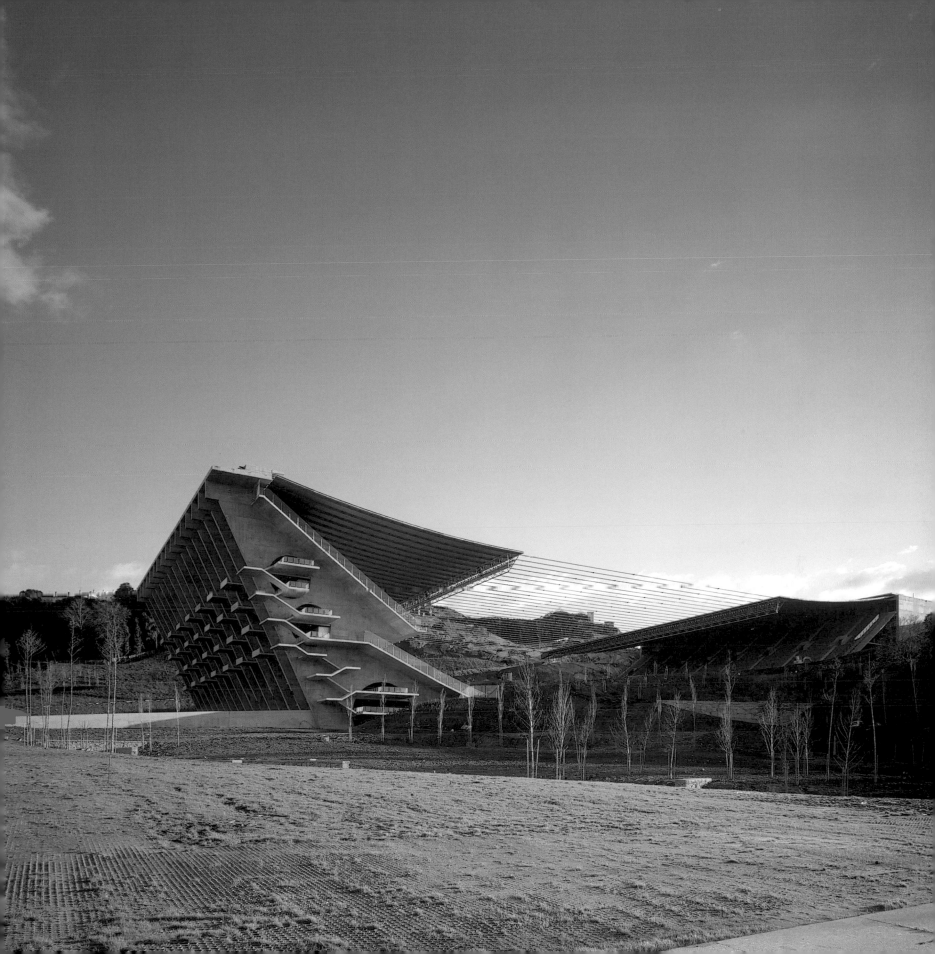

CAC Cincinnati

Zaha Hadid

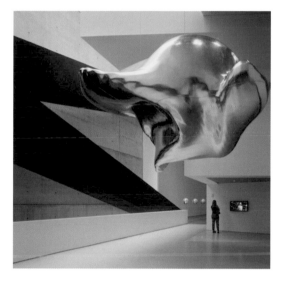

CAC Cincinnati

Architect: Zaha Hadid

Location: Cincinnati, OH, USA

Completion: 2003

Photography: Roland Halbe / Artur

The Contemporary Arts Center (CAC) in Cincinnati was founded in 1939 as one of the first institutions in the United States dedicated to contemporary visual arts. The new CAC building designed by Zaha Hadid represents the center's first freestanding home and marks this established architect's first U.S. commission. Known for her radical language in the transformation of shape and space, Hadid aimed for a highly accessible building that would open itself to the city and its people. According to Hadid, "It's not a compact building and there is a degree of transparency on the ground and above. So it's not only how we use it, but also how we pass through it. Every time you confront the space you have a different experience."

The concrete, steel, and glass building features undulating levels and ramps to accommodate the varied shapes, scales, and media of contemporary art. Its six-story, 87,000-square-foot surface area features 17,000 square feet of gallery space, the UnMuseum (a children's education center for participatory art installations, hands-on projects, and other programs), a 150-seat performance space, a bookstore, a café, and office facilities. To draw in pedestrian movement from the surrounding areas and create a sense of dynamic public space, the entrance, lobby, and the circulation system are organized as an "urban carpet" represented by a smooth, concrete floor that curves upward as it enters the building and rises to become the back wall. This element visually leads visitors up a suspended mezzanine ramp through the full length of the lobby, which functions during the day as an open, landscaped expanse with the ambience of an artificial park. The ramp culminates as a landing at the gallery entrance.

The galleries, which appear to float over the main lobby, connect and interlock like a three-dimensional jigsaw puzzle made up of solids and voids, allowing for unobstructed views from all sides. This contrast to the series of polished, undulating surfaces that express the urban carpet is one of the aspects that make the building so unique. The two façades of the building illustrate this contrast in its entirety, each one becoming the negative imprint of the other.

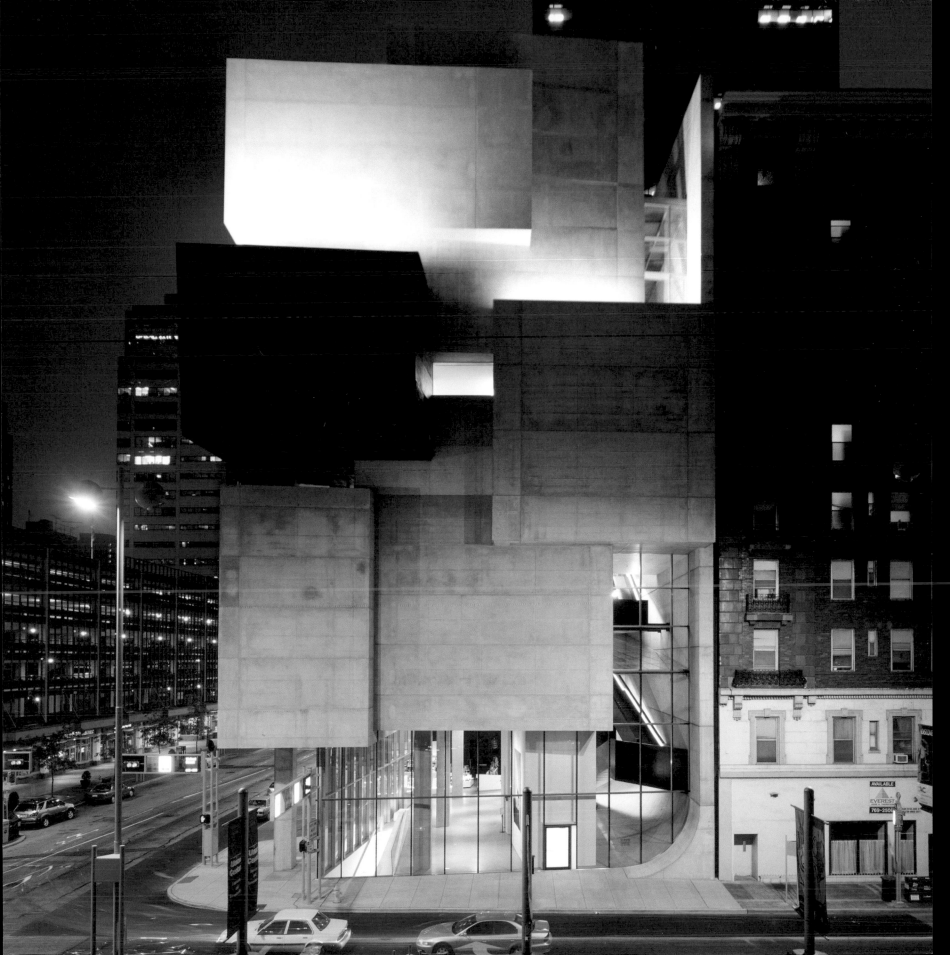

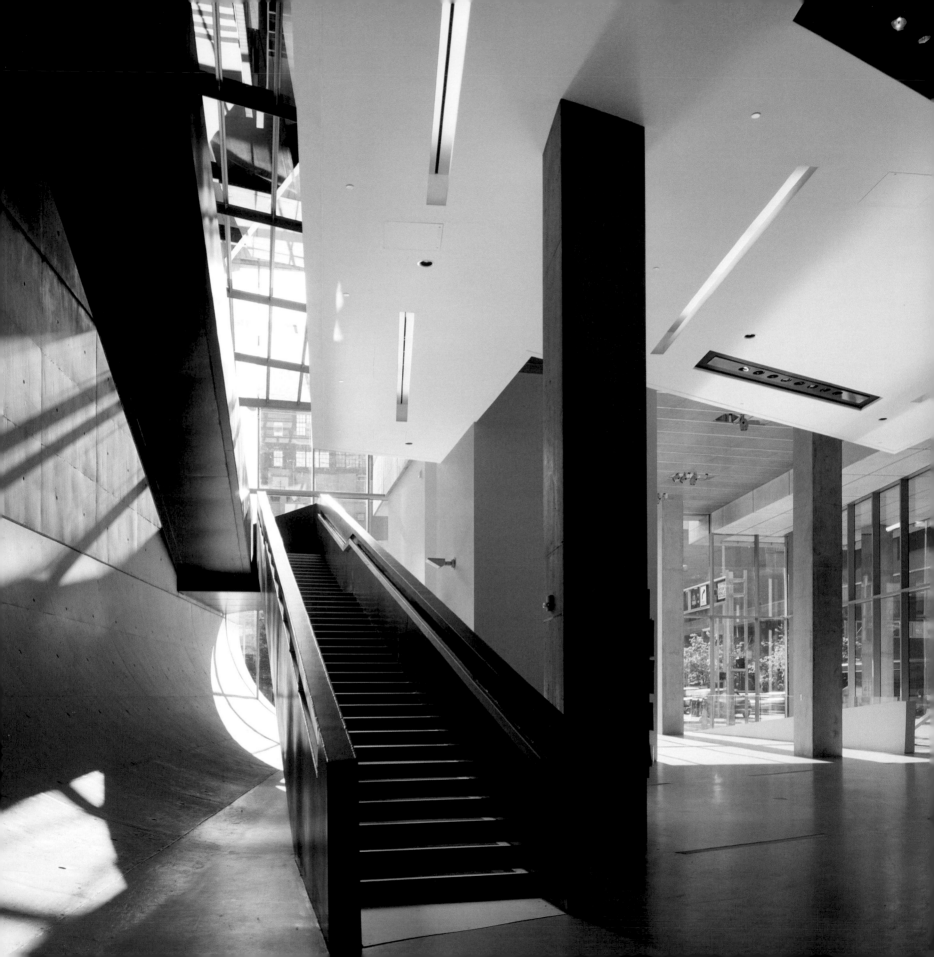

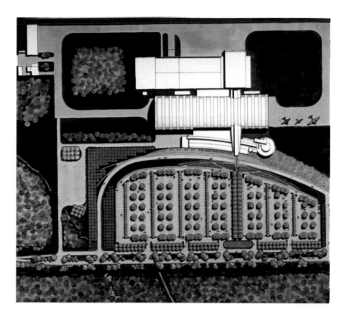

Site plan

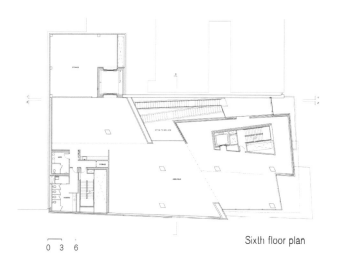

Sixth floor plan

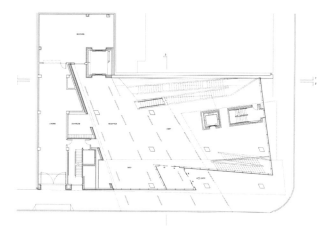

Ground floor plan

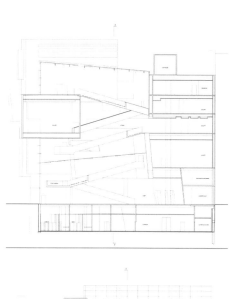

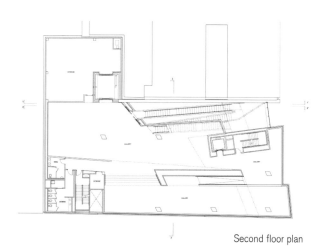

Second floor plan

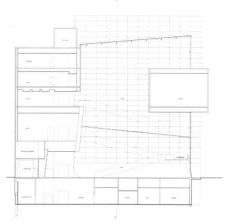

Cross sections

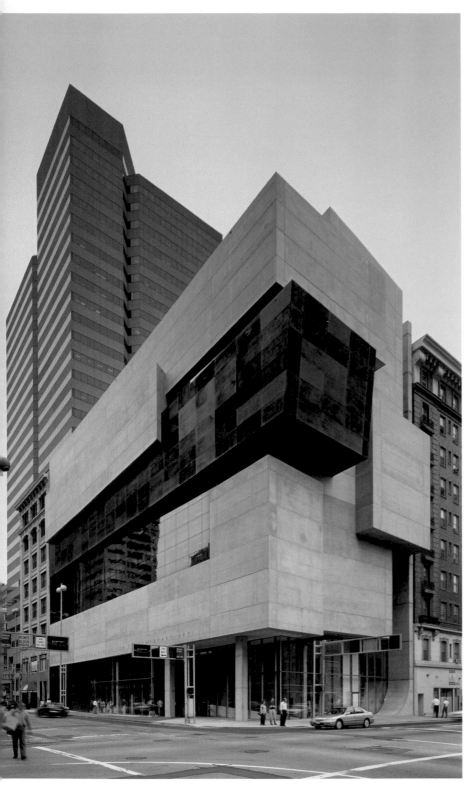
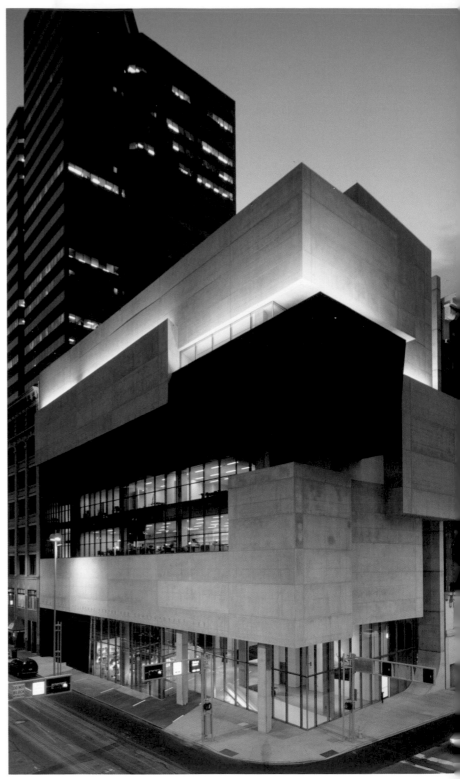

The building's corner situation led to the development of two different but complementary façades. While the long southern façade forms an undulating, translucent skin through which passersby can see into the center, the shorter eastern façade is expressed as a sculptural relief, providing a negative imprint of the gallery interiors.

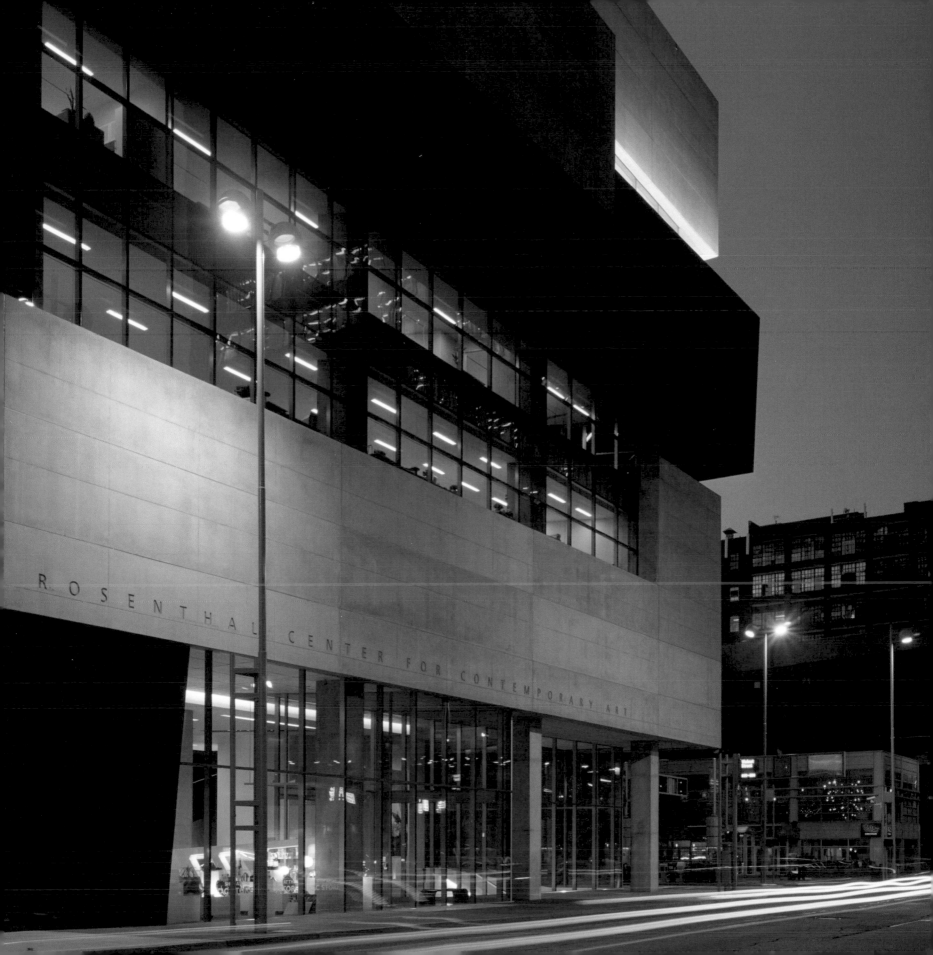

Caja Granada

Alberto Campo Baeza

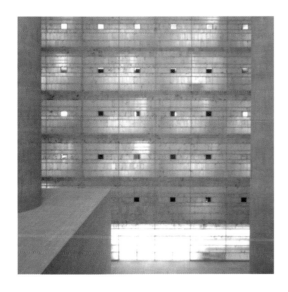 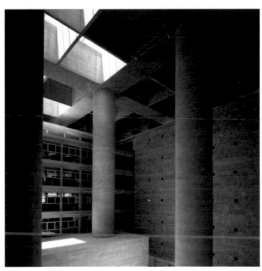 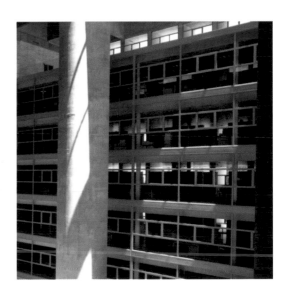

Caja Granada

Architect: Alberto Campo Baeza

Location: Granada, Spain

Completion: 2001

Photography: Hisao Suzuki

It took seven years after having won a competition held by the bank corporation Caja General de Ahorros in 1992 to begin constructing what marks Alberto Campo Baeza's most significant body of work to date. The new head offices' monumental structure is a sober exercise in modern architecture that finds inspiration in classical themes and explores the manipulation of light and space on a remarkably large scale.

The bank complex, nearly 430,000 square feet, adopts a massive semi-cubical volume built of reinforced concrete and supported by four enormous hollow columns on which rests a dual, horizontal beam system. An extremely simple, linear scheme organizes the space into approximately 1,000 square feet to collect light and create a strong effect of depth. The south-facing façades employ a system of brise-soleils to filter the sunlight and provide illumination to the open offices, while the northern façades that give onto the individual offices are characterized by a structural latticework of reinforced concrete punctuated with three-part windows and door frames and travertine slabs.

In harmony with the architect's earlier work, Campo Baeza reinterprets traditions of the past, such as the theme of the Renaissance palace with its inner court-yard, as seen in the palace of Charles V in the Alhambra. Campo Baeza refers to the immense atrium contained within the structure as an "impluvium of light," "impluvium" being a term that recalls the uncovered portion in the center of the atrium of a Roman house designed to receive rainwater. In this case, water is replaced by light, in an almost tangible form that renders it as a true element of construction and a driving element behind the design.

The contrast of different materials like glass, alabaster, and travertine, which reflect and transmit light, is used intentionally to make light an integral part of the architecture. Through it, the building elegantly expresses the essence of modern architecture—its spatial character and unique luminescence evoking the solemnity of a grand temple or that of a great stage set silently waiting for the spectacle to begin.

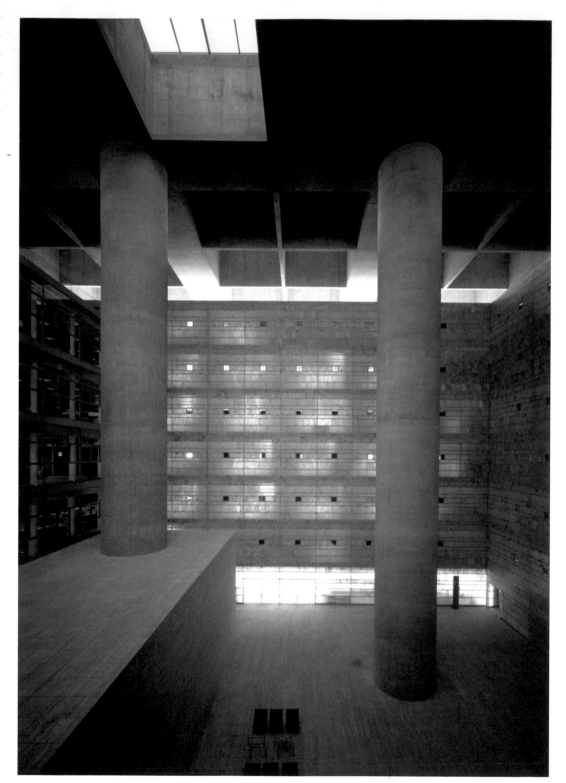

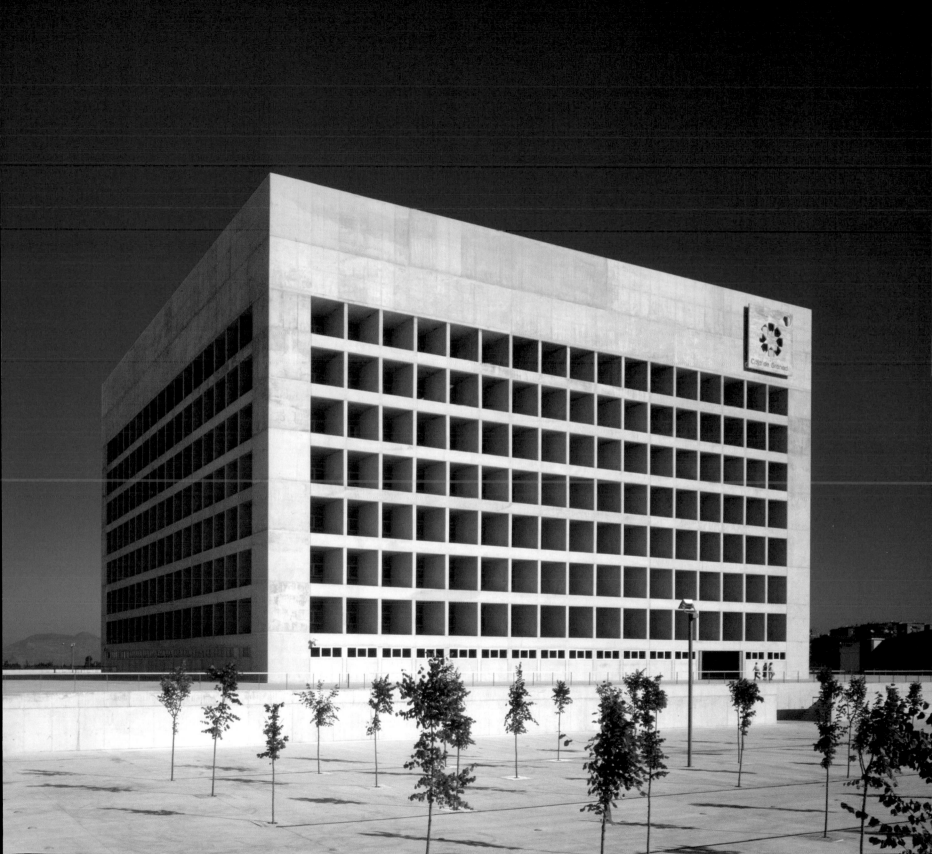

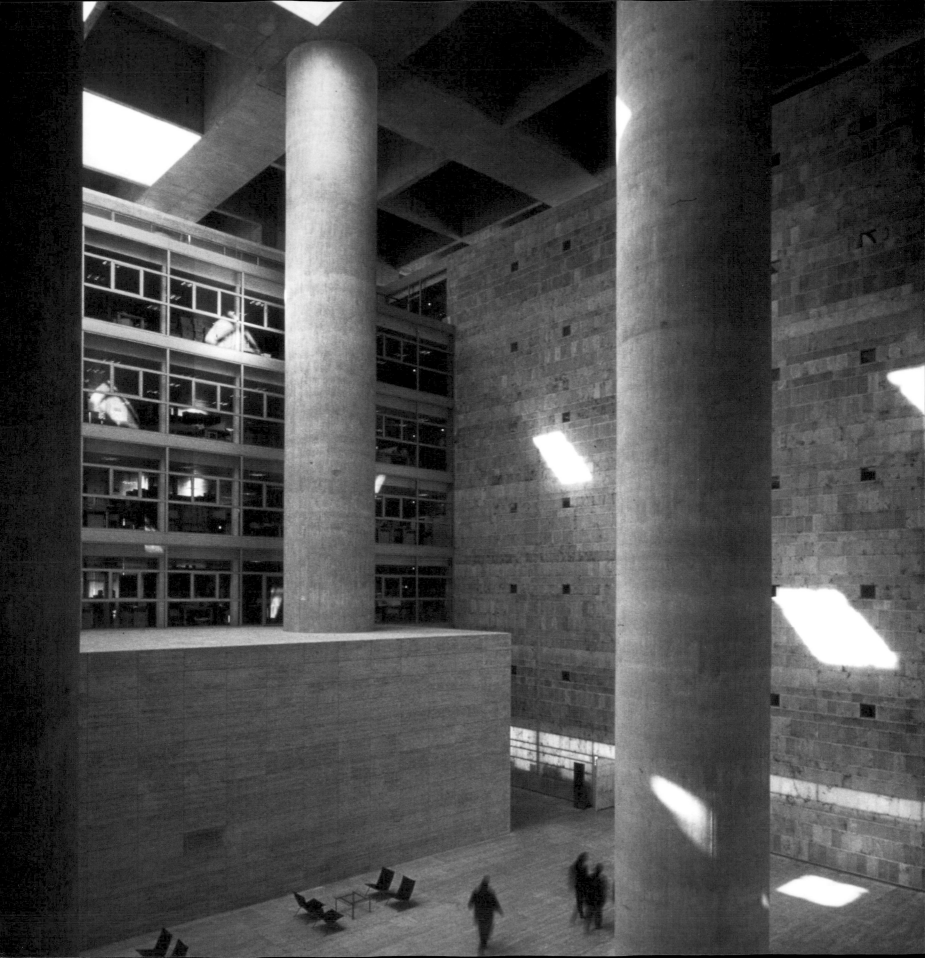

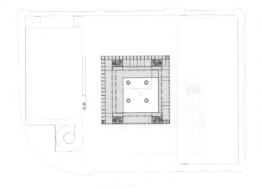

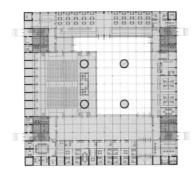

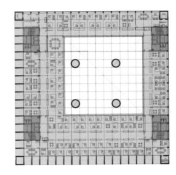

Ground floor plan

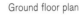

0 5 10

Second floor plan

Third floor plan

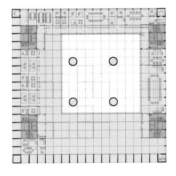

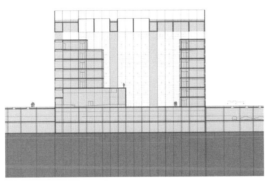

Fourth floor plan

Sections

Sketch

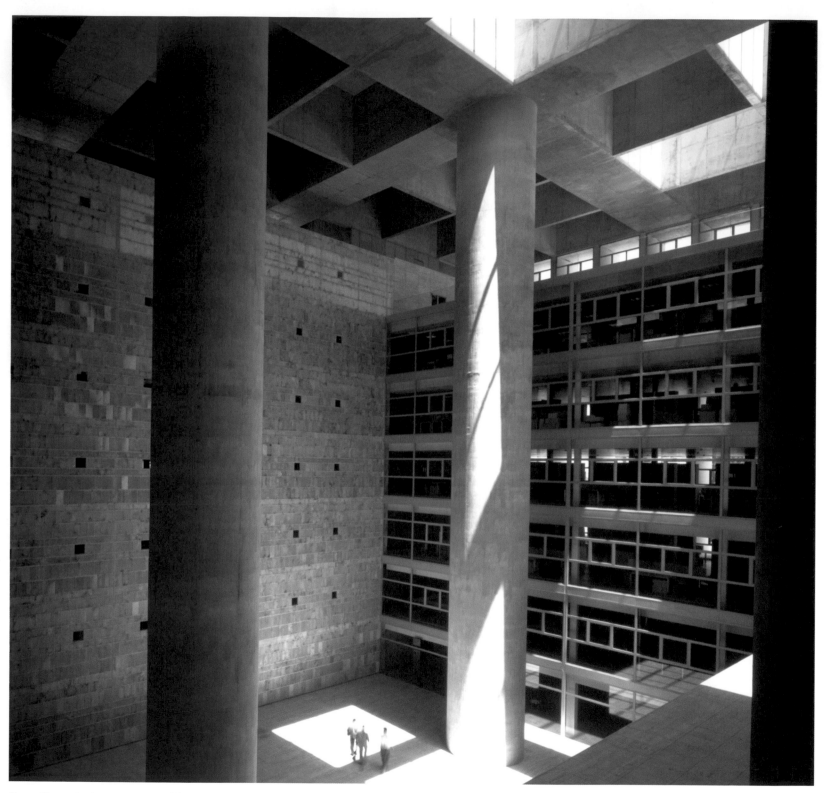

Campo Baeza also borrows aspects of Granada's cathedral, in particular that of the dimensions of the structural columns, generating a unique relationship between visitor and space with respect to variations in scale and proportion.

Federation Square

Architect: LAB Architecture Studio

Location: Melbourne, Australia

Completion: 2004

Photography: Wolfram Janzer / Artur

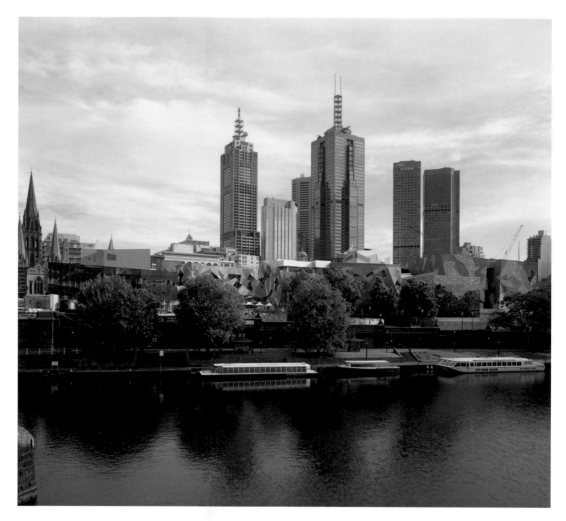

Set inside a previously undeveloped site, Federation Square is the creation of a new center of cultural activity for Melbourne. The complex fulfills the long-held dream of the citizens of Victoria for an authentic civic destination based on the collective and the unique. The design unifies the disparate institutions of difference and coherence, while maintaining a visual and formal integration across the site. Ultimately, the project has sought to produce a cultural and civic precinct based on permeability to cultivate the interaction of visitors, workers, and passersby.

The square, covering an area equivalent to an entire city block, is situated above the railway tracks and consists of nine separate cultural and commercial buildings with a combined area of approximately 485,000 square feet. Included are the new galleries for the National Gallery of Victoria's collection of Australian art, the Australian Center for the Moving Image (ACMI), SBS (Australia's multicultural broadcaster), Melbourne's Visitor Information Center, retail spaces, parking, and numerous restaurants and cafés, all grouped around two new civic spaces. One of them is the Plaza, capable of accommodating up to 25,000 people in an outdoor amphitheater, and the other is a unique glazed and covered atrium with a glass-walled theater on the south side.

In association with Bates Smart, the architects developed a grid system that generated a continuously changing façade, rather than the traditional repeatedly flat surface. Zinc, sandstone, and glass were manipulated with an incremental system of fractals that uses a triangular pinwheel grid to produce the intricate pattern of the buildings' façades.

Rather than a design that started out as a fixed, iconic object, Federation Square's design is based on emergence, allowing for the vicissitudes of an evolving and complex integration of multiple tenants, user groups, and governmental management. The project reaffirms the original interactive nature of civic existence, and rather than a closed enclave of controlled and regulated activities, creates a network of animated, emotional, and enlightening experiences.

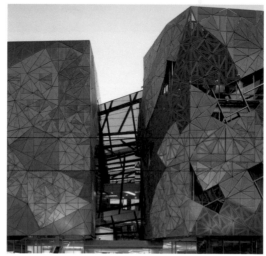

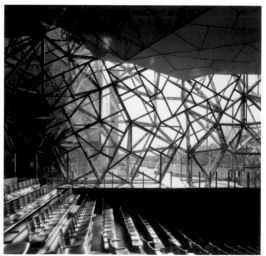

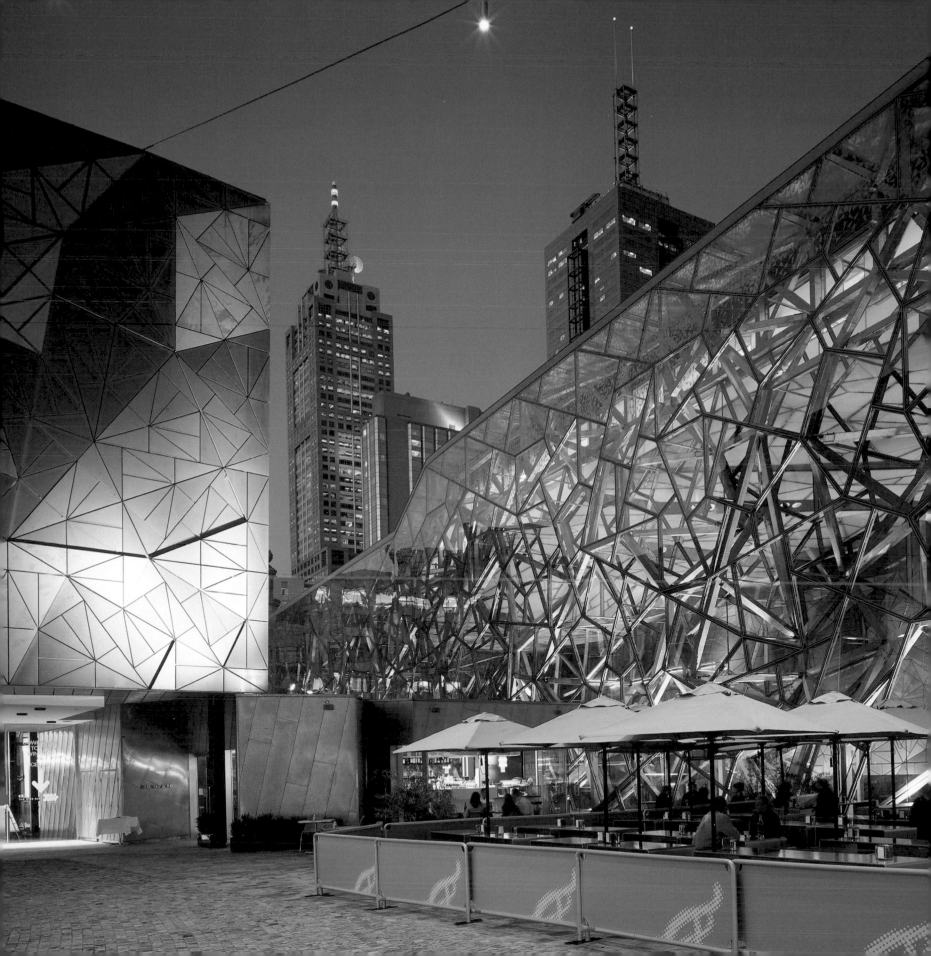

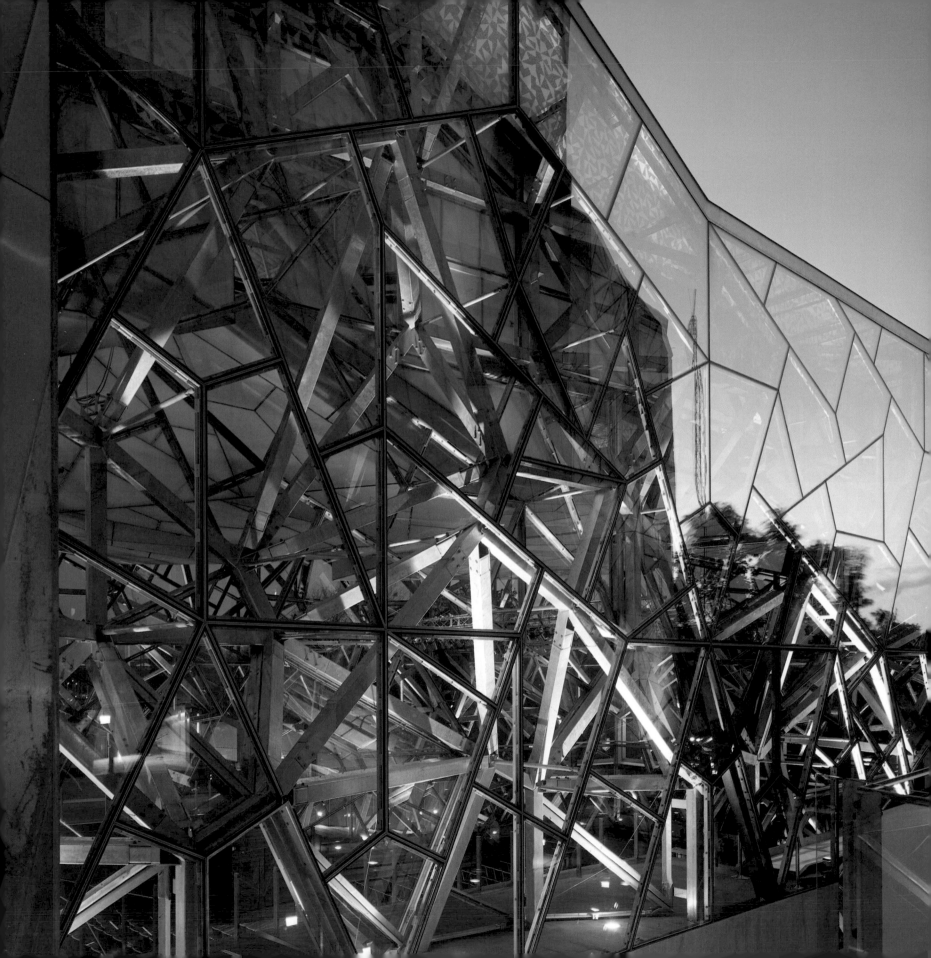

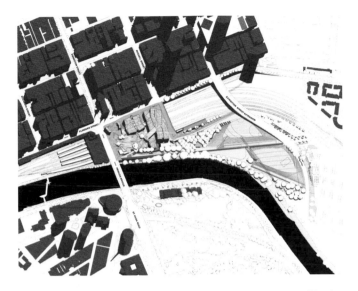

Site plan

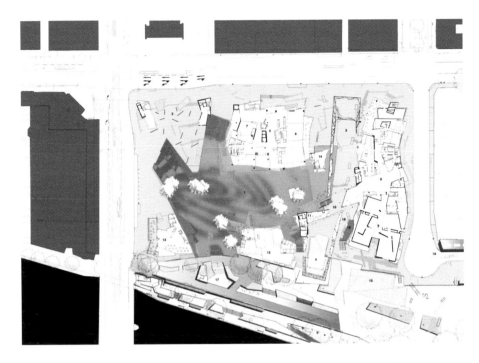

Ground floor plan

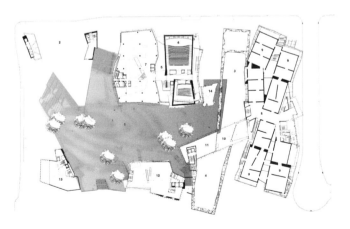

Second floor plan

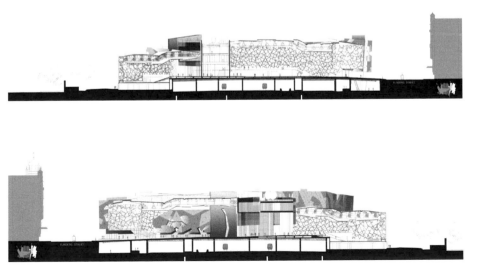

Sections

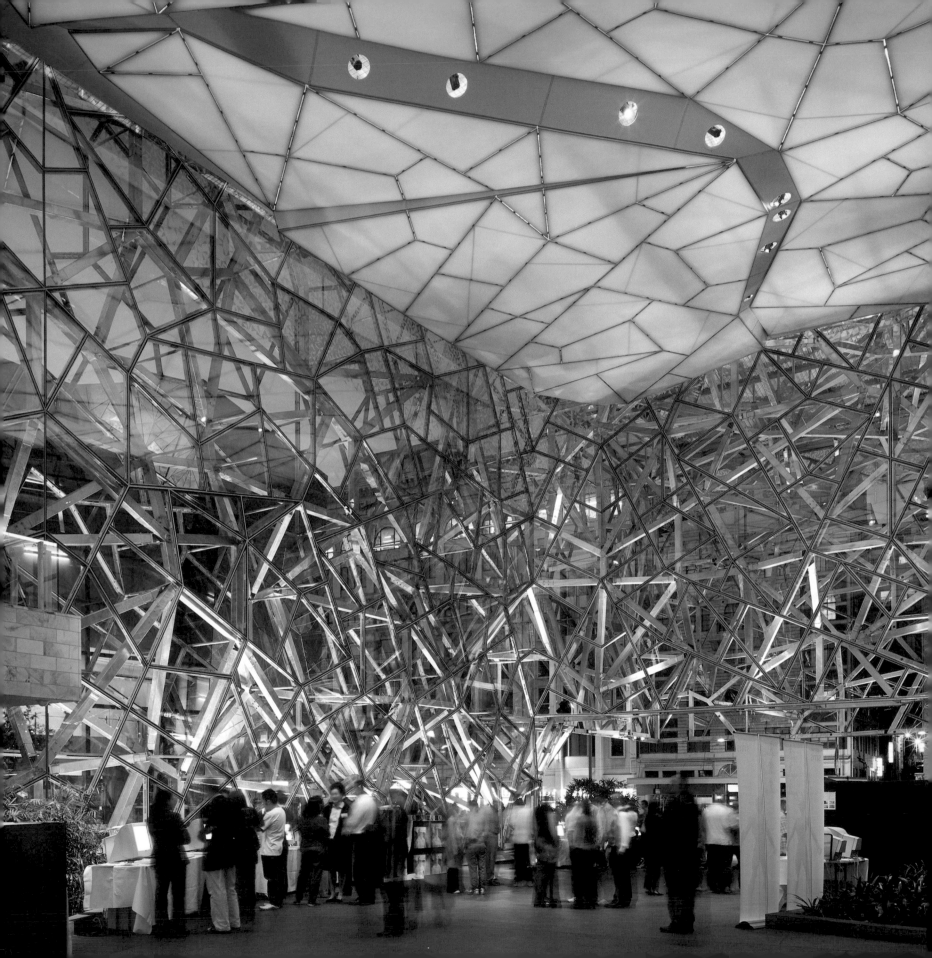

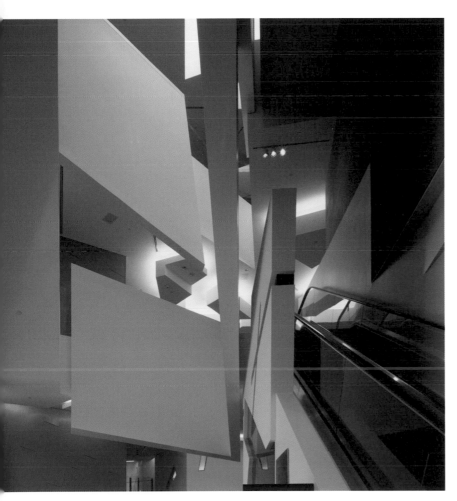

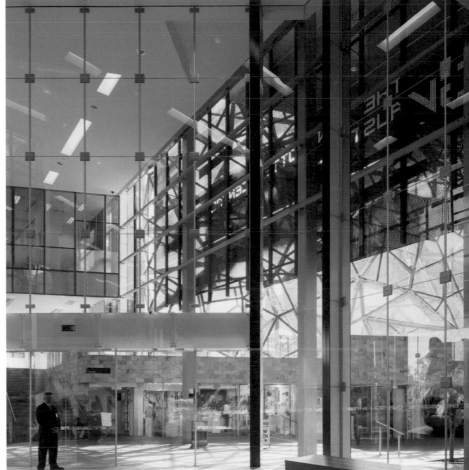

ABOVE: Inside, the elevators, escalators, and stairs are enhanced by a dynamic lighting system that emphasizes the drama of the internal space.
RIGHT: The design's geometry allows for a vast array of configurations and arrangements, from the largest-scale public gathering of up to 15,000 people to intimate sites for relaxation and contemplation.

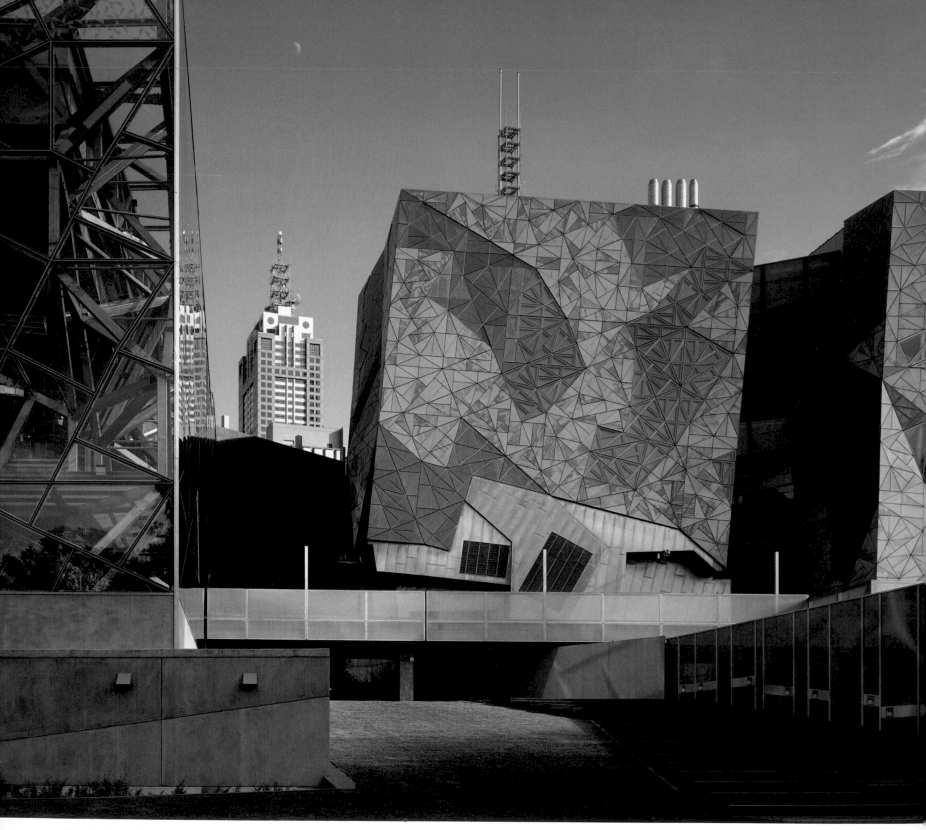

The façades at Federation Square define a new sense of surface and form.
Through the variation of material proportions and their combinations within a changing pattern
or configuration, different surface qualities have been developed not only for each building, but
also for the different orientations of each façade.

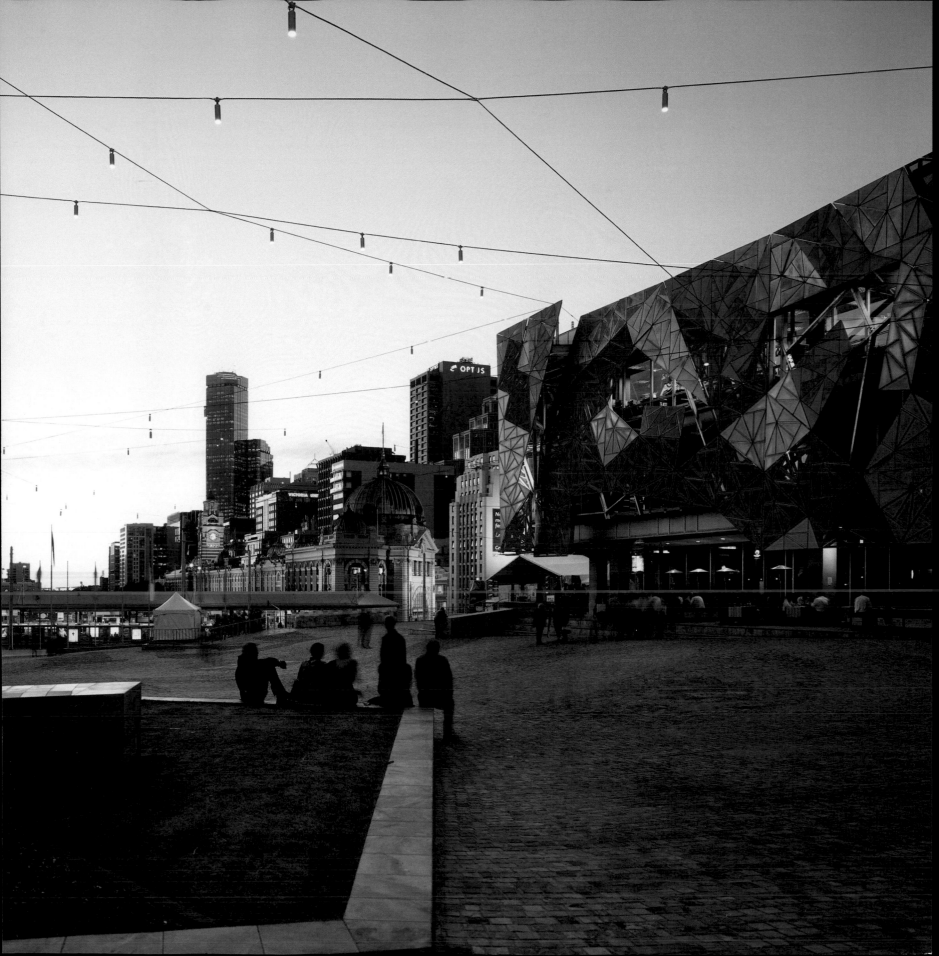

Forum Building

Herzog & de Meuron

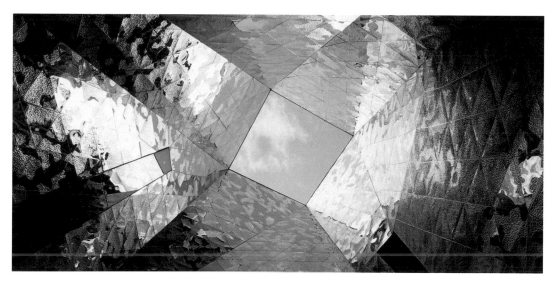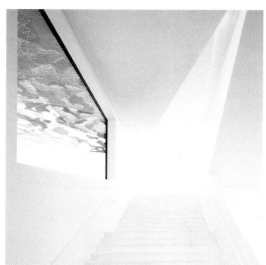

Forum Building

Architects: Herzog & De Meuron

Location: Barcelona, Spain

Completion: 2004

Photography: Monika Nikolic / Artur

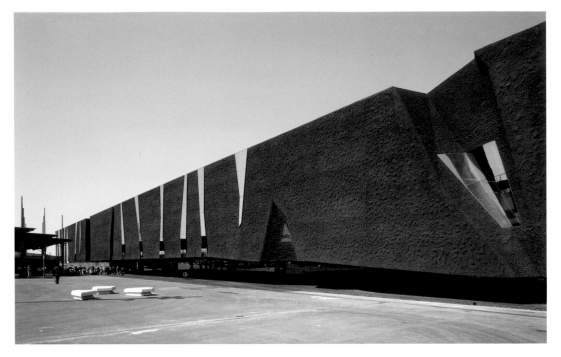

If there is one aspect of Barcelona that plays an important role in the city's historical character and continuous development, it would have to be its architecture. After undergoing a major makeover for the 1992 Olympics, this city has become one of most popular international European centers. The hometown of Antonio Gaudí is also the cradle of innovative, contemporary architecture generated by local and foreign architects alike. One of the latest additions to the city's urban landscape, reckoned by some as Barcelona's most emblematic building, is Herzog & de Meuron's Forum Building, the architectural symbol of the cultural platform Forum 2004.

The building is the dominating feature of the 40-acre Forum Plaza, located near the lower end of Avenida Diagonal, where land meets sea. Intended to echo the geometry of this major avenue—which cuts across the city's characteristic grid pattern—and reflect the coastline's natural features, the structure adopts an 85-foot-tall, 525-foot-long triangular block that faces the water and tip faces the city. The elevated, flat mass employs dark blue concrete walls that reflect the presence of the sea, and approximately 28,000 individual stainless steel triangular panels arranged to form a pattern of irregularly shaped embossed surfaces that represent the sky above.

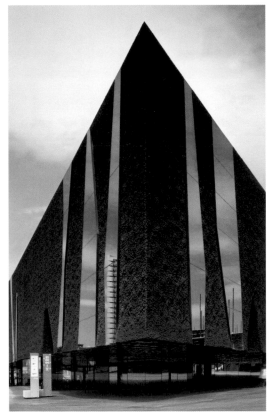

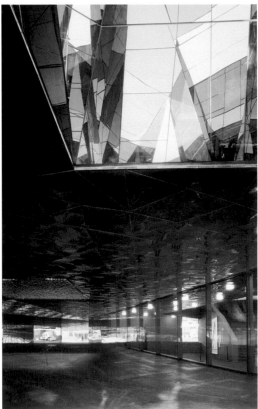

Pocketlike apertures around the building allow for circulation spaces that offer a unique perspective of the architecture from underneath the structure, leading to various areas above and below the ground level, including a 7,000-square-foot exhibition space, a 3,200-seat auditorium, foyer spaces, conference rooms, and restaurants. The covered area beneath the triangular volume acts as a hybrid space, offering a combination of urban typologies. The series of courtyards that intersect the elevated structure establish a complex interaction between the covered open spaces and the various levels of the building, continuously generating new perspectives and diverse light effects. In terms of urban planning and development, the project envisions a striking culmination of one of the city's grandest historical avenues and provides Barcelona with a new landmark for its coastal skyline.

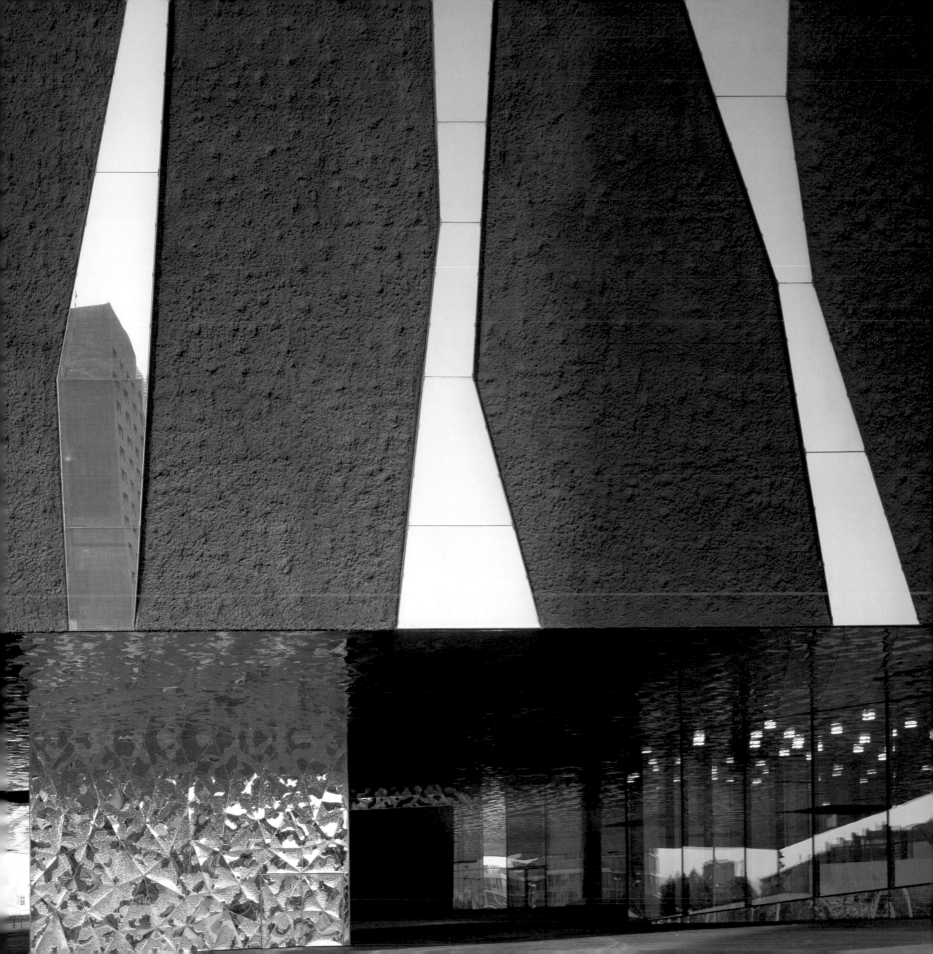

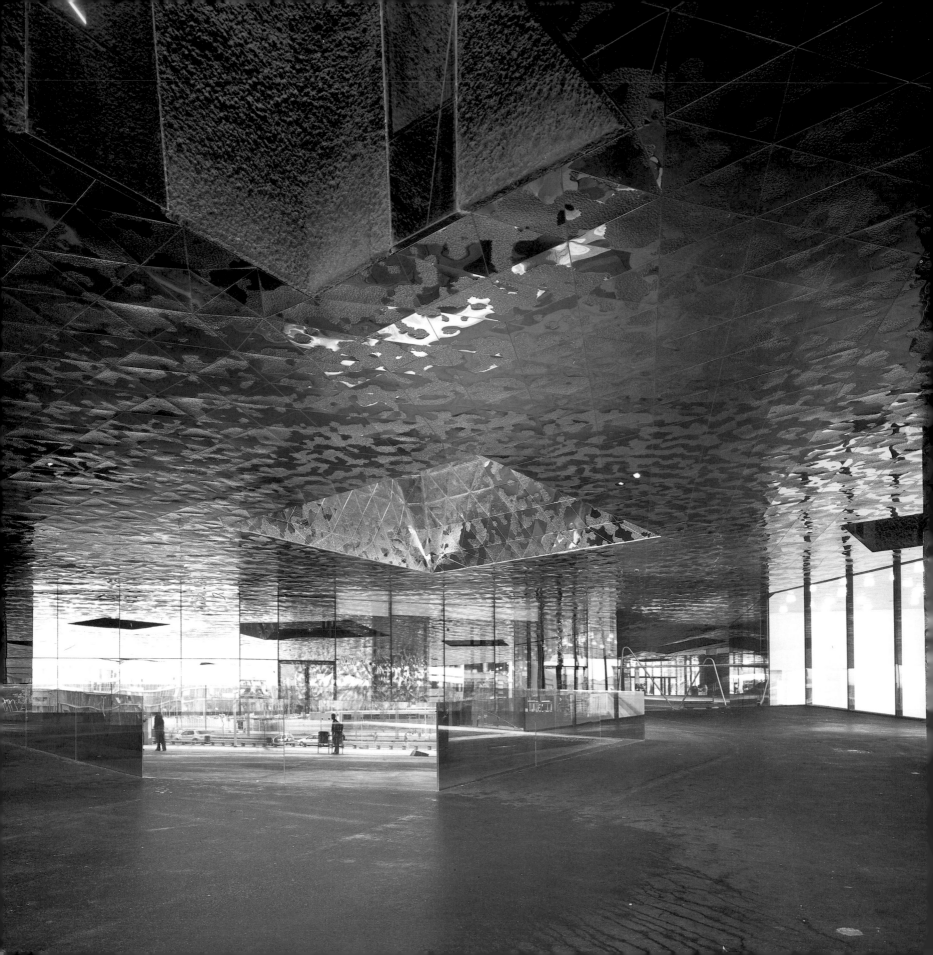

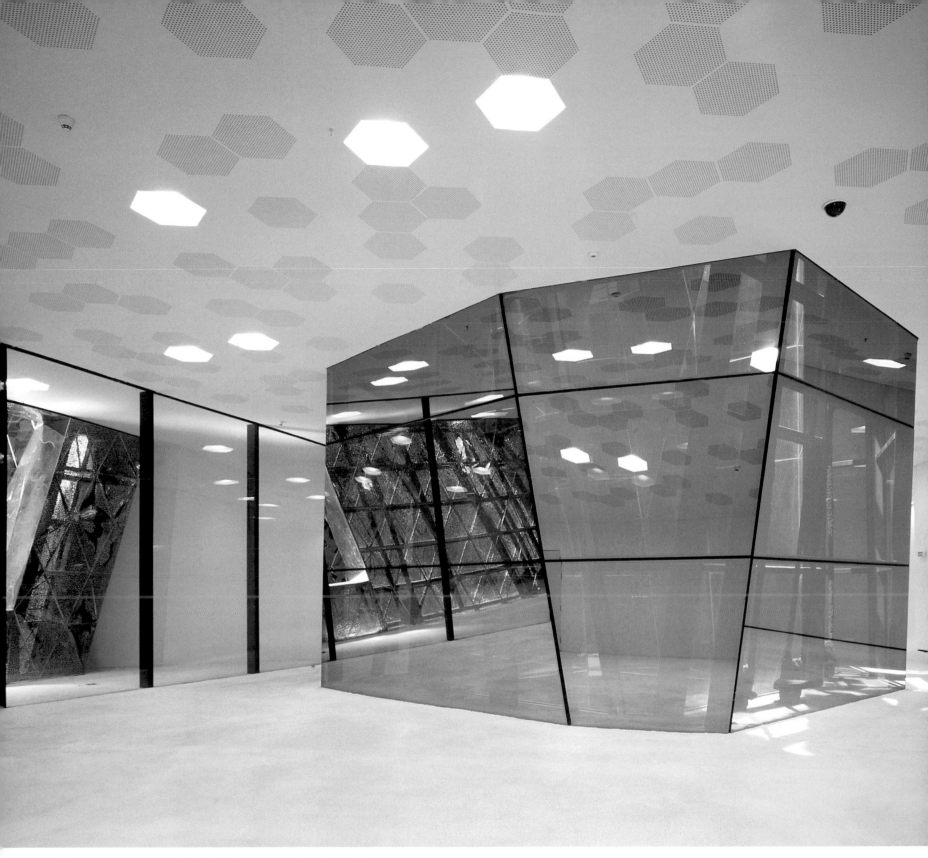

The use of transparency and reflection achieves an underwater sensation that is emphasized by the bubblelike hexagonal pattern along the ceiling.

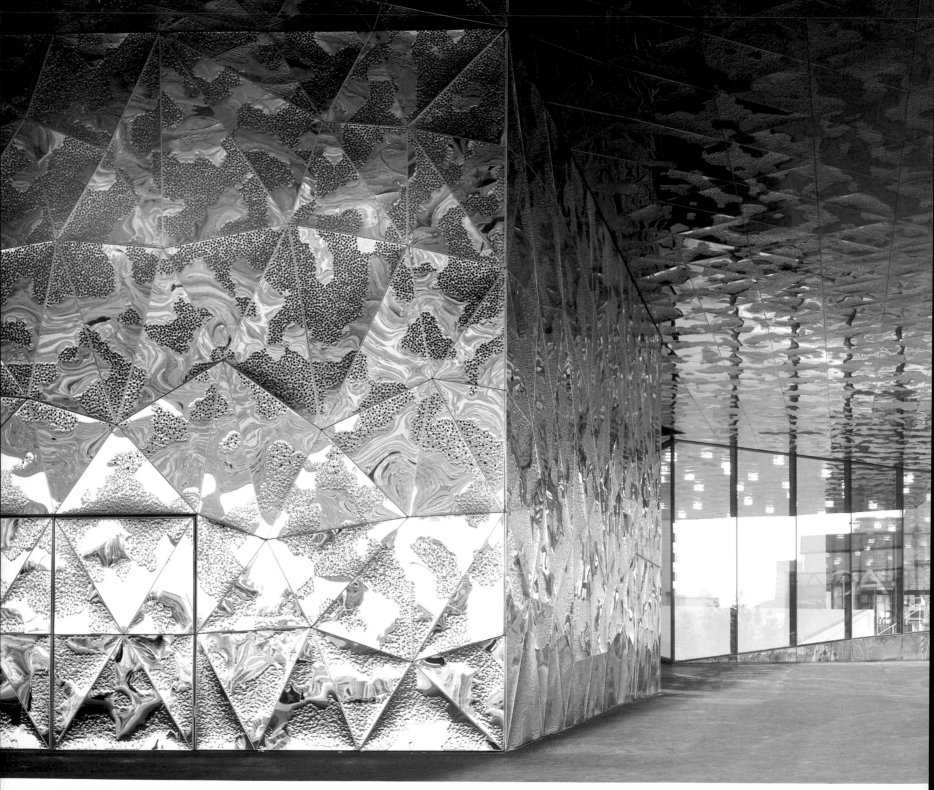

The light that grazes the sides of the building is drawn underneath by the reflective panels that line the building's underside, provoking a glistening shimmer that resembles the reflection of the sun on the sea.

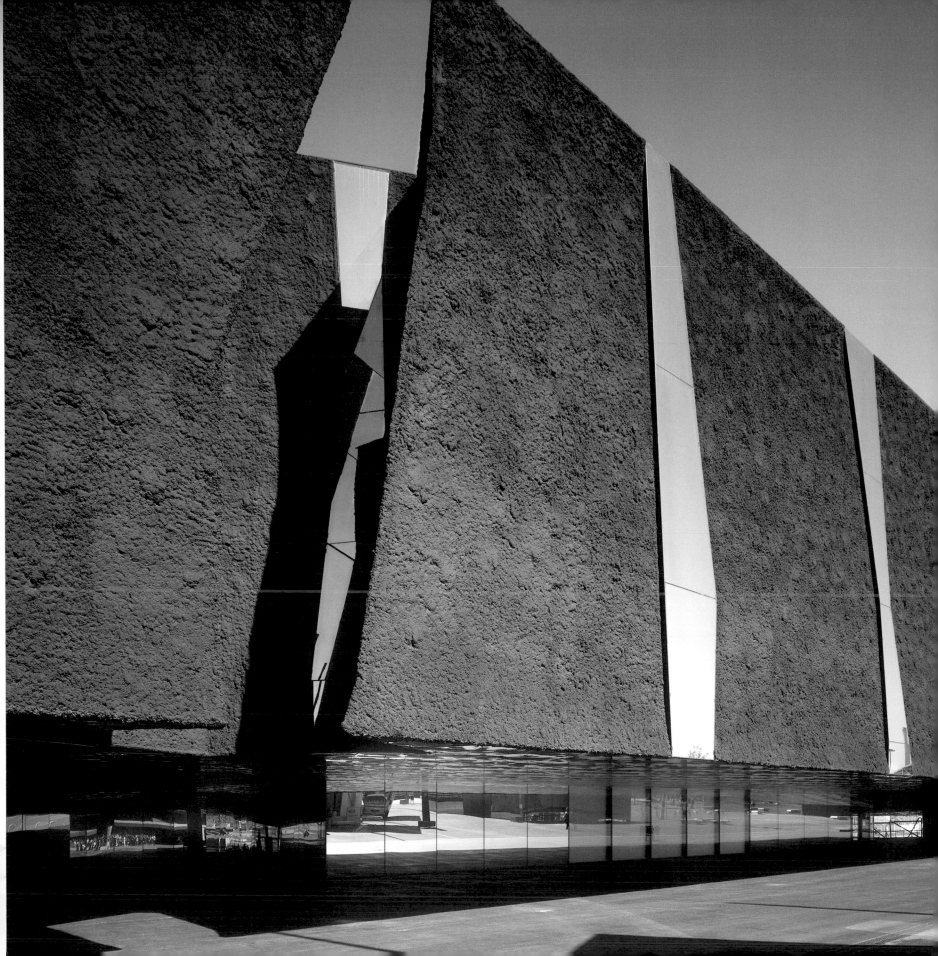

ING Head Offices

Architect: EEA

Location: Budapest, Hungary

Completion: 2004

Photography: Christian Richters

The 430,000-square-foot development was designed for ING Real Estate Hungary, part of the Dutch ING Group, whose philosophy is to offer additional value by creating distinctive yet functional architecture. The brief presented to the architects at Erick van Egeraat (EEA) called for the design of a high-quality office building, with an internal layout that would conform to commercial market standards. The result is a marriage between the city's historical architecture and the dynamics of contemporary design.

The overall mass, located in a prominent location in Budapest, is expressed as three volumes, linked by fully glazed atrium spaces and connected by glossy stainless steel lines. This concept derives from its urban context in which it creates a 21st-century transition between the orthogonal volume of the adjacent modernist building of the 1950s, previously renovated by EEA, and the late-19th-century eclectic-style villas that are typical of the area. The façade, in accordance with the adjacent modernist building, is free from the traditional place-ment of openings. Slightly undulating façades become an instrument of light, generating an ever-changing composition of visual effects illustrated by contrasts of brightness, reflection, and transparency.

The exterior's dynamic design continues within the building upon entering through one of the several atria. Connecting all office floors, this bright communal space—with slightly inclined, translucent surfaces—uses glass and steel drapery to create a layered effect for a feeling of intimacy and solace. In contrast to this emotional space, the overall office layout reveals a strict functional arrangement with three underground parking levels, a public ground floor, six office floors, and an executive meeting area on the seventh floor. The rationality of the floor plan is softened by the variety of windows and the visual connections between offices and atria. The combination of references and compositional schemes successfully marries the commercial demands of the client with the architec-turally historic context of Budapest, and contributes to a sensitive metamorphosis of the contemporary city.

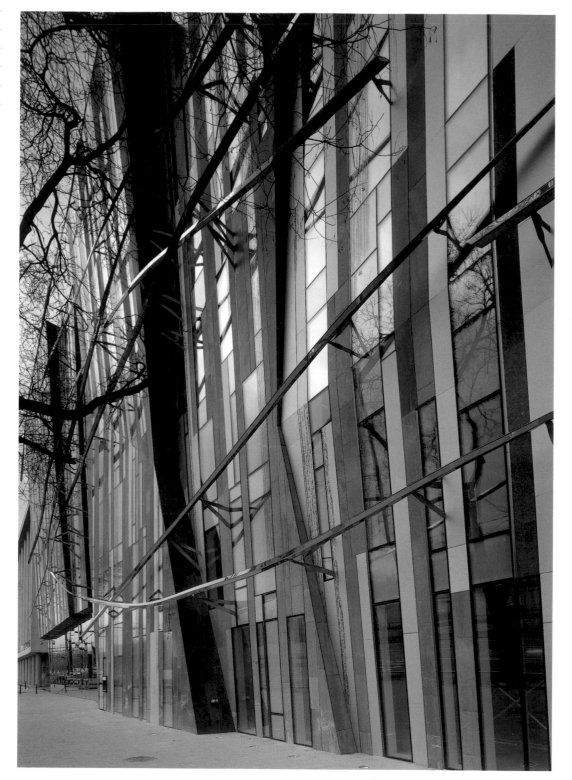

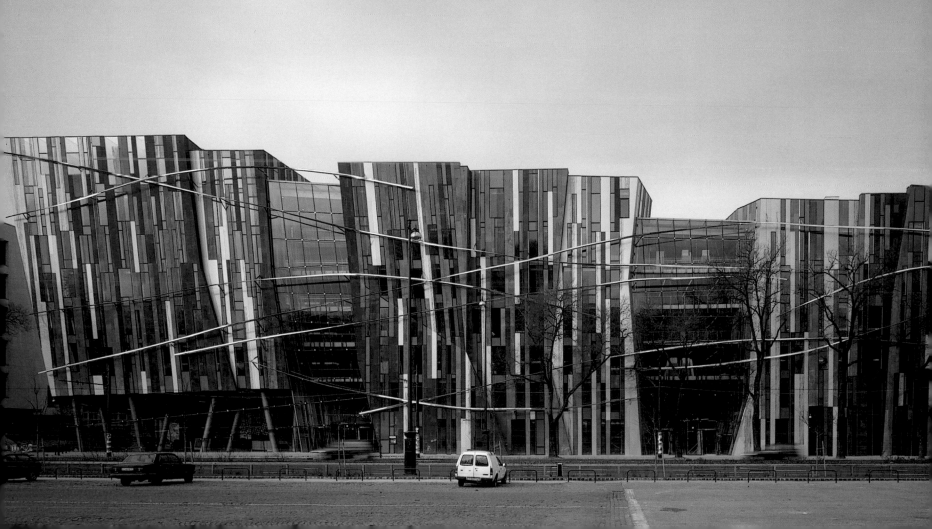

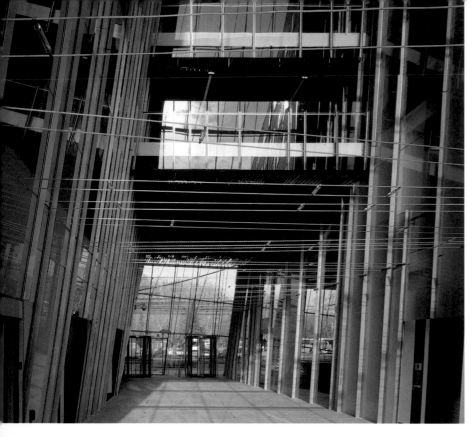

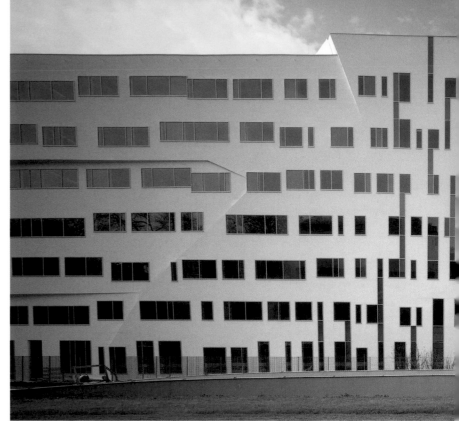

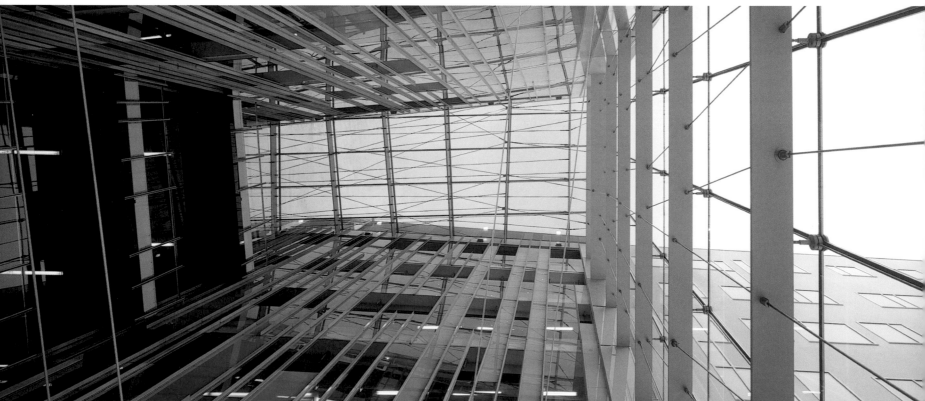

The building's contemporary composition, detailing, and treatment of materials at once recall the richness and complexity of the historic façade detailing of the city's buildings.

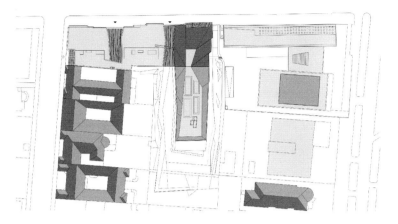

Site plan

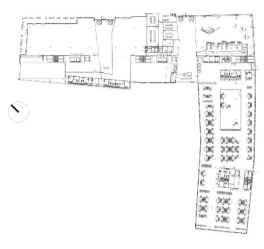

Ground floor plan

0 6 12

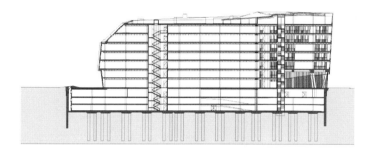

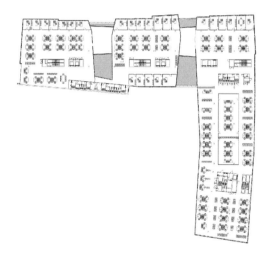

Second floor plan

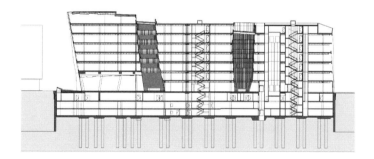

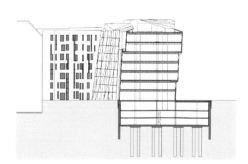

Sections

Seventh floor plan

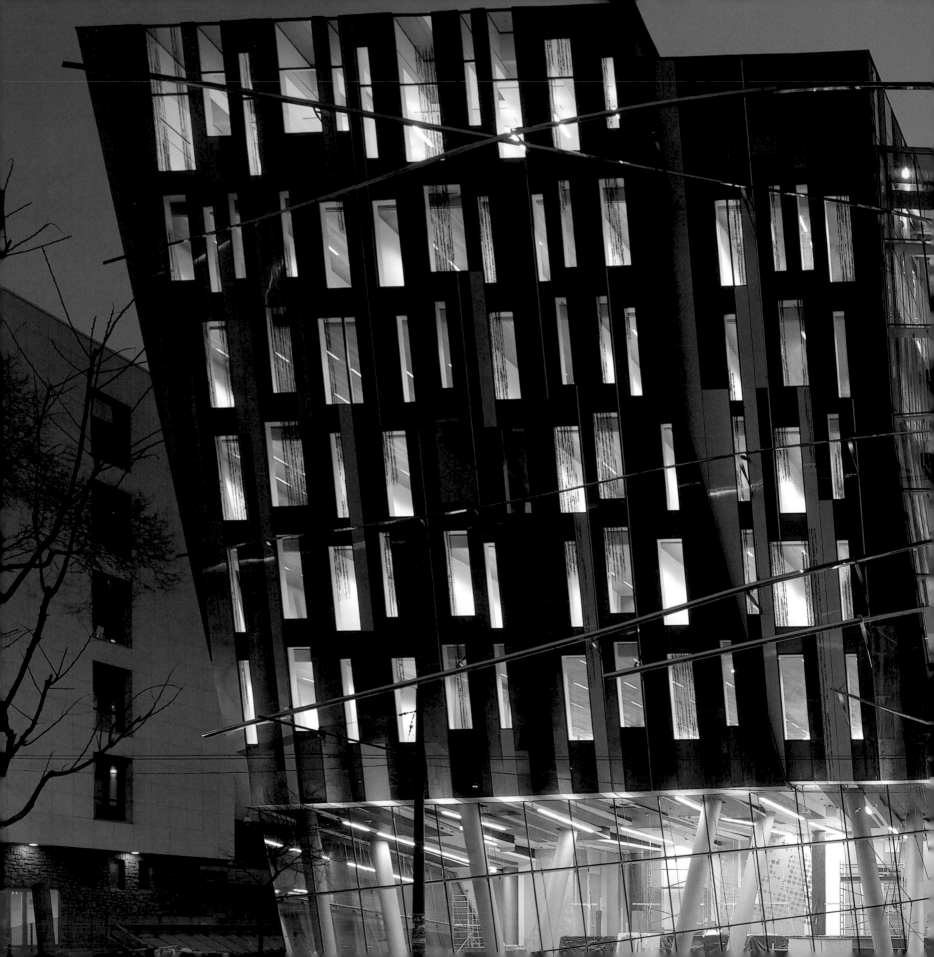

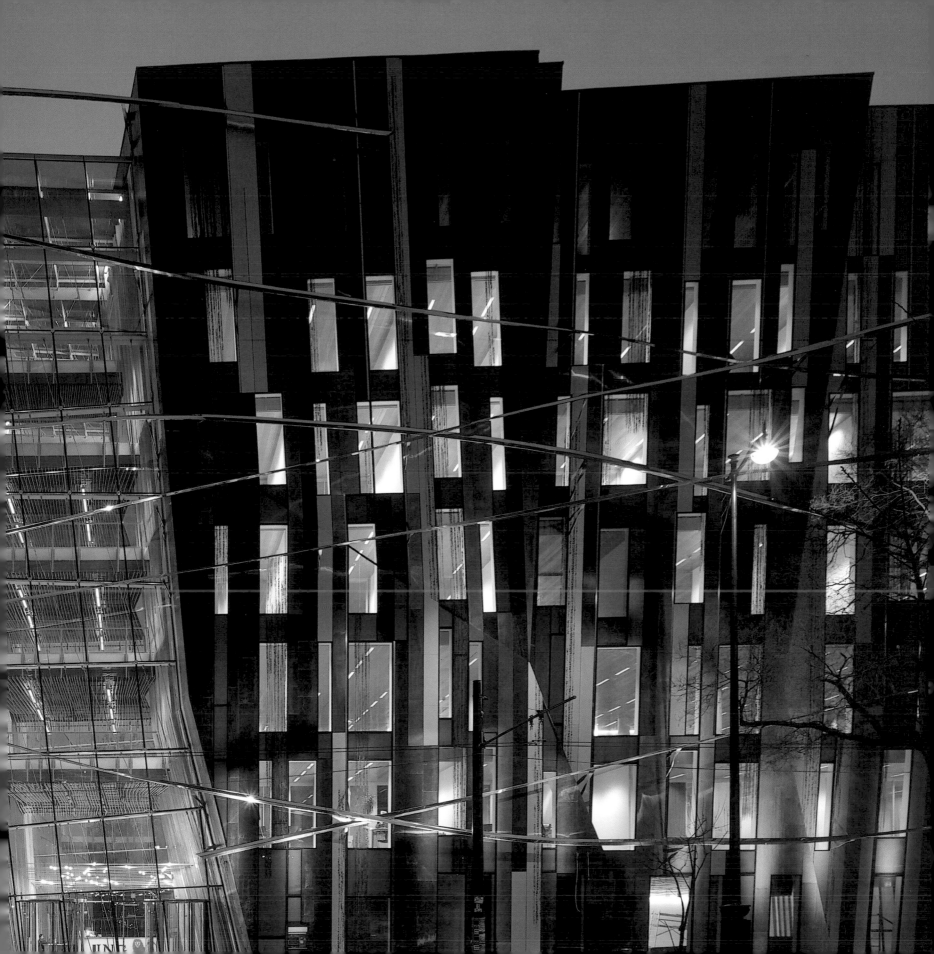

Jubilee Church

Richard Meier & Partners

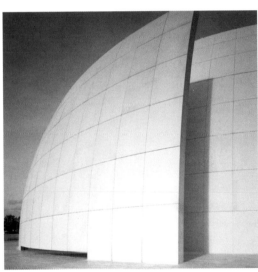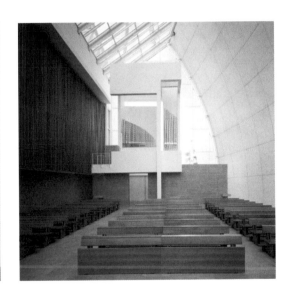

Jubilee Church

Architects: Richard Meier & Partners

Location: Rome, Italy

Completion: 2003

Photography: Klaus Frahm / Artur

Richard Meier's unequivocal style marks this new addition to Rome's rich landscape of religious architecture. The Jubilee Church, named by Pope John Paul II as Dio Padre Misericordioso, was conceived as a new center located in the Tor Tre Teste area of Rome. The church forms part of the Millennium Project of the Archdiocese of Rome and, as its highlight, stands as the 50th new church and community center built throughout the suburbs of Rome.

The triangular site is articulated through three gestures: first, dividing the sacred realm to the south, where the nave is located, from the secular precinct to the north; second, separating the walkway from the housing situated in the east; and third, separating the walkway from the parking lot situated to the west. The proportional structure is predicated on a series of displaced squares and four circles that generate the three shells and the spine wall of the nave.

The building, predominantly featuring concrete, stucco, travertine, and glass, is characterized by its three dramatic shells that discreetly imply the Holy Trinity. The complex contains both a church and a community center, connected by a four-story atrium. The glass ceiling and skylights of the church span the entire length of the building, allowing natural light to flow generously and play off of the wall surfaces throughout the day. At night, the building emanates light from within, creating an ethereal presence and animating the landscape.

One of the leading examples of contemporary architecture in one of the world's most historic cities, the Jubilee Church sets an important precedent in international church design and makes it Meier's third ecclesiastical building project. In his own words, "I have always admired the work of Italy's Baroque masters . . . likewise the coalescence of aesthetic and spiritual inspiration that one sees in the great modern churches of the 20th century. . . . With the Jubilee Church, we have worked to create a new Roman Catholic church for the 21st century—a landmark that upholds and builds upon the city's rich architectural tradition."

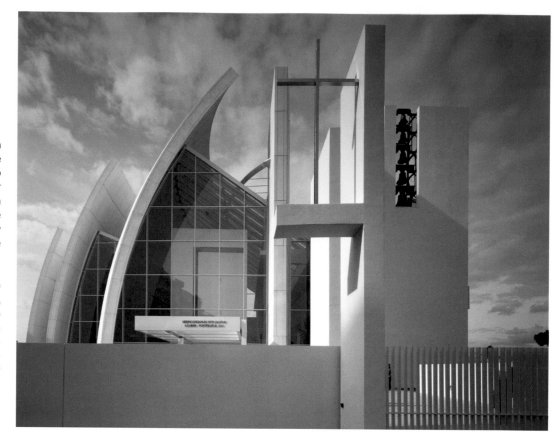

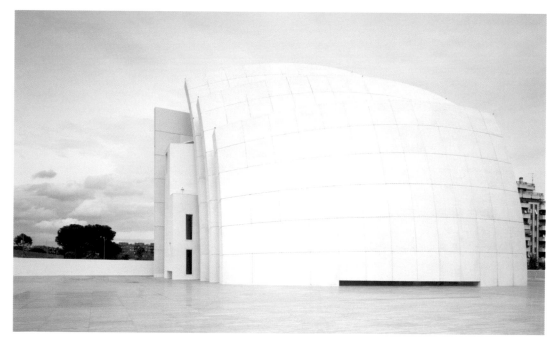

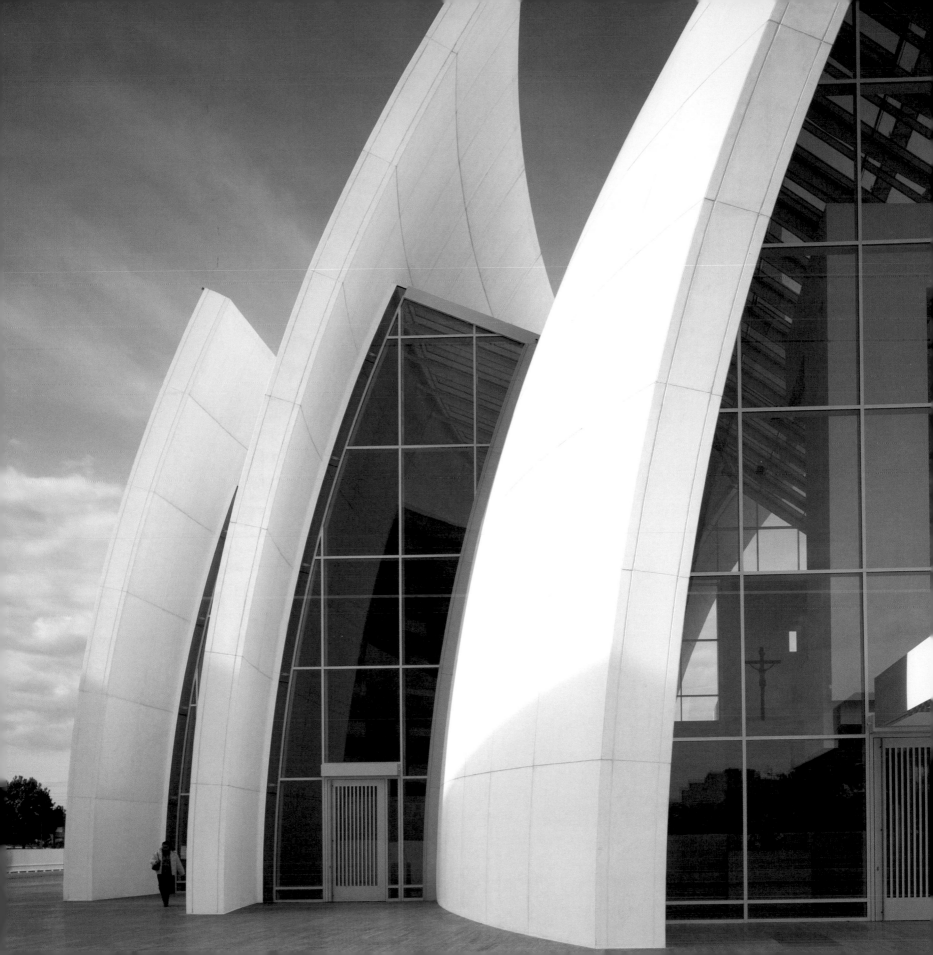

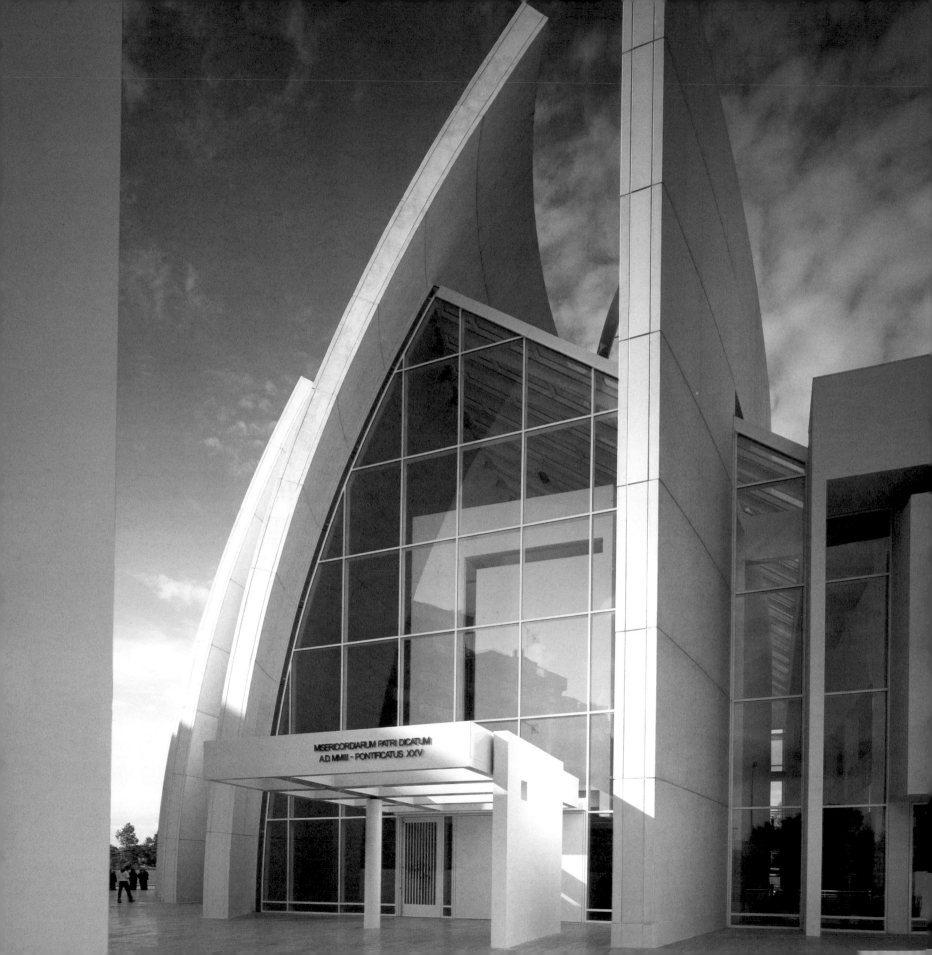

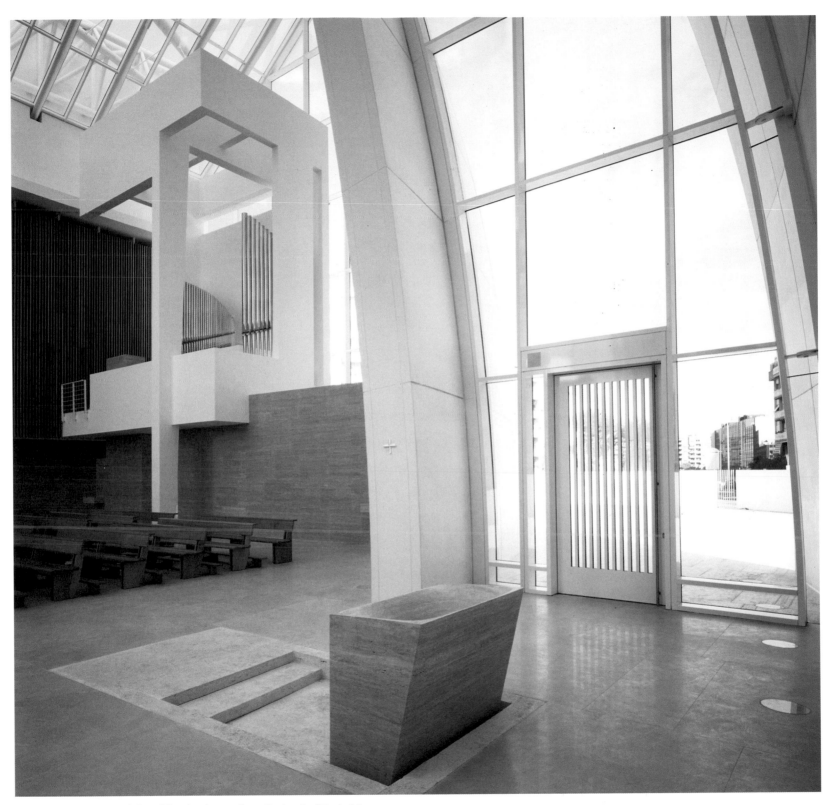

The glass ceilings and skylights of the church span the entire length of the buildings, rising upward in a metaphor for enlightenment and the spiritual realm.

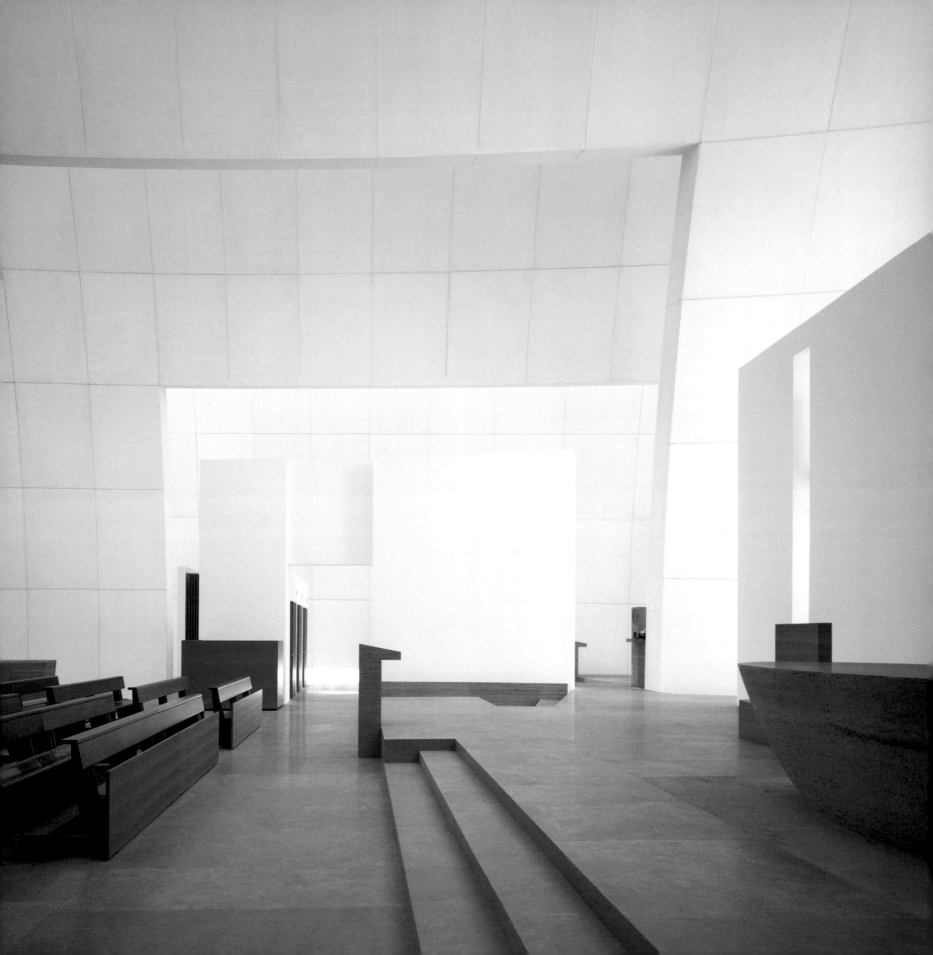

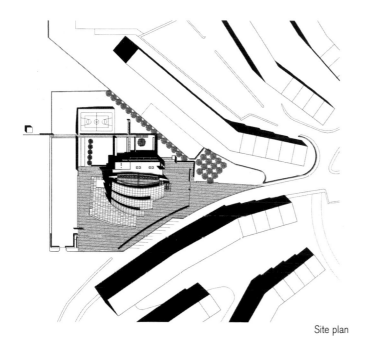

Site plan

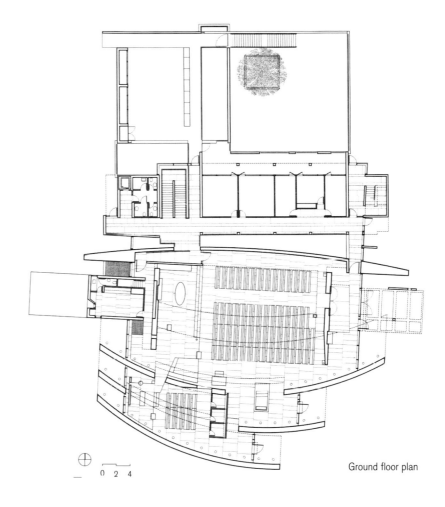

Ground floor plan

0 2 4

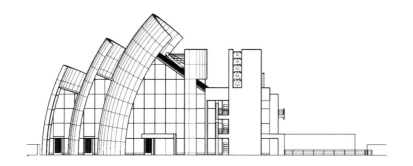

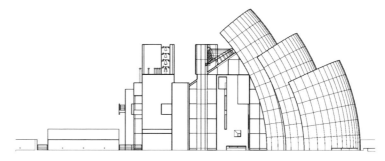

Elevations

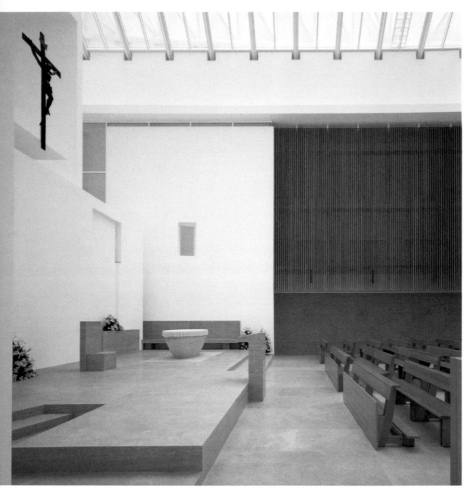
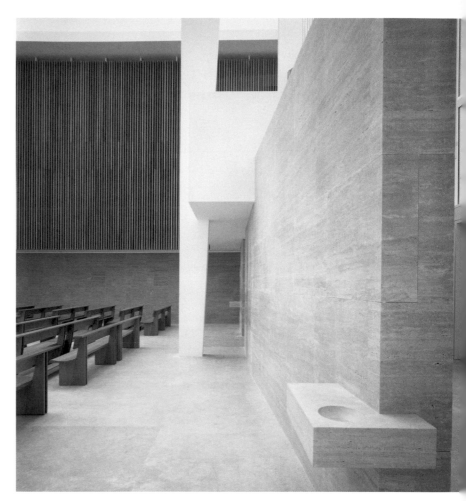

The church combines modern formalism with a respect for historical integrity, thus transforming the traditional house of worship. Concrete, stucco, travertine, and glass dominate an austere combination of straight and curved lines.

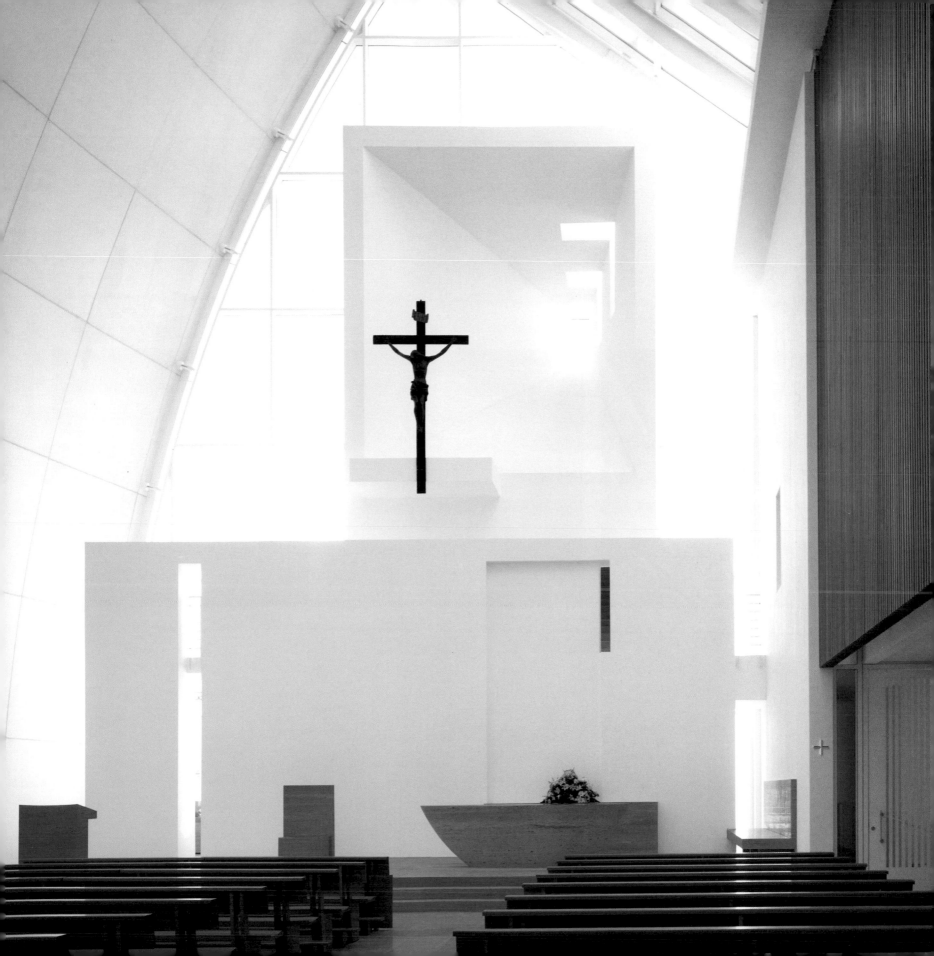

Kunsthaus Graz

Architects: Peter Cook and Colin Fournier

Location: Graz, Austria

Completion: 2003

Photography: Monika Nikolic / Artur

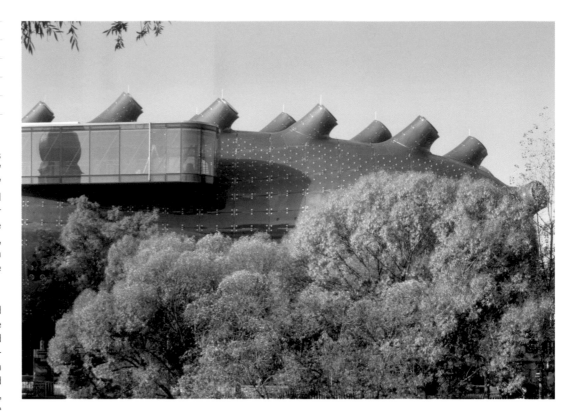

It has been nicknamed the "friendly alien" by its creators and referred to by others as the "blue bubble" and the "artistic porcupine." Graz's new "art house" quickly gained iconic status in the city's architectural landscape, after having aroused much controversy for its unconventional form and inconsistency with the surrounding historical structures. Today the unique, biomorphic structure stands as a trademark of Graz, in representation of a city that constantly fuels a productive dialogue between tradition and avant-garde.

Located on the banks of the Mur between the red brick roofs of neighboring historic buildings, the Kunsthaus is an art center that houses exhibition and performance spaces as well as a café and a bookstore. The gigantic steel and acrylic structure takes on the form of a huge bubble, its organic appearance and strange projections resembling that of an overblown, snail-like creature from another planet. From the surface of the acrylic glass outer skin, strikingly shaped nozzles project outward and toward the north to provide optimum natural lighting. The main eastern façade is integrated with an additional architectural installation called BIX that consists of 930 fluorescent lamps, situated underneath the Plexiglas surface, which can be computer-controlled to display images, films and animations. In this way, the Kunsthaus façade constitutes an extraordinary medium for presenting art and related information transfers.

Originally, the project was to be built within the Schlossberg "castle mountain" of Graz, where the British architects Peter Cook and Colin Fournier would have used an organically shaped membrane to smooth out the coarse, complex structure of the walls within the mountain. Ultimately, this membrane would have protruded from the mountain and into the city like a dragon's tongue. However, the form was altered and the construction site was relocated to the western part of the city to serve as an efficient catalyst for positive changes in the previously disadvantaged half of the city, in a gesture that fuses architecture, technology, and information.

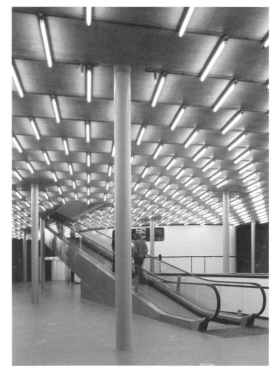

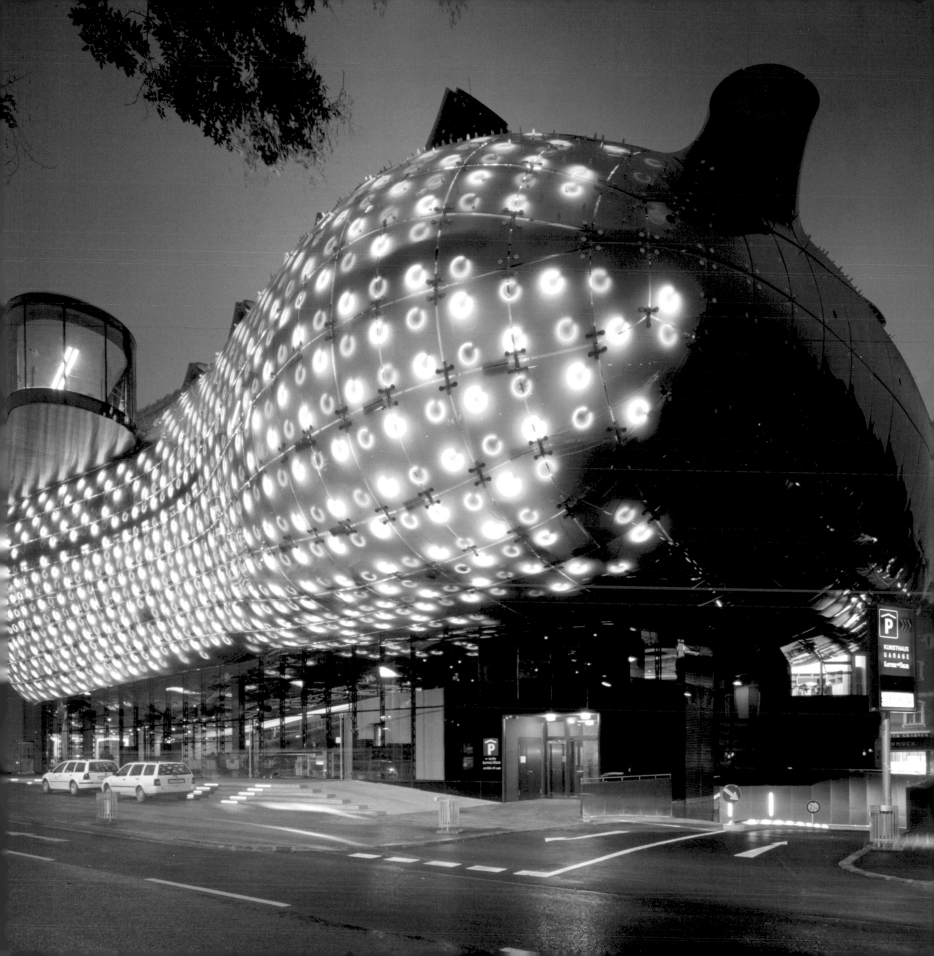

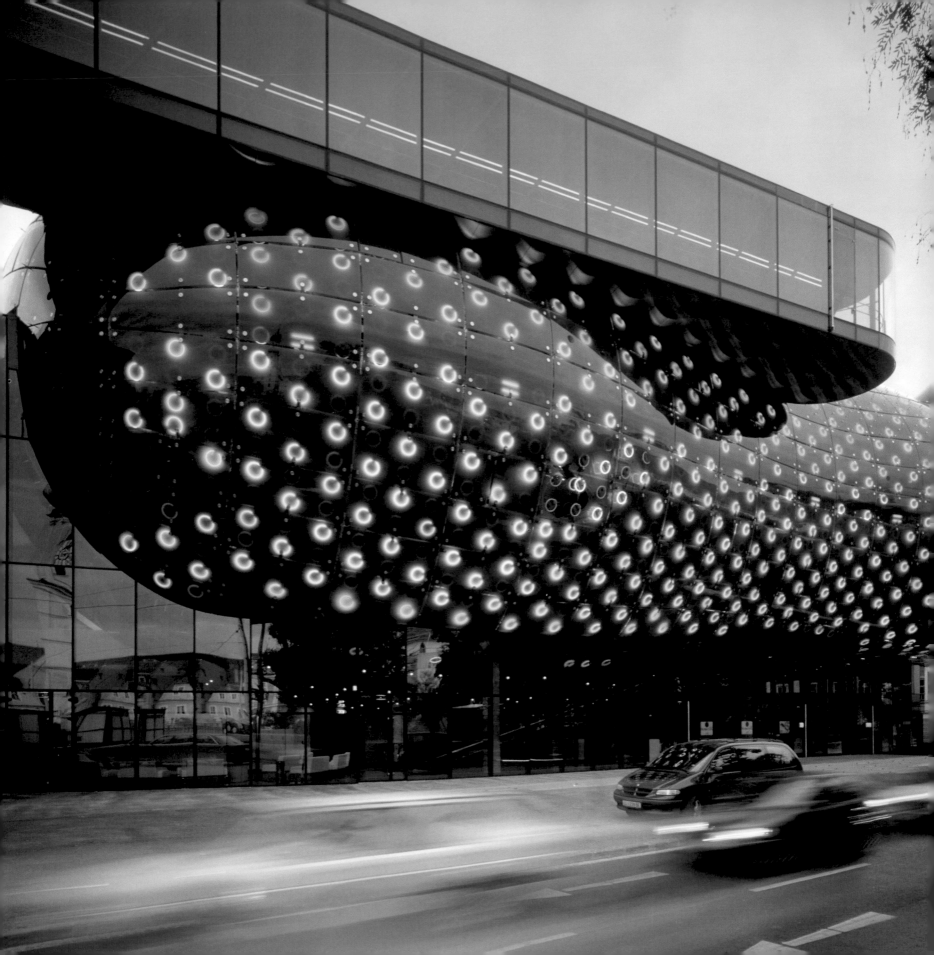

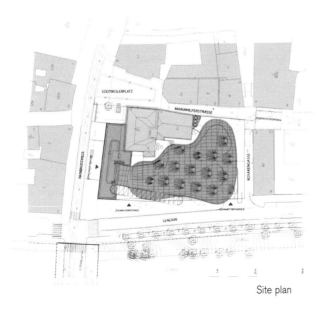

Site plan

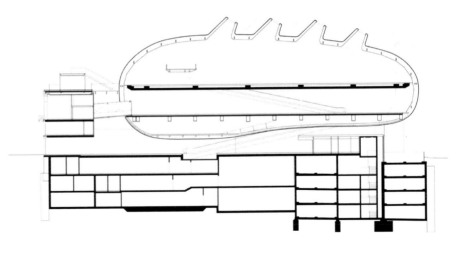

Section

Sublevel floor plan

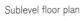

0 5 10

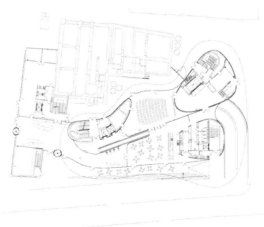

Ground floor plan

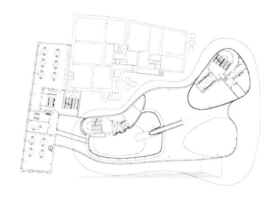

Second floor plan

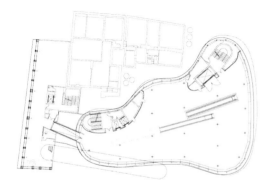

Third floor plan

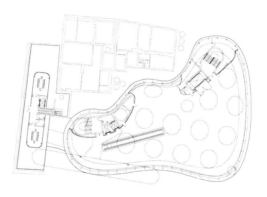

Fourth floor plan

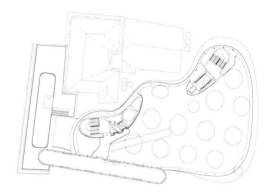

Fifth floor plan

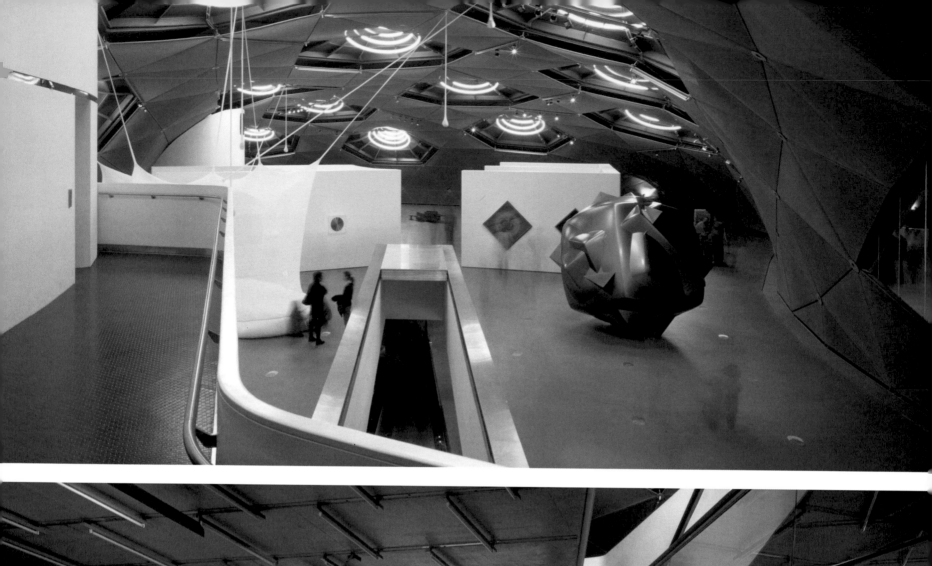

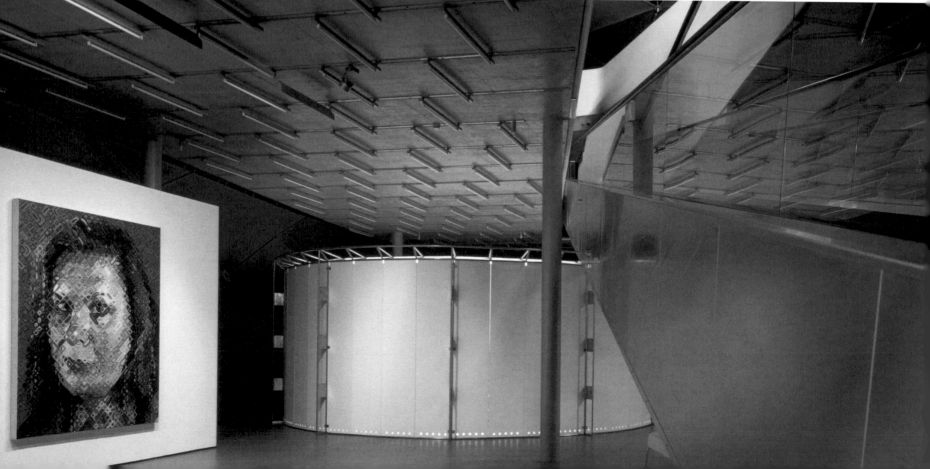

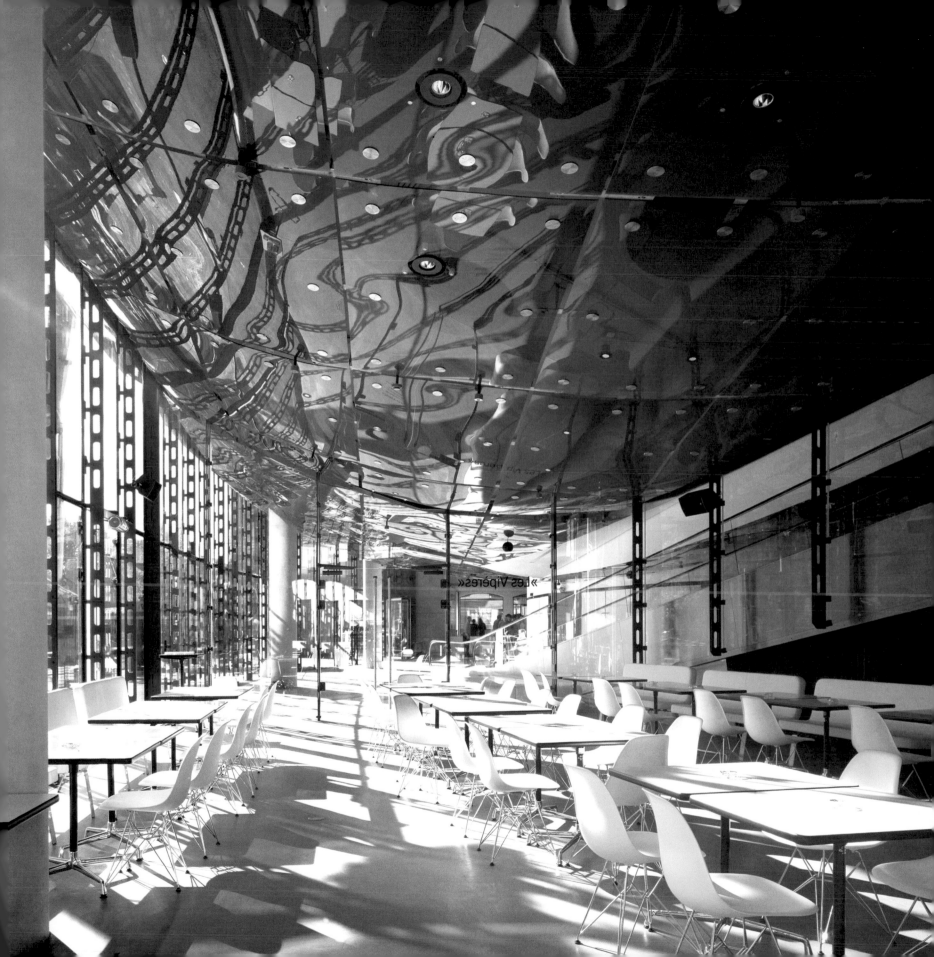

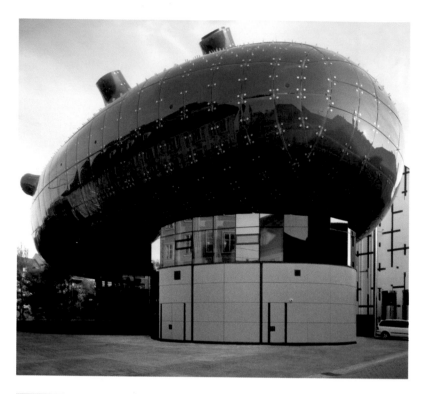

LEFT: The sleek blue shimmering façade made of opaque plastic tiles incorporates reflections of the nearby historical façades, expressing both its contrast to and integration with the city's traditional architecture. BELOW AND RIGHT: Isolated, transparent window areas in the building's skin allow visitors to look out, while the "needle," a projecting, glass-enclosed structure, offers a stunning view of Graz from a height of about 50 feet.

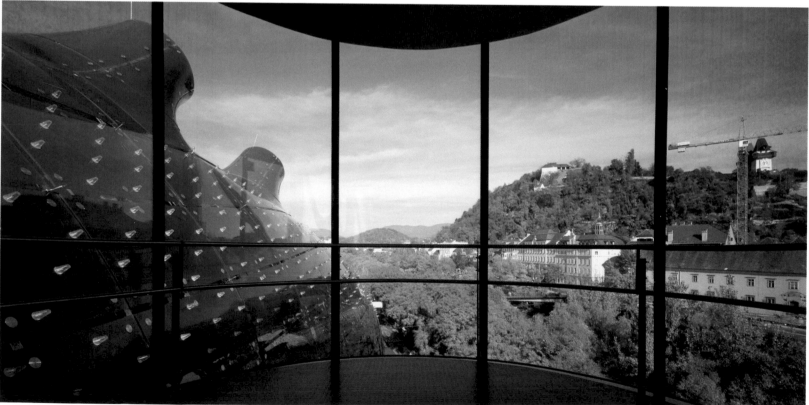

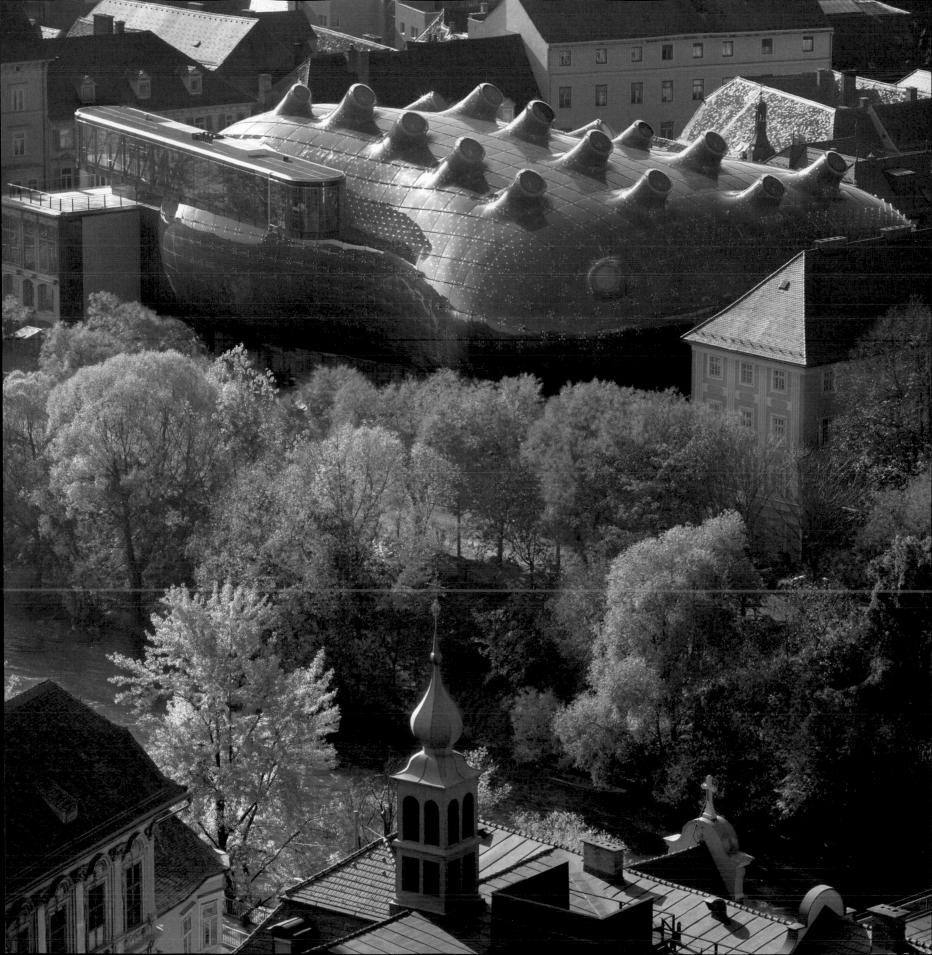

La Defense

La Defense

Architects: UN Studio

Location: Almere, Netherlands

Completion: 2004

Photography: Christian Richters

The town of Almere was founded in 1977 on the reclaimed land of Flevoland, forming part of the youngest settlement in Europe. Created to relieve Amsterdam and Utrecht of their crowded population, the town is now a haven for idealistic architecture in what was conceived as a model city. Housing developments are built to provide views of greenery and open spaces, with easy access to the surrounding forests to avoid the sense of crowded urban living. Located on a typical Dutch polder, what was once a swampland has rapidly transformed into a flourishing city.

Proof of this evolution is the creation of La Defense, a 250,000-square-foot complex situated behind the Central Station in Almere-Stad's business center. The building, sheathed in a gleaming, newly minted foil, appears in its urban context as a modest volume composed of a neutral, rational layout of four partly interconnected blocks of varying lengths. The building units range from five or six to three or four floors in height, resulting in sharply sloping angles that constitute one of the visually dominant characteristics of the project. The most remarkable aspect, however, is undoubtedly the buildings' brightly colored, iridescent surface. While the exterior walls are covered with aluminum cladding and silver-colored glass, the internal walls feature glass sheeting covered with a film that reflects shifting hues of red, yellow, and blue, depending on the light and the observer's perspective.

The chromatic effect is created by Radiant Light Film, a new foil originally designed by 3M for perfume bottles. In collaboration with 3M, UN Studio covered the foil with additional layers that render it suitable as transparent, sunscreening wall cladding. The hues that radiate during the day transform into complementary colors at night as a result of the indoor lighting. A deep red emanates throughout the early morning, fading into orange around noon, turning into blue in the early afternoon, and finally becoming yellow as the day subsides. The application of this innovative material has rewarded the town with a celebration of color, livening up its all too familiar gray skies.

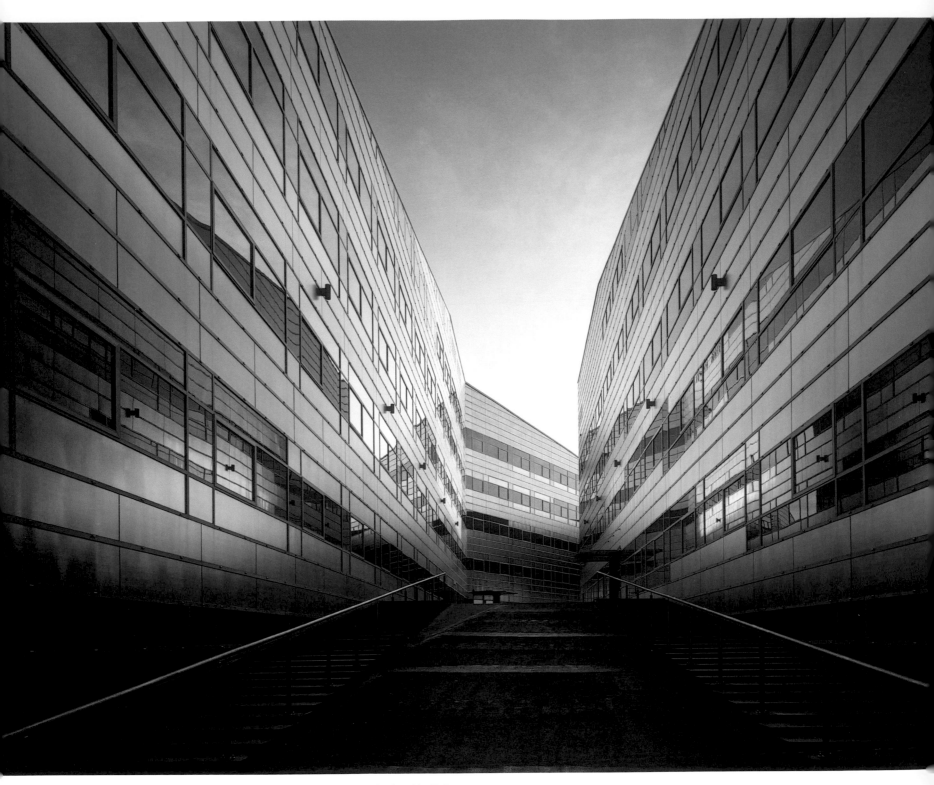

Ben van Berkel and Caroline Bos of UN Studio offer this description of a day at La Defense:
"Eight-thirty in the morning, red time: men and women enter their offices. Eleven o'clock, orange time:
seven meetings start. Two-thirty, blue time: a few late eaters are enjoying a company lunch.
Five o'clock, yellow time: three junior partners are discussing company dealings, the last meeting ends."

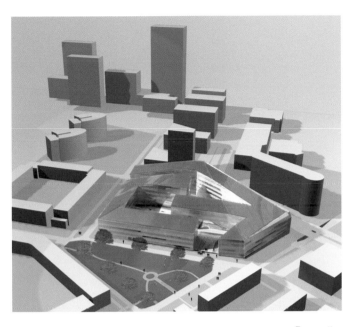

Perspective

Sun-path diagram

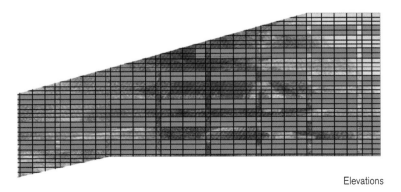

Elevations

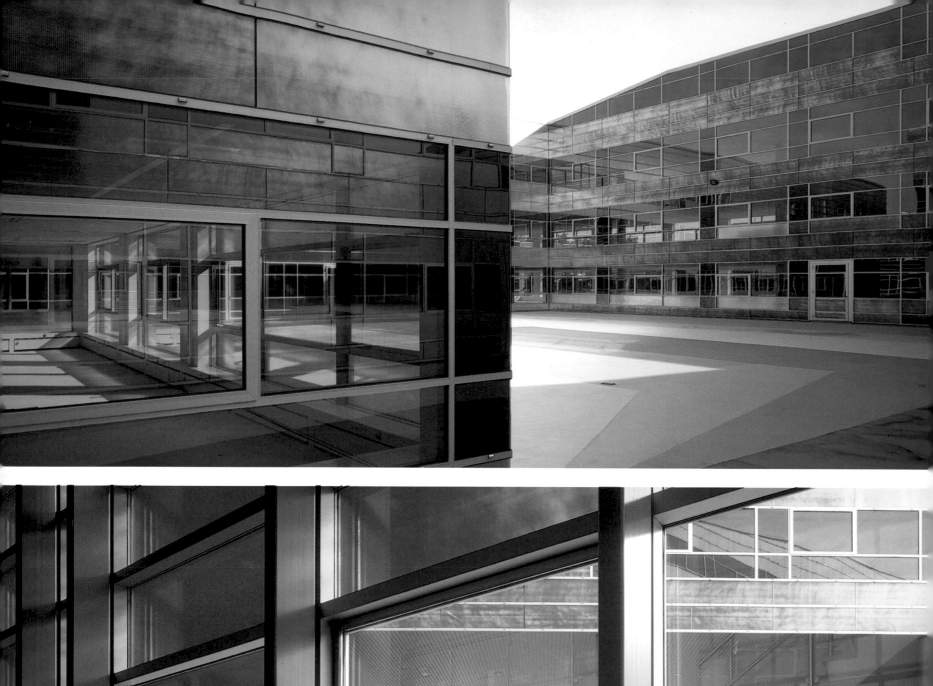
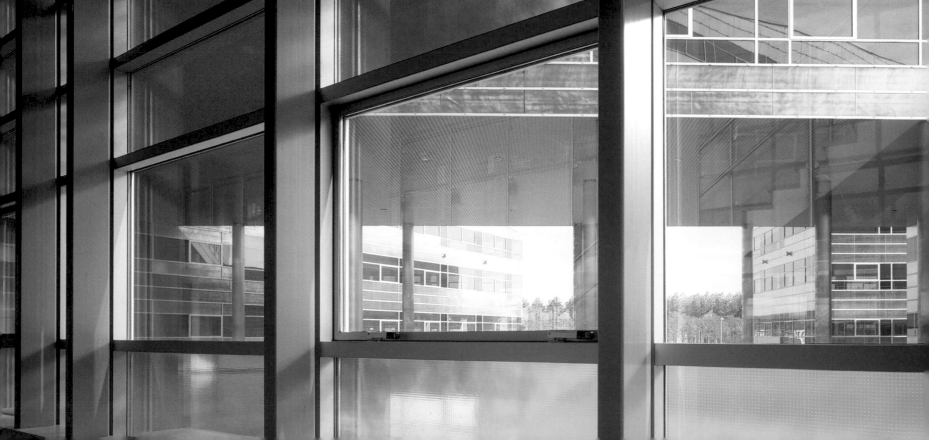

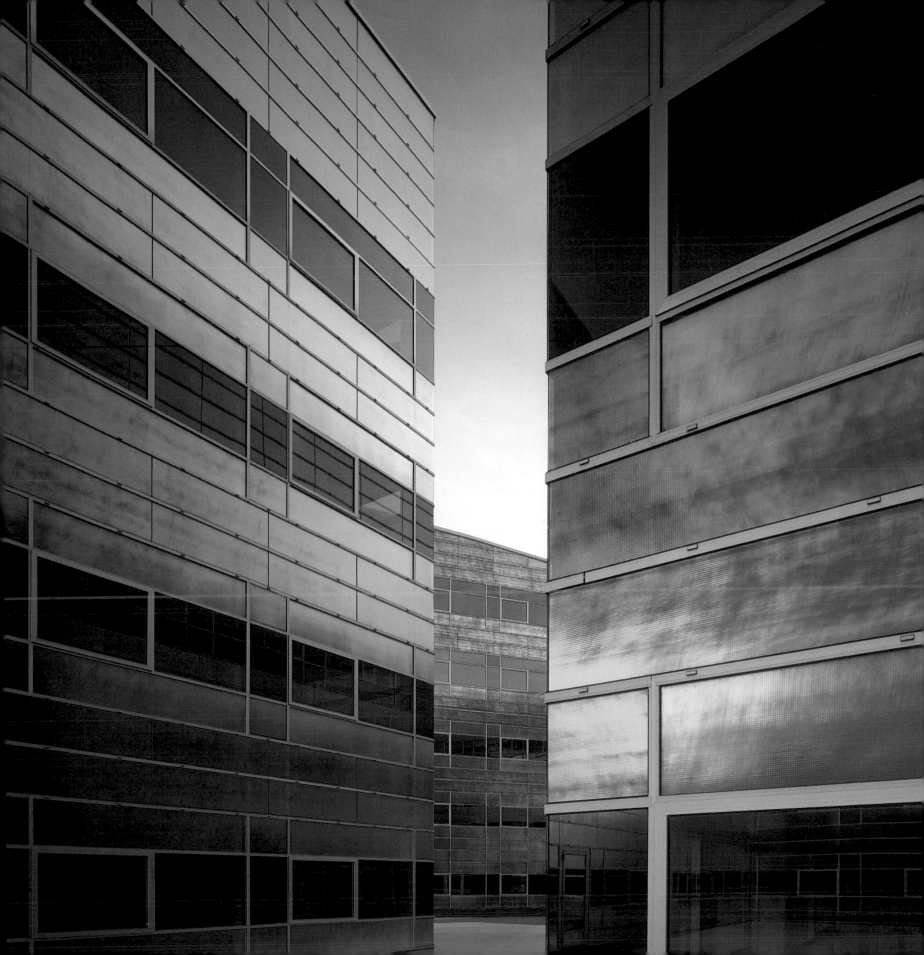

Langen Foundation

Tadao Ando

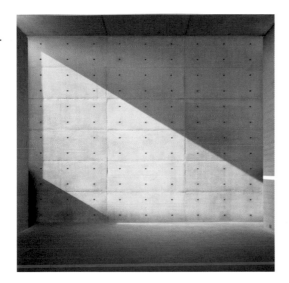 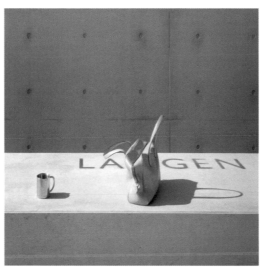

Langen Foundation

Architect: Tadao Ando

Location: Neuss, Germany

Completion: 2004

Photography: Tomas Riehle / Artur

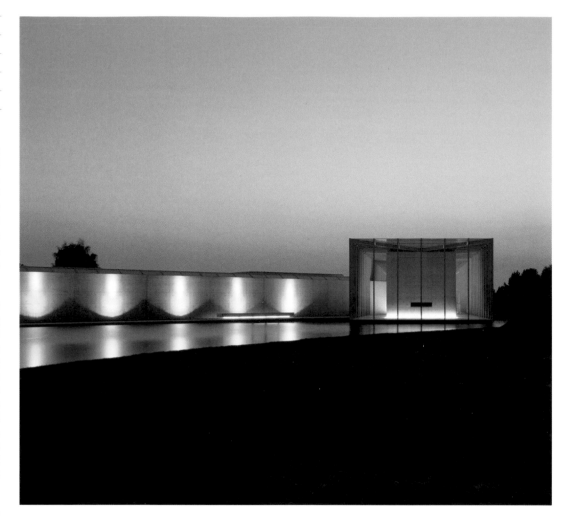

The austerity and elegance that characterize Tadao Ando's architecture become that much more potent when its role is to integrate the presence of nature. The Langen Foundation exemplifies this aim in the form of a new building designed to house art and culture located at the Raketenstation Hombroich, a former NATO base set in the midst of an idyllic landscape. The abandoned site, once devoted to the storage of warheads, was transformed into a unique synthesis of art, nature, and architecture.

Harmoniously embedded in the landscape, the Langen Foundation presents itself as a complex of silky, smooth concrete, glass, and steel surrounded by sculptural earthworks. Making reference to the history of the location, the earthworks protect the building from the exterior and, at the same time, heighten interest in what lies inside. Through a broad concrete arch, a path leads past a row of cherry trees and a shallow, man-made lake to two joined complexes that differ from each other architecturally: a long concrete structure surrounded by a mantle of glass and, at a 45-degree angle, two parallel concrete walls buried 20 feet underground, of which only 11 feet protrude from the ground.

Housing an important collection of Japanese and modern art, the exhibition spaces feature sleek, concrete walls and exceptionally high ceilings that create a simultaneously intimate and monumental effect, which is intensified by the light shining through linear light rails and slits worked into the ceilings. The three exhibition rooms, comprising a permanent Japanese art collection and two temporary modern art collections, add up to a total surface area of 9,685 square feet that contains the most significant European collection of Japanese art in terms of size and quality. One of the few buildings built by Ando in Europe, the Langen Foundation is a masterpiece of linear purity that maintains a serene dialogue between exterior and interior, art and nature, weight and weightlessness: an exhibition space in which the largest sculpture on display is the architecture itself.

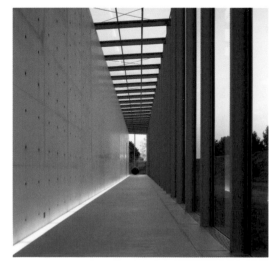

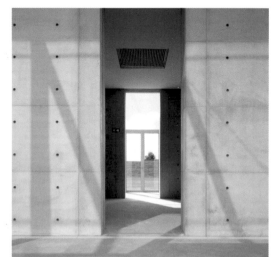

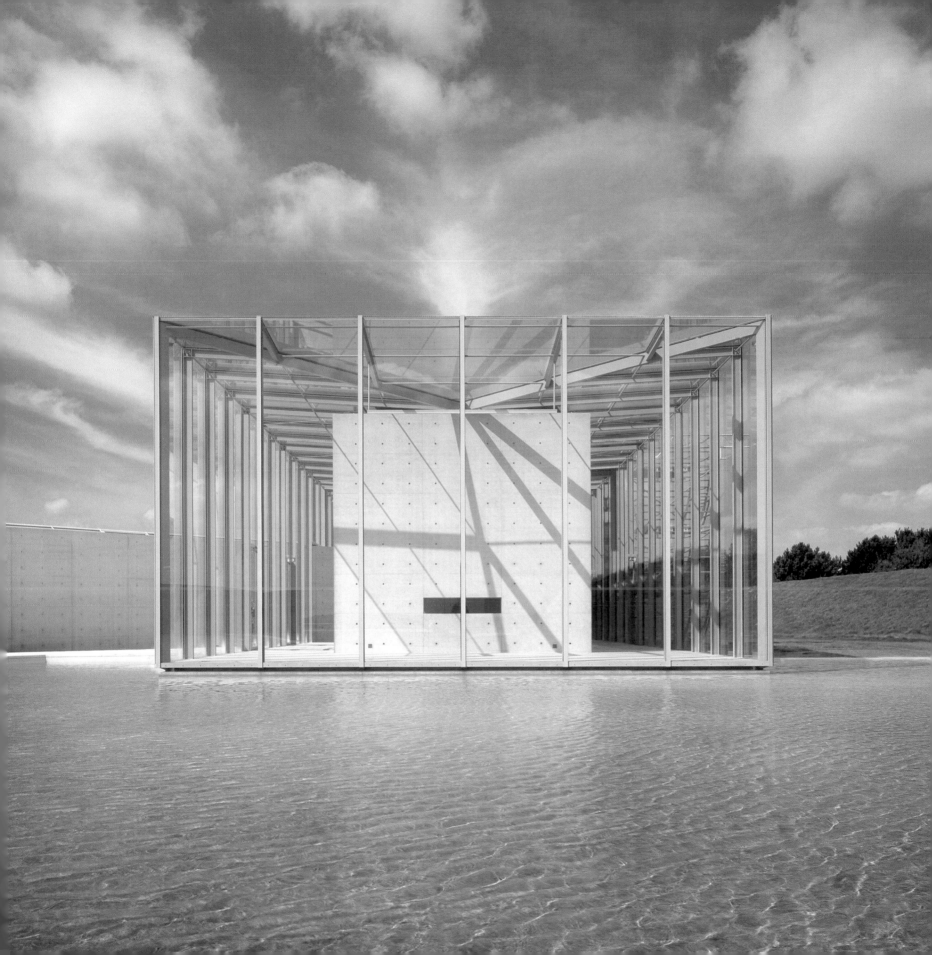

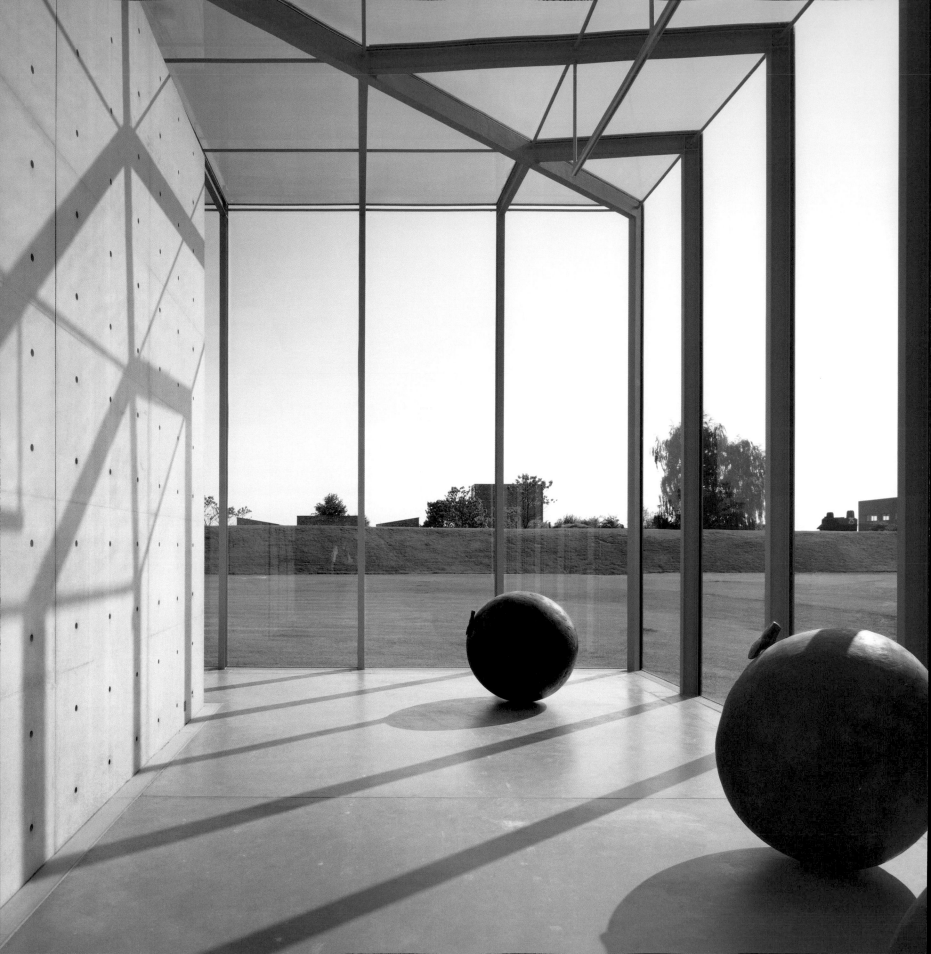

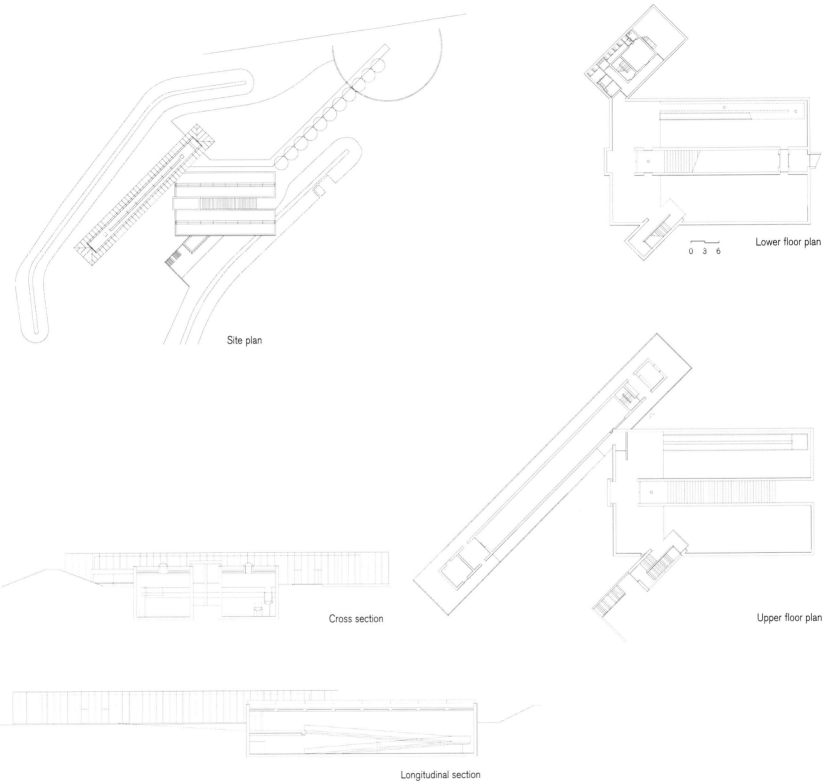

Site plan

Lower floor plan

0 3 6

Cross section

Upper floor plan

Longitudinal section

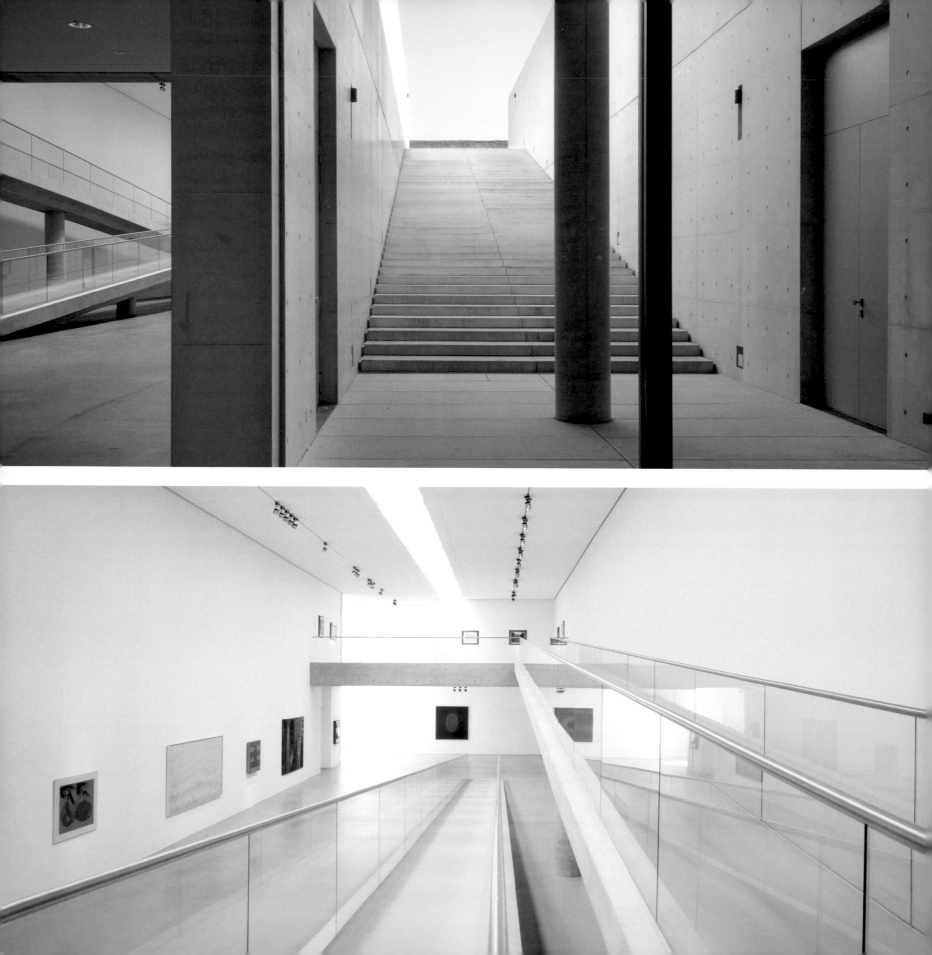

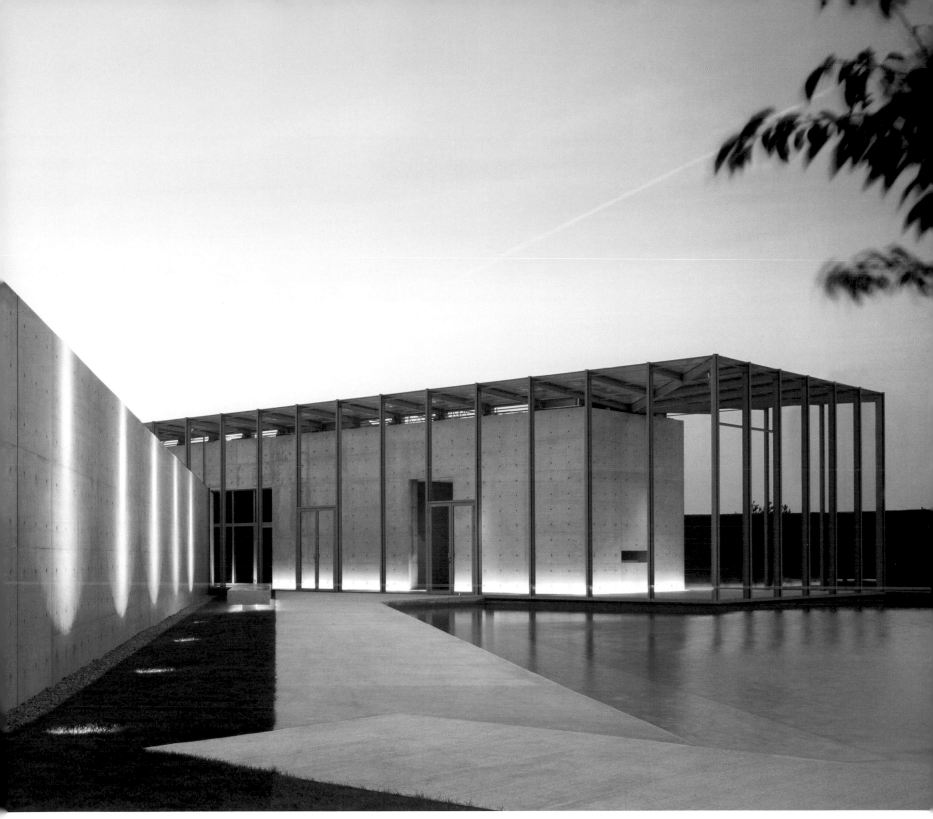

The "still" space consists of a concrete box nested inside a glass case to create a buffer zone along the perimeter, similar to the veranda-like *engawa*, a typical feature of traditional Japanese architecture. Designed to blend in with nature, two banks of earth form the background scenery and recall the site's former function, while a reflecting pond abstractly links the architecture to the natural landscape.

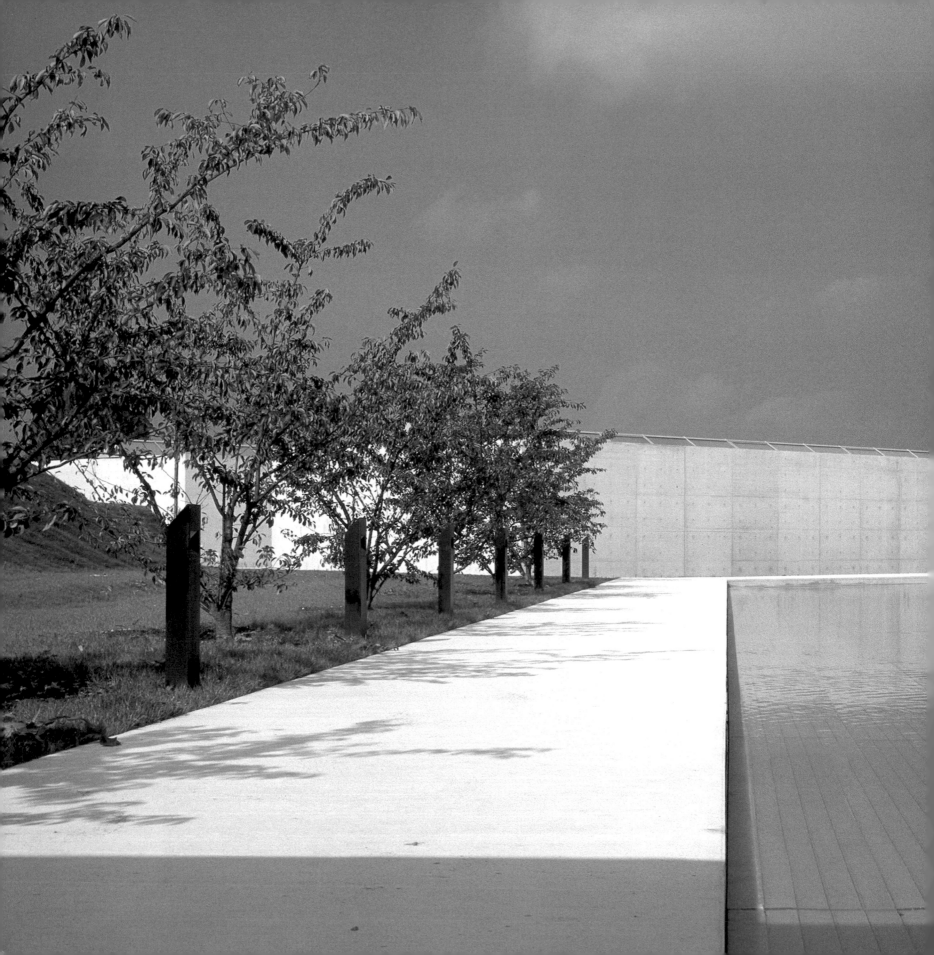

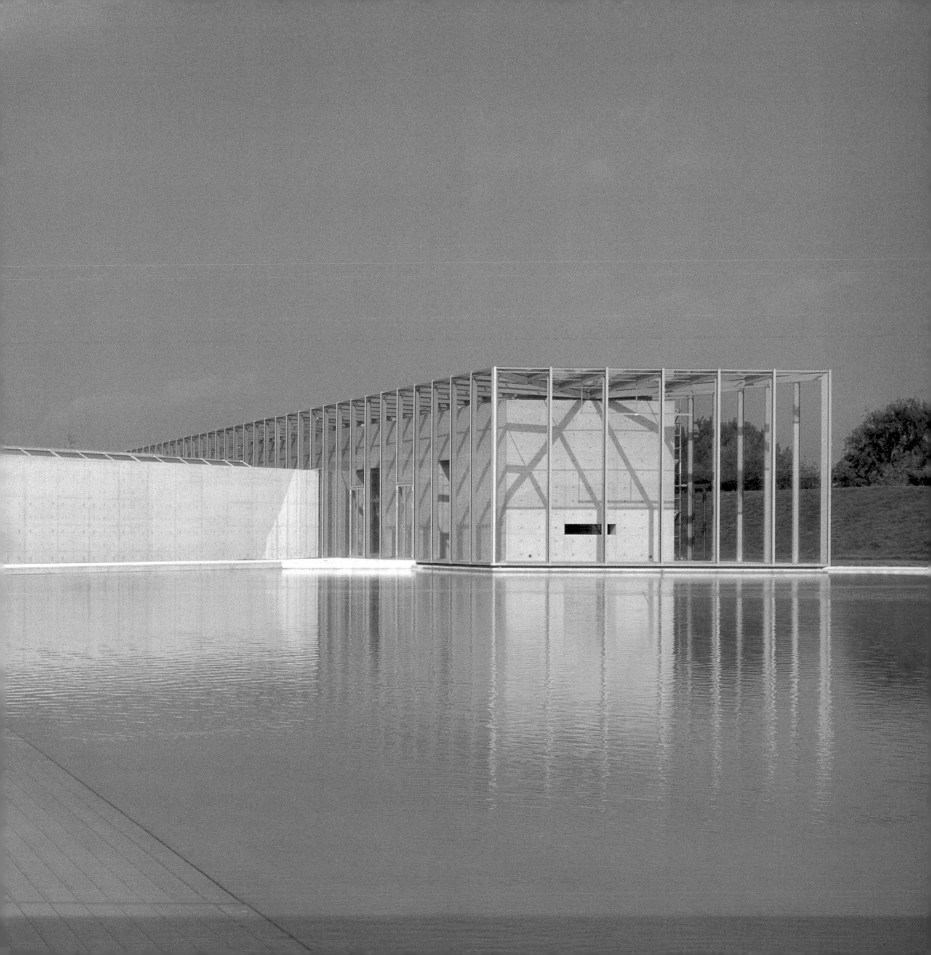

MIT Stata Center

Gehry Partners

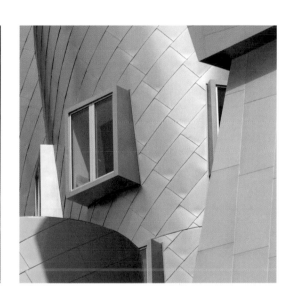

MIT Stata Center

Architects: Gehry Partners

Location: Cambridge, MA, USA

Completion: 2004

Photography: Andy Ryan

The site for MIT's new Ray and Maria Stata Center was once a drab, gray block of concrete that housed some of the greatest thinking machines of the 20th century. The new office complex concocted by Frank Gehry is now the home of the Computer Science and Artificial Intelligence Lab (CSAIL), a think tank for the prodigies of the future. The glistening jumble of cubes, cones, and colorful towers constitutes a brave, care-free gesture that represents the intellectual daring and innovation that pulsates within the walls of the legendary research center.

The aim of Gehry's sprawling design was not only to express the joy of invention that MIT embodies, but also to encourage the interaction of its residents in order to stimulate interdisciplinary thinking and, thus, the possibilities for more interesting work. The new building's priorities involved the integration of light, air, and interesting views, and no less importantly a smooth adaptation by those who felt like they had become a permanent fixture—and wanted it to stay that way—within the old, banged-up walls of the famed Building 20, where some of the world's most illustrious scientists put their genius to work. In addition, the research elements of the program needed to be entirely distinct from the educational and public elements of the program, yet integrated within a single building.

The result is a high-ceilinged warehouse space topped by a nonidentical twin pair of six-story towers that contain research units endowed with double-height open spaces and spiral staircases, as well as seminar rooms, lunchrooms, exhibition spaces, a gym, a day-care center, a basement pub floored with timbers from the original Building 20, and the campus's first amphitheater. The use of a variety of materials—including concrete, brick, stainless steel, and glass—creates a range of colors and textures that emphasize and reinforce the depth of the overall architectural composition. No doubt, the new center will provide MIT with the prestige and reputation that it needs to continue leading the world's most groundbreaking research studies.

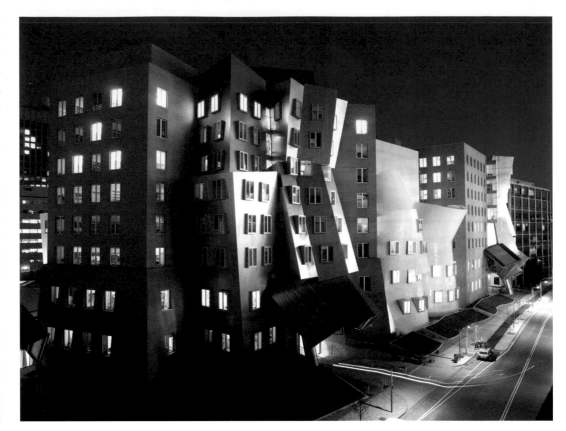

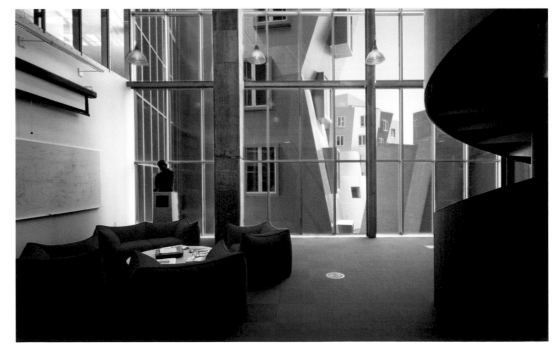

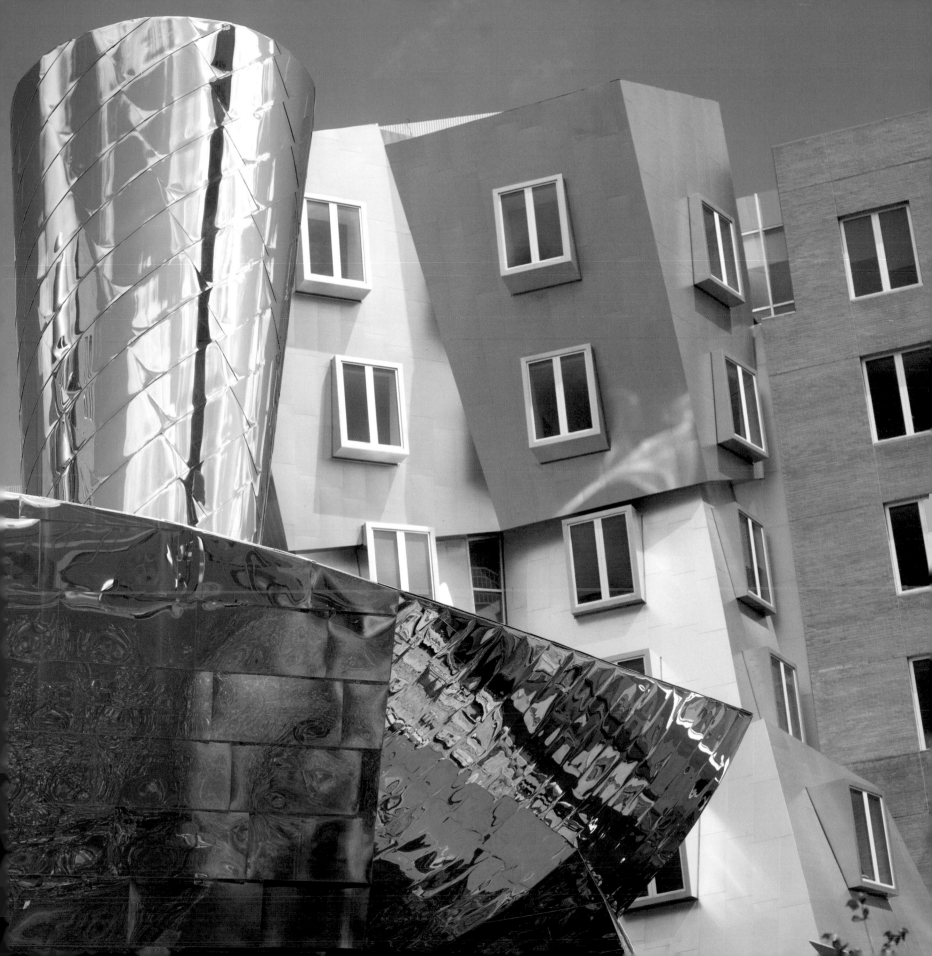

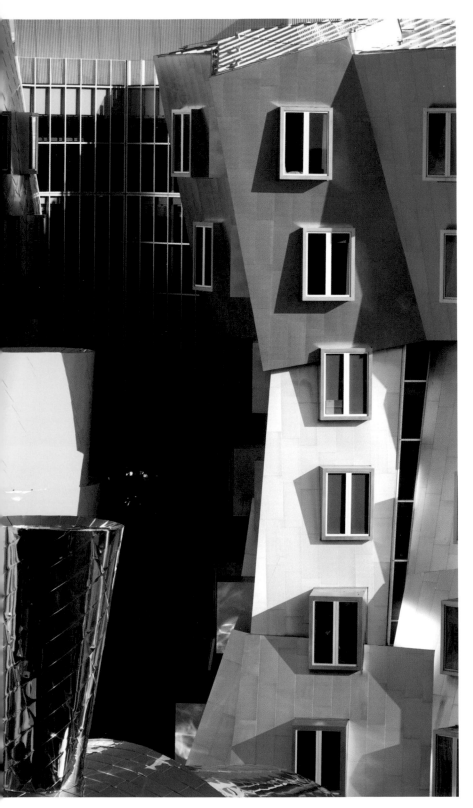
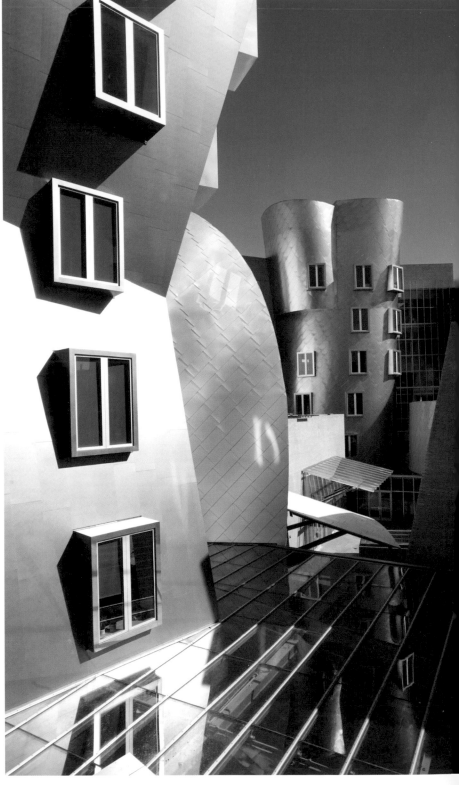

Exterior walls are alternately clad with brick, stainless steel, and painted aluminum.
Windows are integrated into stainless steel boxes that protrude from the façade.

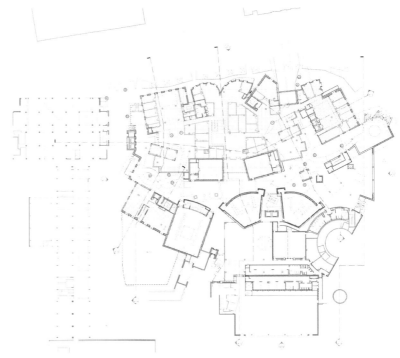

Site plan

Ground and second floor plan

0 6 12

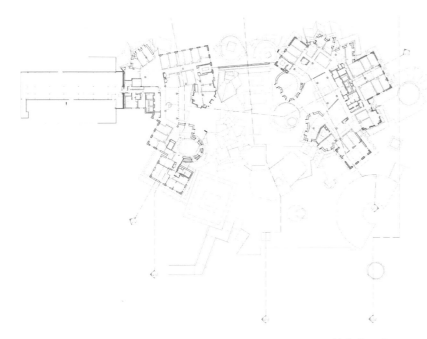

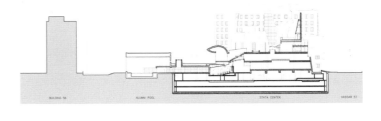

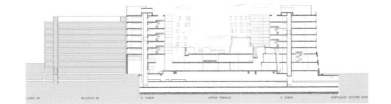

Ninth floor plan

Sections

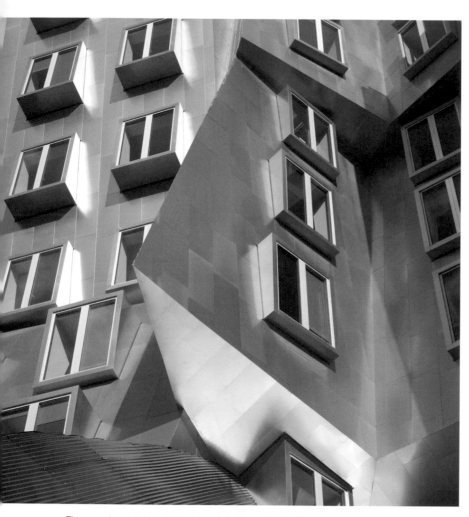
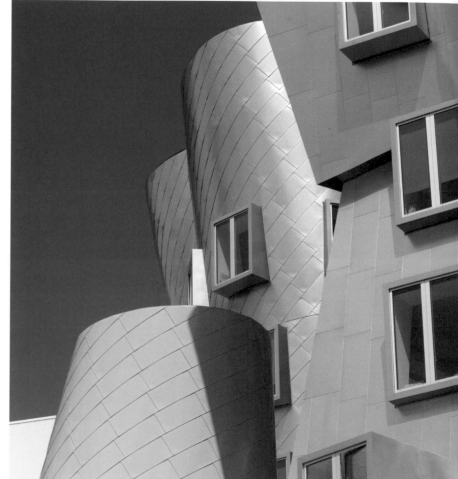

The complex stainless steel elements between the brick tower wings
vary from flat, angular surfaces to curved, undulating volumes.

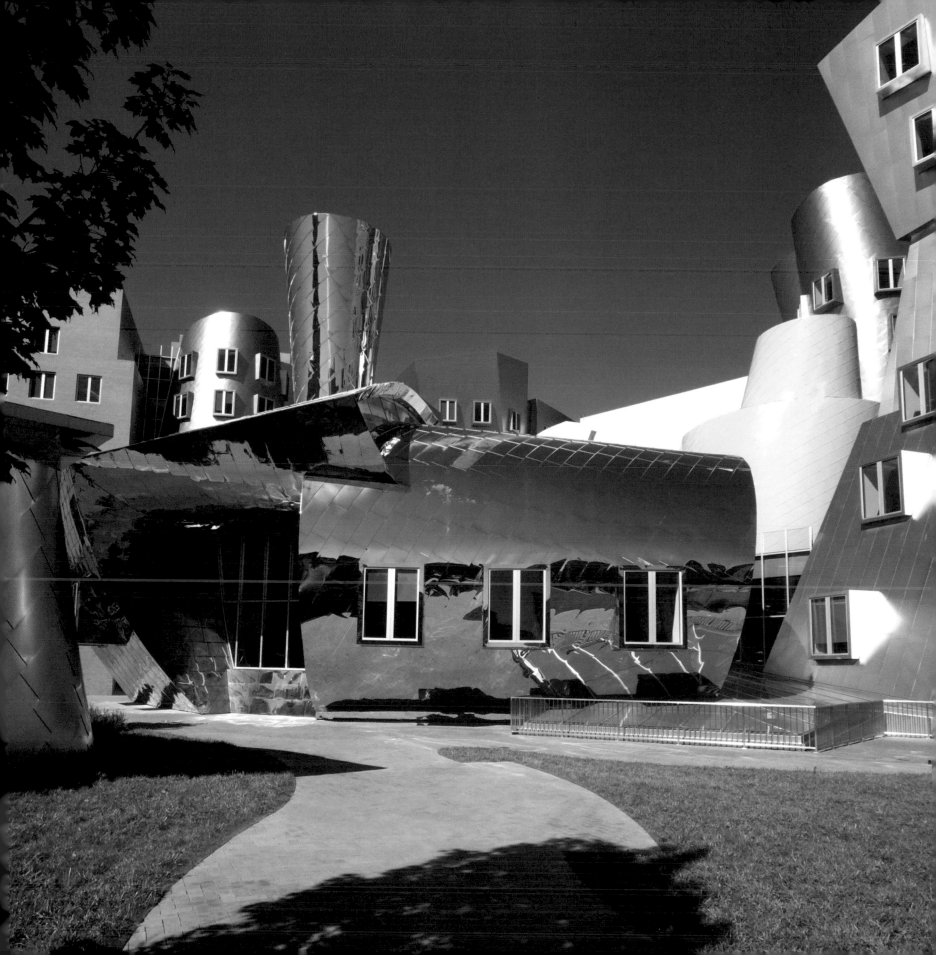

Mori Tower

Architect: KPF

Location: Tokyo, Japan

Completion: 2003

Photography: H.G. Esch and Kohn Pedersen Fox

In Asia, the combination of uses such as retail, office, hotel, residential, entertainment, and transportation in single buildings or complexes has given rise to popular mega-mixed-use projects. One such project is Roppongi Hills, a monumental development situated in the heart of Tokyo that constitutes Japan's most ambitious urban-renewal scheme since the postwar era. The 58-story Mori Tower, named after its owner and the country's most powerful and influential building tycoon, is the centerpiece of the 27-acre Roppongi Hills project, located in an important commercial and entertainment district of Tokyo.

Known for integrating multiple uses into vertically organized structures, Kohn Pedersen Fox (KPF) does so once again with this monolithic structure that stands out like a giant among the surrounding buildings and smaller skyscrapers. Located on the Roppongi Dori, an arterial highway, the building houses over 3 million square feet of office space, a 380-room hotel, and a variety of cultural facilities, including a 1,200-seat theater at podium level and the Mori Arts Center for contemporary art designed by Gluckman Mayner, located at the crown of the tower. The entire complex, featuring works from a host of worldrenowned architects and engineering companies, achieves a uniquely organic and evolving environment by mixing the uses and purposes of various street-level spaces.

The form of the tower draws from traditions in Japanese design, where natural forms are expressed in geometric patterns. Using compositional techniques derived from cubist paintings, a constantly shifting impression of its volume and surface is created. Forms observed in Japan, including the folded paper of origami and samurai armor, influenced the articulation of the building's top and base. Conceived without any preferred vantage point or view, the tower was planned as an object intended to be seen from an infinite number of locations. This massive skyscraper undoubtedly fulfills this purpose, having become a distinguishable urban landmark of Tokyo.

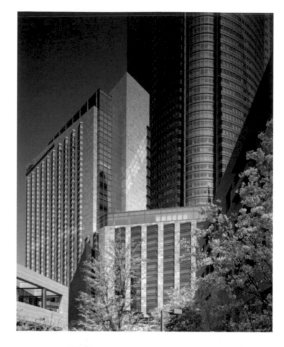 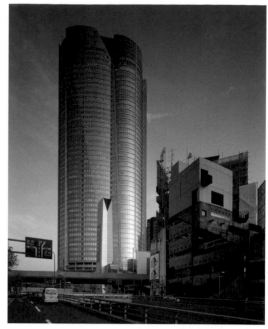 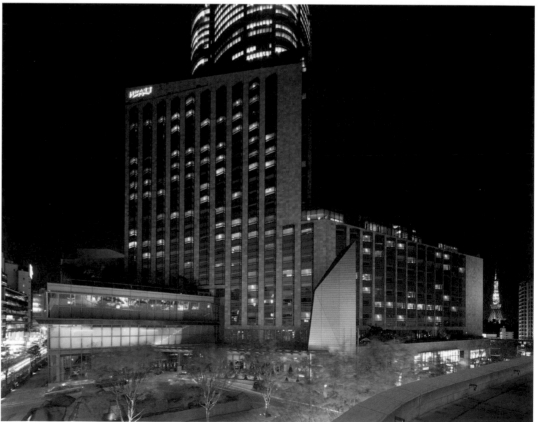

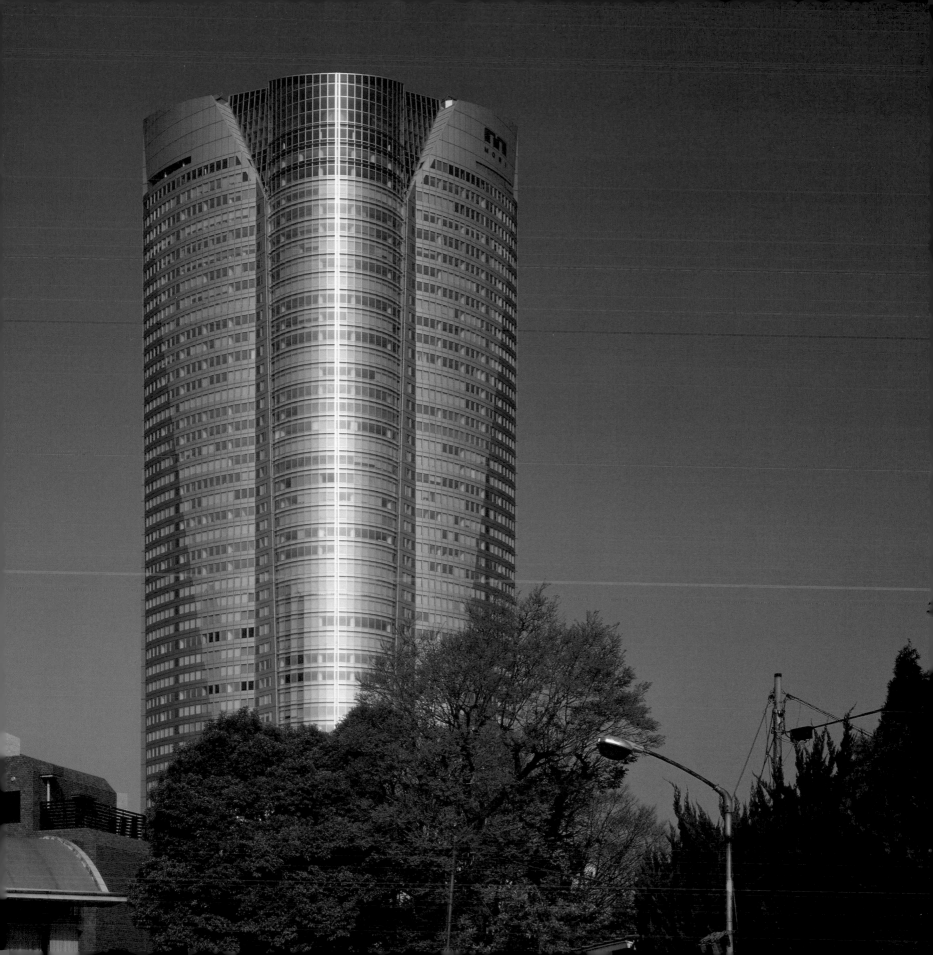

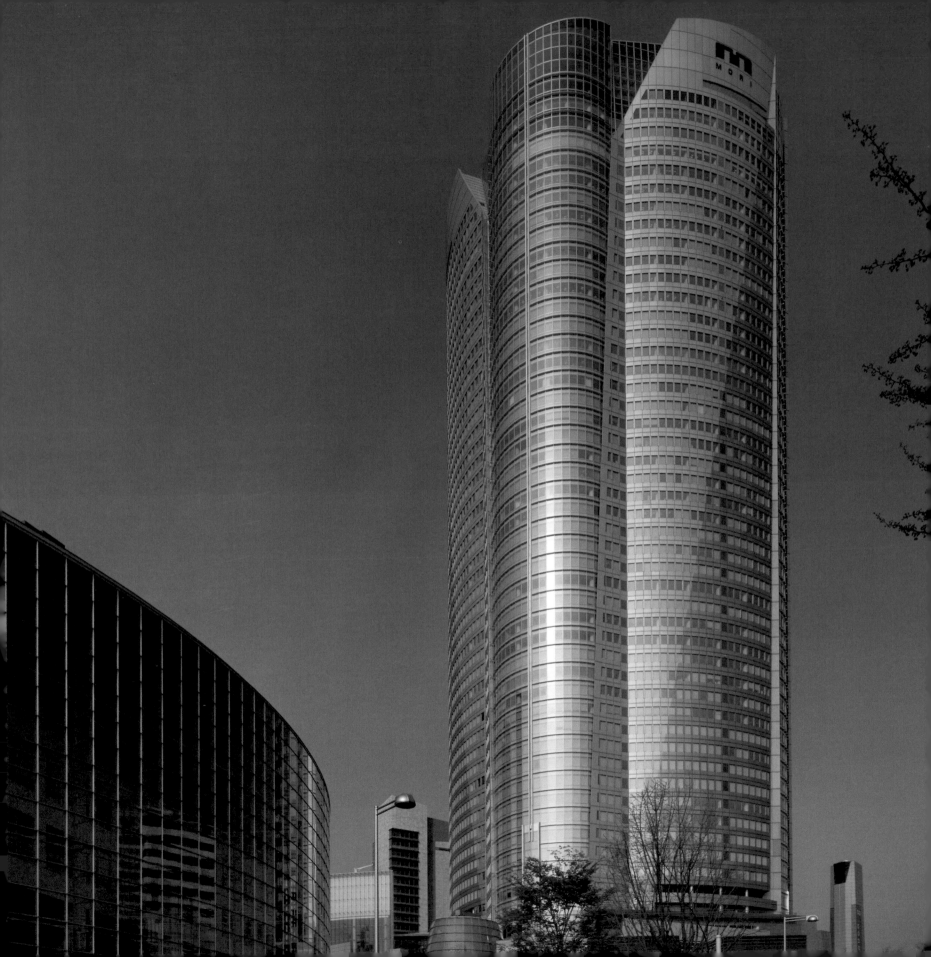

Perspective

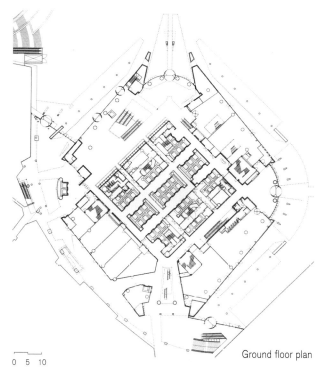

0 5 10

Ground floor plan

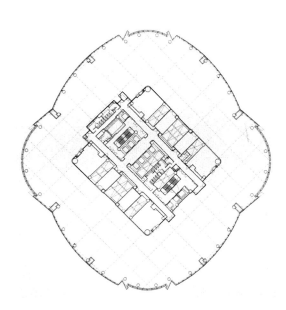

Typical floor plan

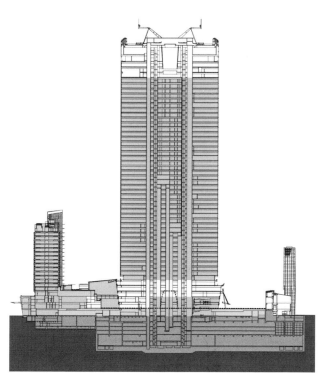

Section

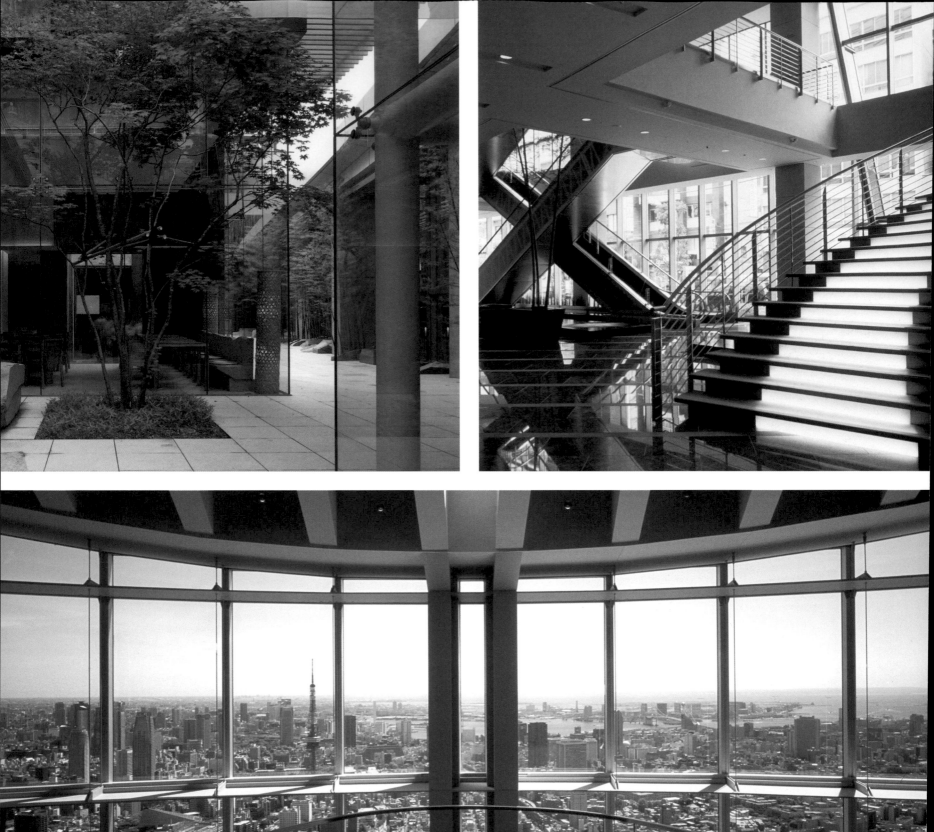

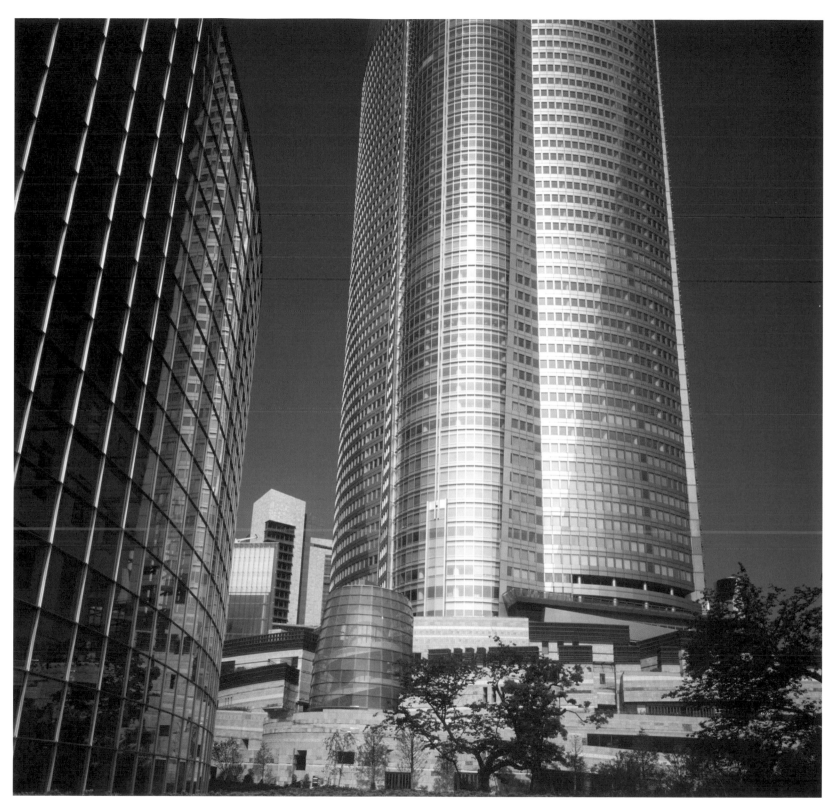

The lower volumes of the hotel and the theater surround the tower, responding to both
the central tower and the localized conditions of the project's periphery.

Deutsche Post Tower

Architects: Murphy/Jahn

Location: Bonn, Germany

Completion: 2003

Photography: Zooey Braun / Artur, Jochen Helle / Artur, Andreas Keller / Artur

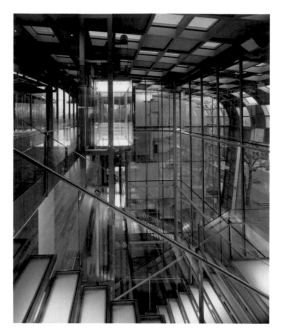
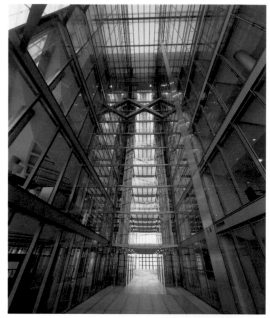

The long-established, award-winning Chicago firm Murphy/Jahn constitutes one of the world's most internationally renowned architects, whose work has evolved in tune with the times and continually produces distinguished and technologically innovative designs. The Deutsche Post Tower is one of the firm's most recent and impressive accomplishments, a 41-story office building located in the center of Bonn.

Conceived as a reinterpretation of the typical high-rise office tower in relation to function, technology, and user comfort, the building rises 530 feet off the ground and features a split oval plan with a 24-foot-wide atrium between the two halves, shifted along their axes. The connecting glass floors at nine-story intervals form sky gardens that serve as communication floors and elevator crossovers. The glass elevators situated in the center of the sky gardens provide views and orientation.

The building's double-shell façade is part of an automated building management system that controls cross-ventilation in the milder seasons, as well as heating and cooling when needed. While the outer shell is fashioned entirely out of glass to enable natural light and ventilation, as well as protection from rain, wind, and noise, the internal concrete structure features an integral heating and cooling pipe system to acclimatize the interior with the advantage of the low-energy characteristics offered by this material. An air displacement system along the façades assists in creating an optimal environment.

The architects refer to this as responsible architecture, which in their view should control its environment through design, and not solely through added technical and mechanical systems. Their goal lay in the integration of daylight, natural ventilation, and solar energy as essential components of commercial design: a building with high technology and low energy. The installation of LED dots at the foot of the tower adds a visually artistic dimension to this contemporary skyscraper, which Helmut Jahn describes as "a 21st-century classic."

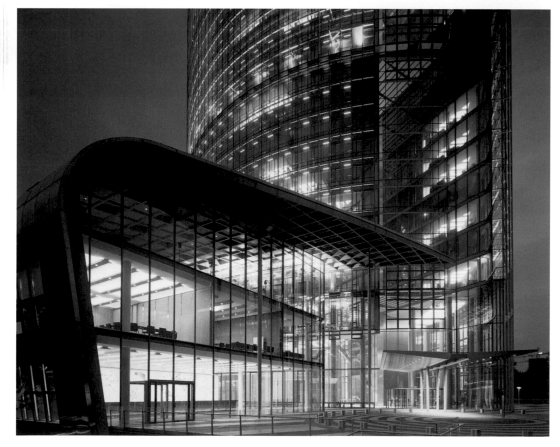

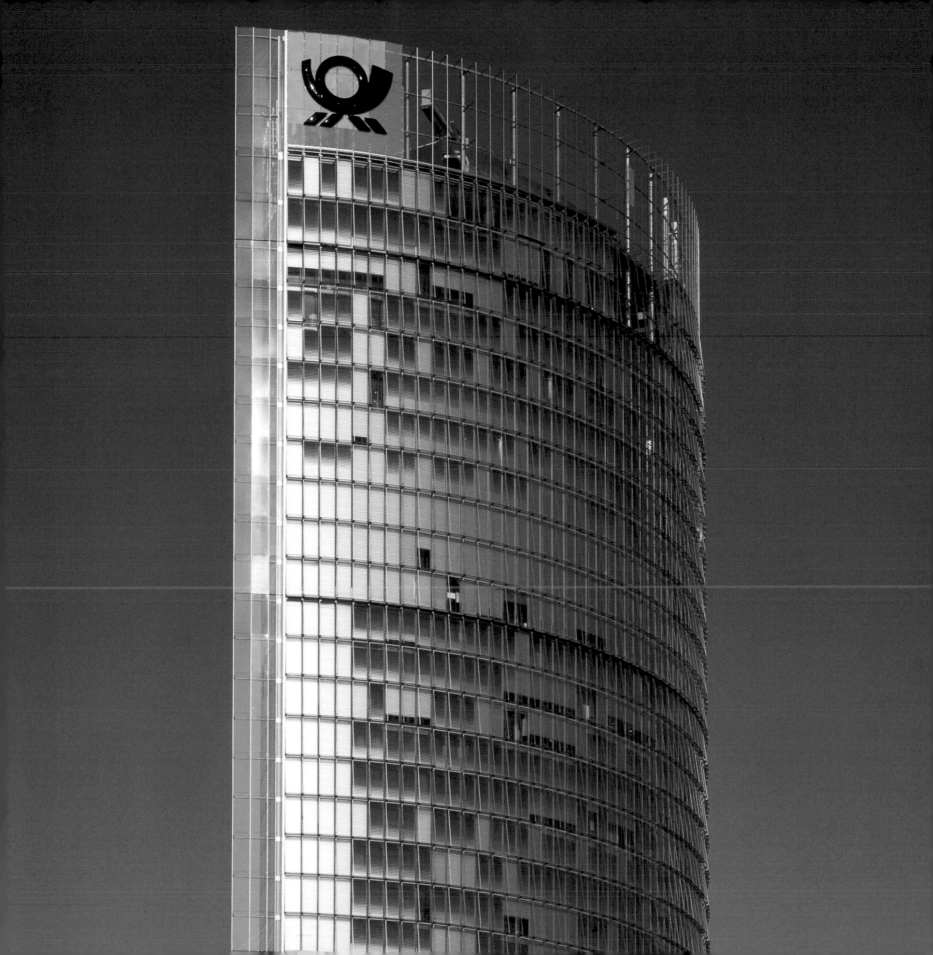

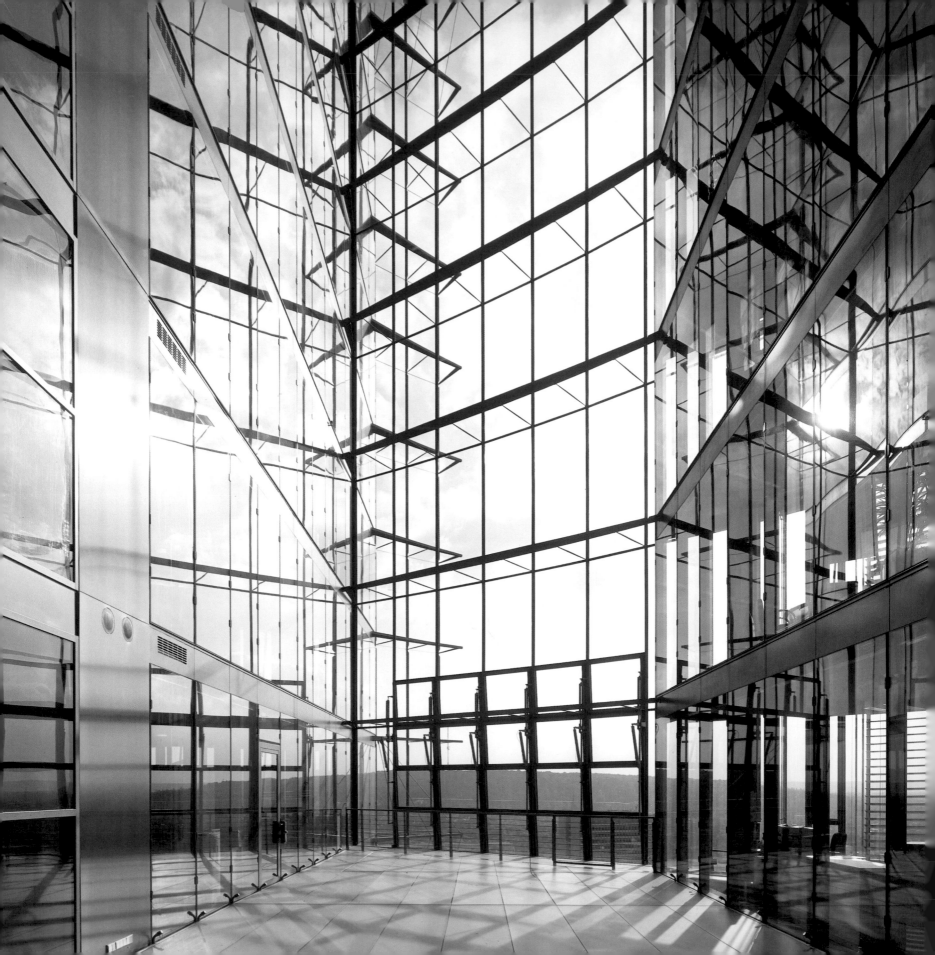

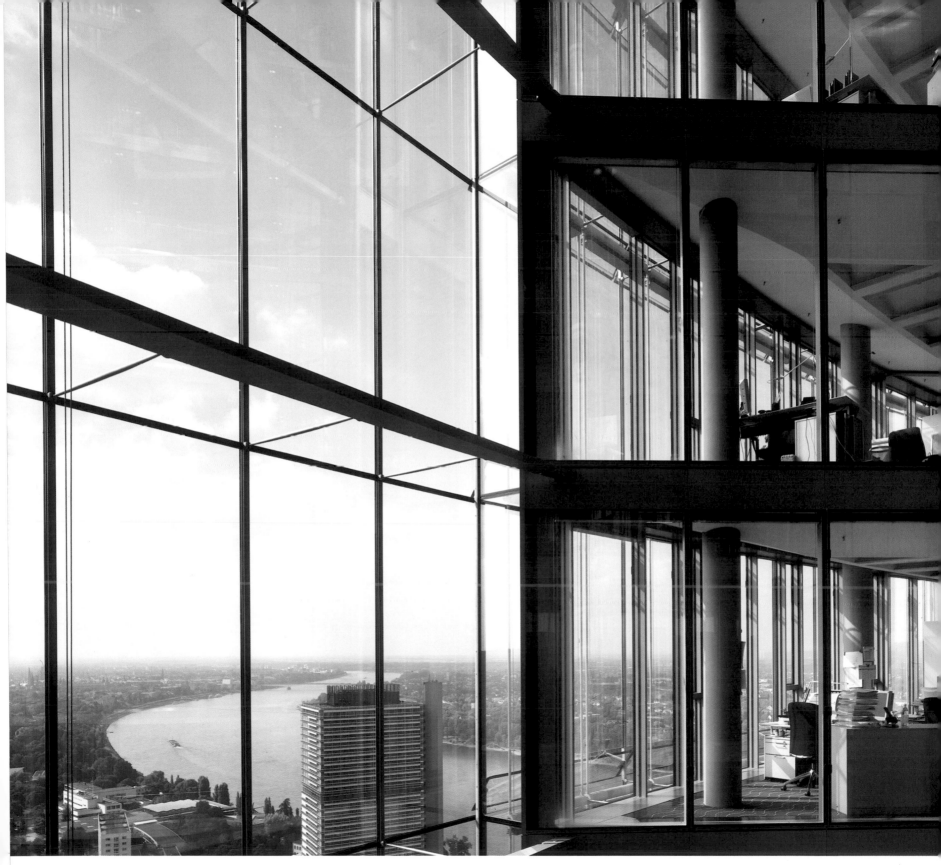

The glass floors that contain the offices connect at nine-story intervals, forming sky gardens that emphasize the idea of transparency, which the architects strove to maintain throughout the project.

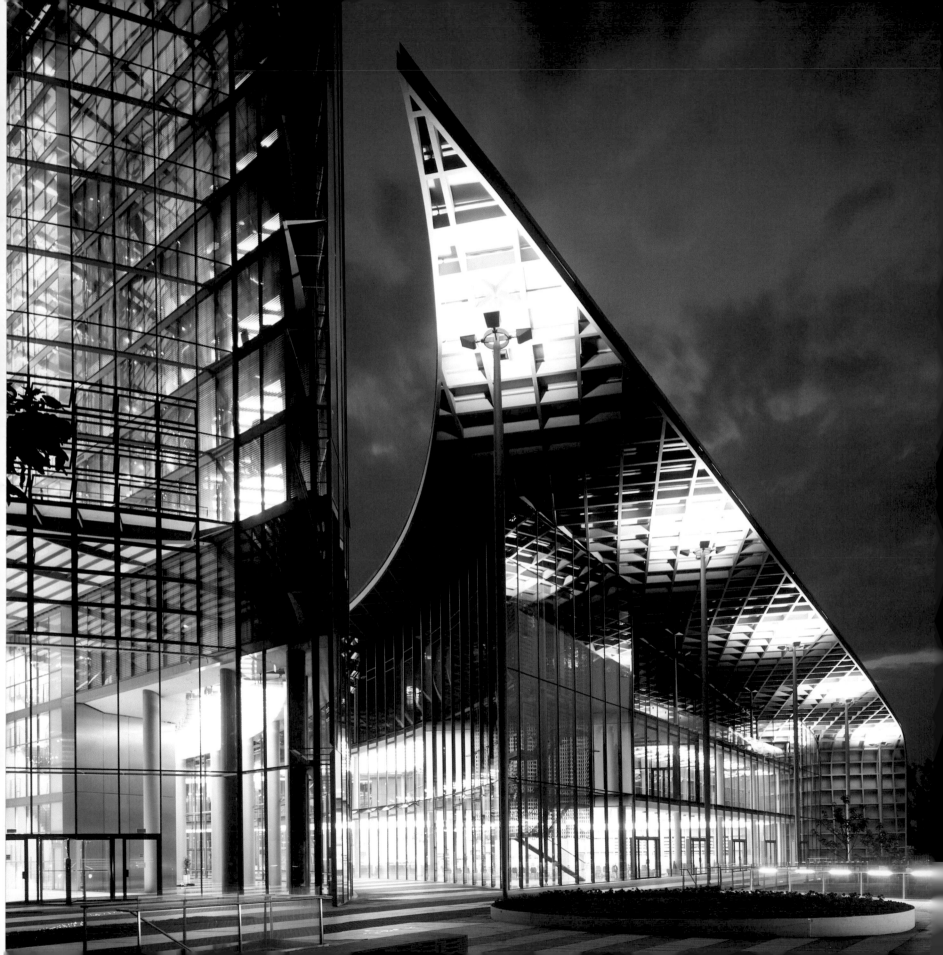

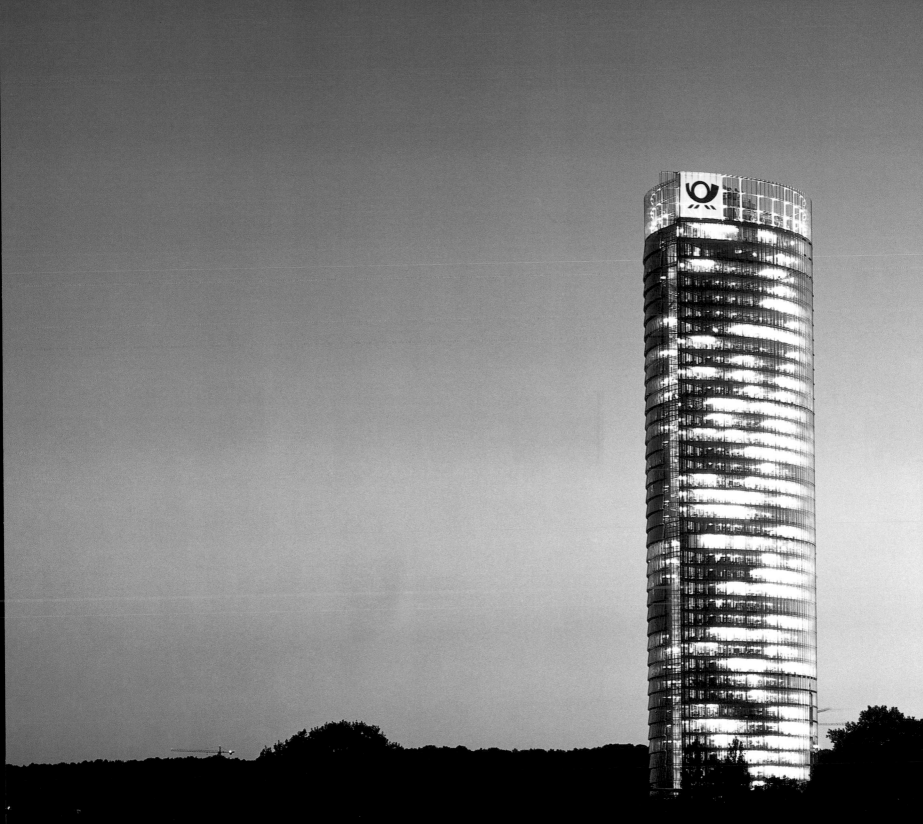

Scottish Parliament

EMBT and RMJM

Scottish Parliament

Architects: EMBT and RMJM

Location: Edinburgh, Scotland

Completion: 2004

Photography: Dennis Gilbert / VIEW

This joint venture between Edinburgh's long-established RMJM practice and Barcelona's EMBT firm represents the conception of Scotland's first independent Parliament in nearly 300 years. After the Scottish public voted in favor of a devolved power for the country in 1997, the search began for the architects who would be responsible for creating a symbolic and representative building worthy enough to house an entity of such importance as the new Scottish Parliament. EMBT and RMJM were announced as the winners of an international competition in July 1998.

The site is located at the bottom of the Royal Mile in Edinburgh's Old Town, opposite the Royal Palace in Holyrood and sitting in the shadow of the imposing Salisbury Crags. A loosely arranged U-shaped cloister opens up to the rugged landscape, containing it like a cupped hand. The complex incorporates the Debating Chamber building; four Tower buildings containing committee rooms, briefing rooms, and staff offices; the Member of Scottish Parliament building; the Canongate buildings; a media building; and a large skylit foyer. The Queensberry House, a 17th-century building located within the site, was refurbished as part of the project.

Enric Miralles, of EMBT, who died only a few months into the construction phase, developed a design that he envisioned as a building "sitting in the land." He drew inspiration from the surrounding landscape, flower paintings, and upturned boats on the seashore. In effect, the Parliament seems to grow in the shape of a large flower with leaves that form the different structures and roofs that resemble upturned boats. The 18-ton vaulted ceilings that characterize the interiors are accompanied by the dominating presence of precast concrete, stainless steel, and oak furnishings. An impressive cantilever design sees that the building, supported at one end by a reinforced concrete structure, spans approximately 60 feet without any supporting columns. The integration of the landscape into the project, as well as elements of sustainability to minimize the use of energy, also forms a crucial part of the design.

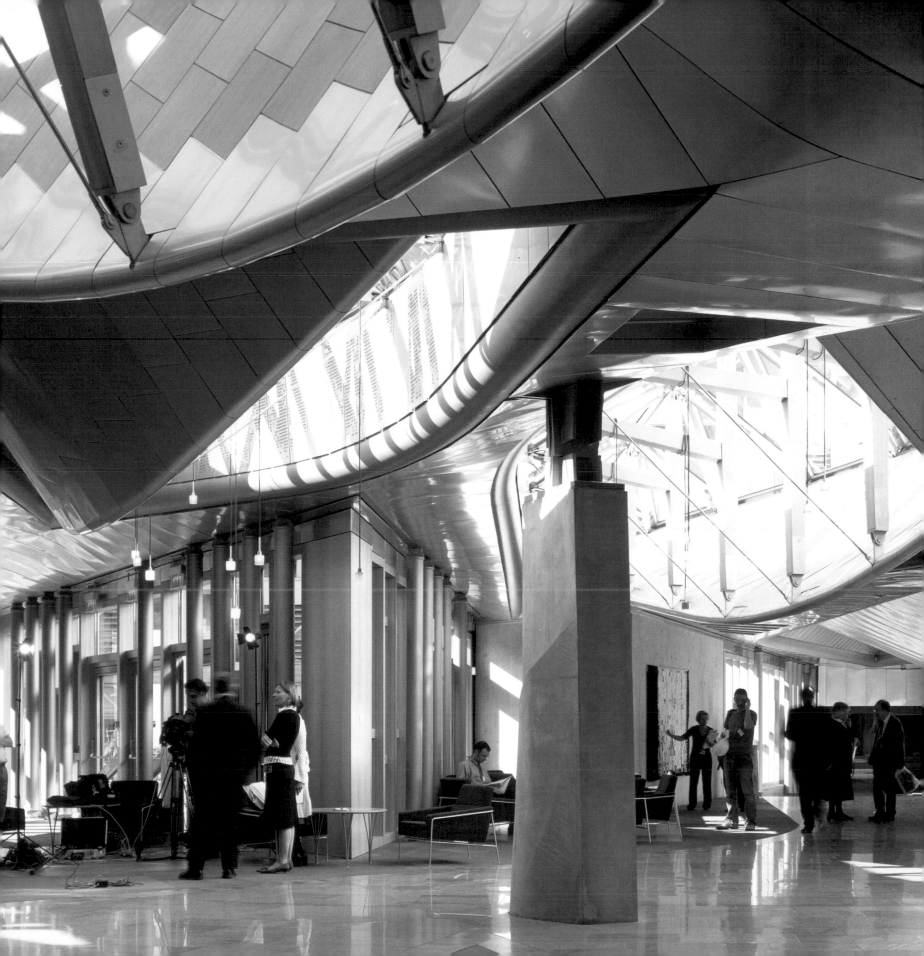

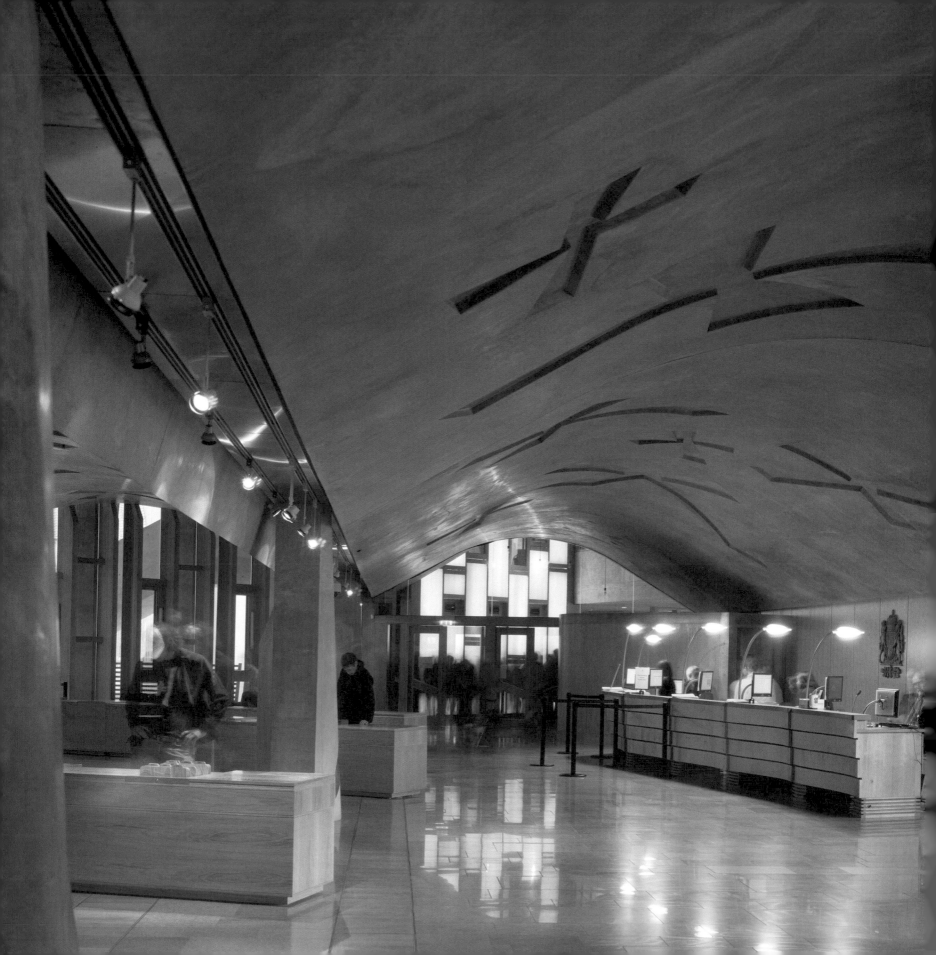

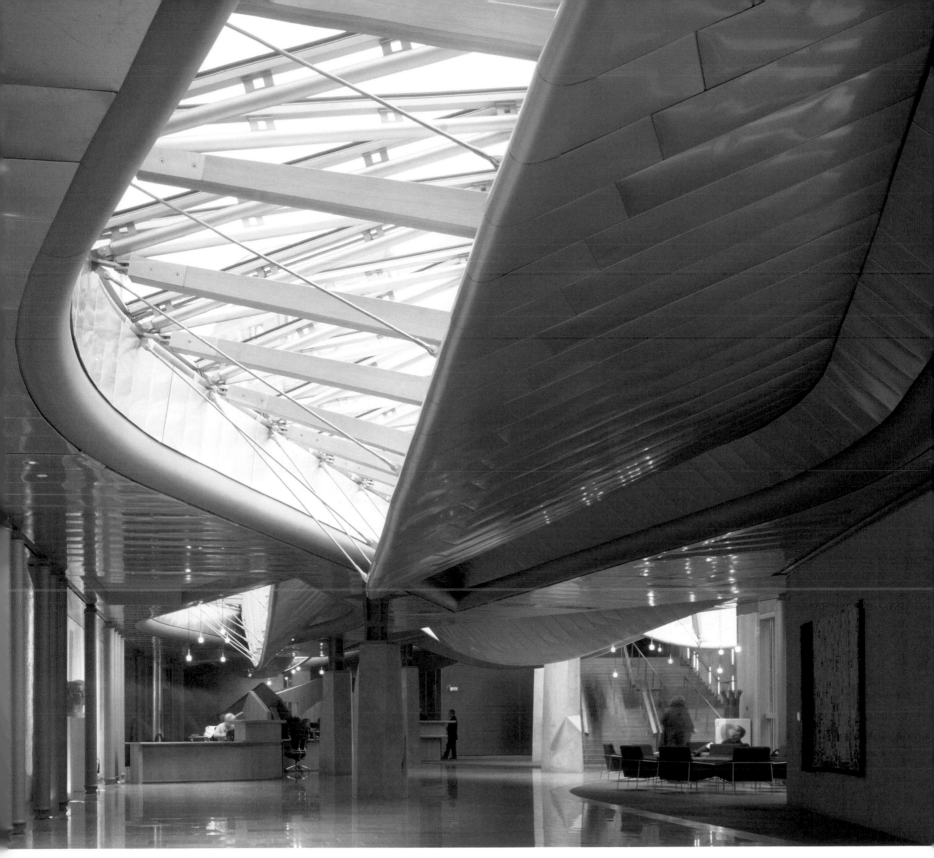

A lobby with twelve sweeping leaf-shaped skylights links all the buildings of the complex.
These unique roof lights, made from steel and glass, allow natural light to penetrate the space.

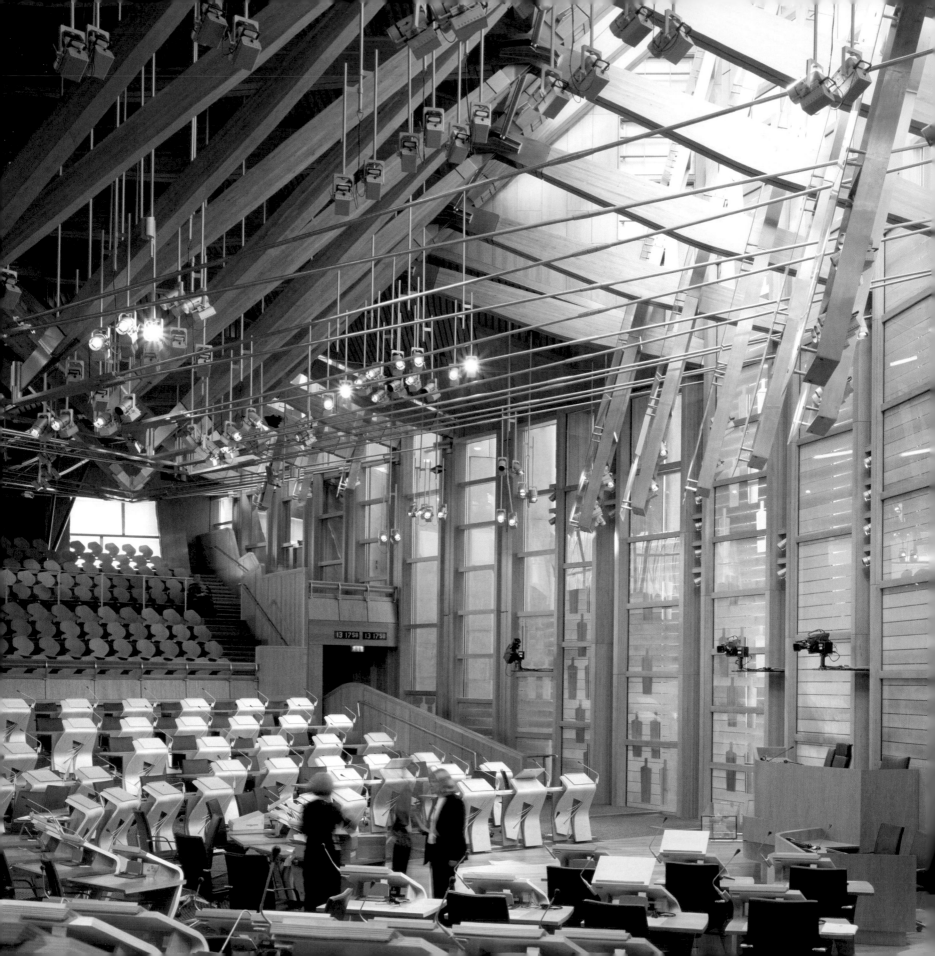

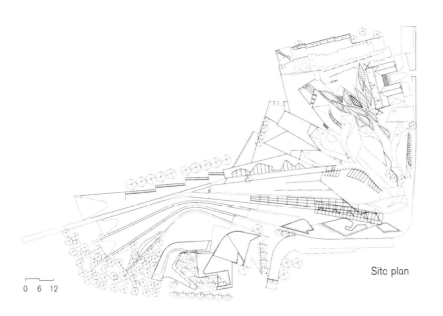

Sitc plan

0 6 12

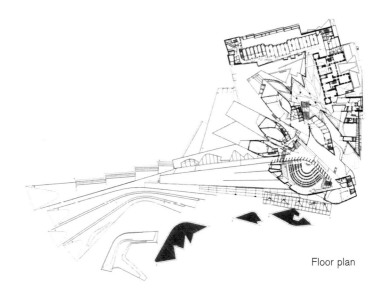

Floor plan

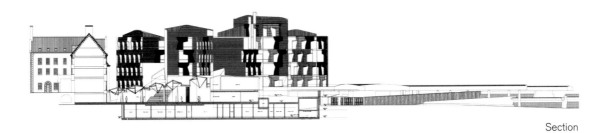

Section

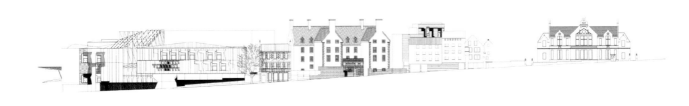

Elevations

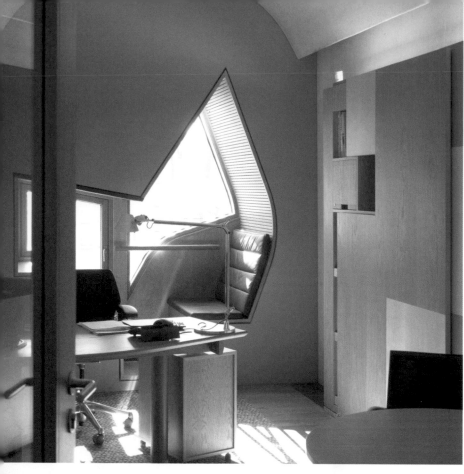

Each office measures 160 square feet and features a barrel vault ceiling and built-in oak furnishings. Window seats were created to facilitate contemplation of the exterior views.

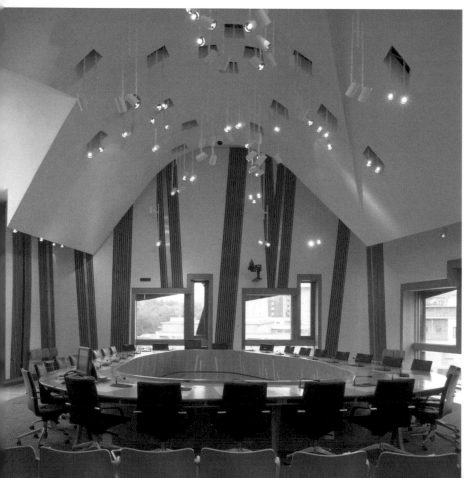

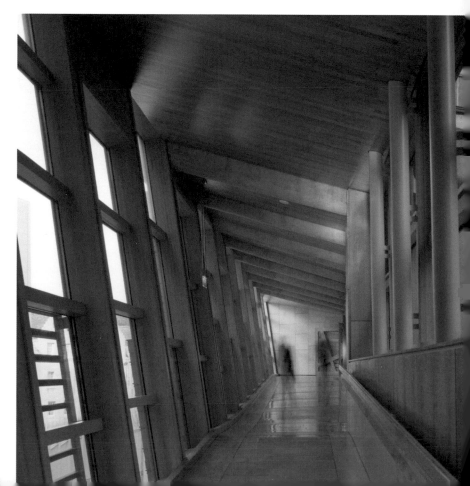

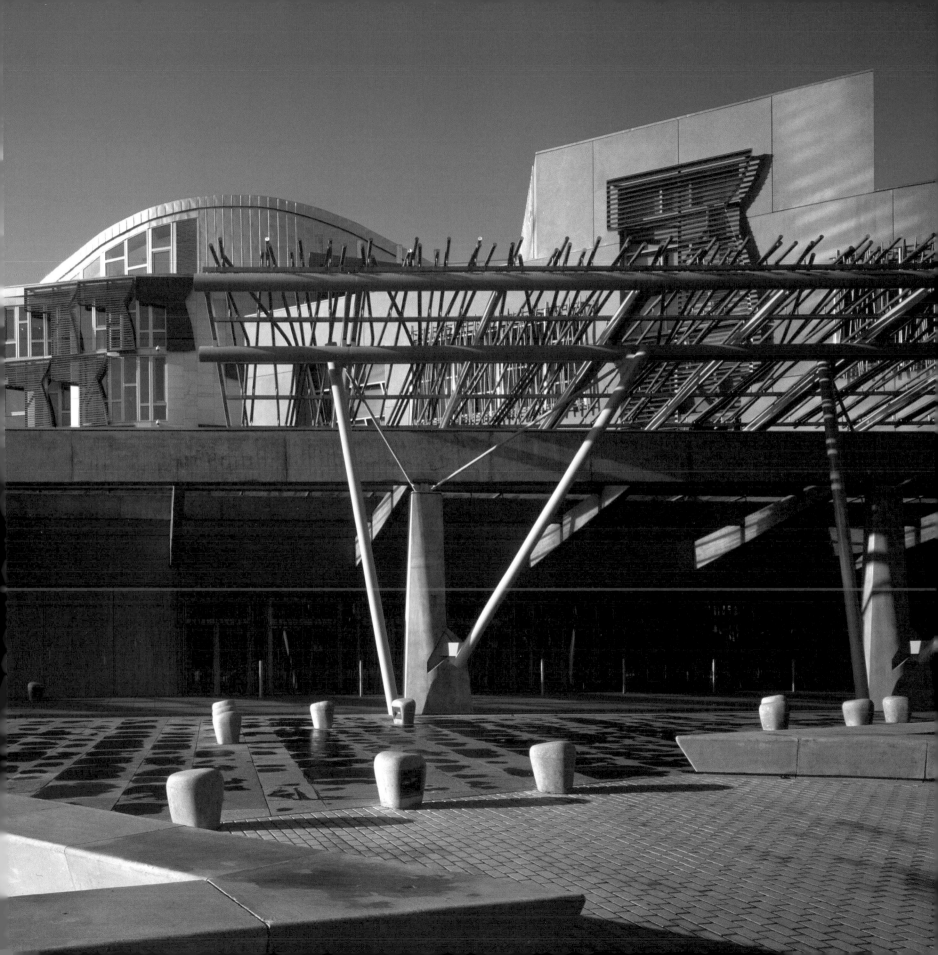

Seattle Central Library

Architects: OMA and LMN Architects

Location: Seattle, WA, USA

Completion: 2003

Photography: Philippe Ruault

According to Archguide, "Unless the Library transforms itself wholeheartedly to aggressively orchestrate the coexistence of all available technologies to collect, condense, distribute, read and manipulate information, its unquestioned loyalty to the book will undermine the Library's plausibility at the moment of its potential apotheosis." In designing the new Seattle Public Library, Rem Koolhaas' Office for Metropolitan Architecture (OMA), in conjunction with LMN Architects, aimed at redefining and reinventing the library. No longer exclusively dedicated to the book, the institution is an information center in which all media, both old and new, are presented equally. In an age where information can be accessed anywhere, it is the presentation and interaction of all forms of media that make the library different and new. In this way, the library is transformed into a social center with multiple responsibilities.

The building is divided into spatial compartments dedicated to and equipped for specific functions. Each section is granted a degree of flexibility, though not at the expense of any of the other compartments. The program was combined and consolidated to identify five platforms, each featuring a program that is architecturally equipped for optimal performance, with different sizes, densities, and opacities. The in-between spaces are trading floors organized into spaces for work, interaction, and play.

Rather than organizing the library according to floor plans, the architects opted for a more dynamic and organic layout. The Book Spiral, for example, arranges the collection in a continuous ribbon in which the subjects evolve relative to one another, without rupture. The building's steel and glass exterior also articulates this desire to stray from conventional forms, expressing the complexity of knowledge through the combined integration of levels, angles, and sustainable materials. By "genetically" modifying the position of floors, a building emerges that is at once sensitive, contextual, and iconic. Its angular facets form a plausible bracketing of Seattle's new modernity.

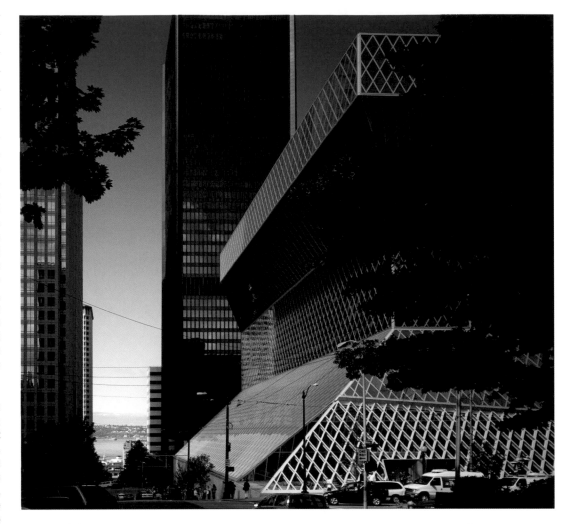

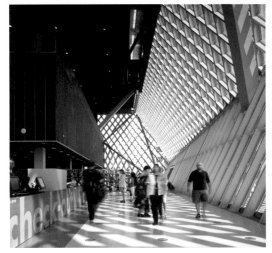

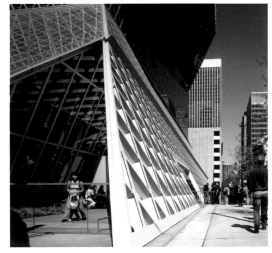

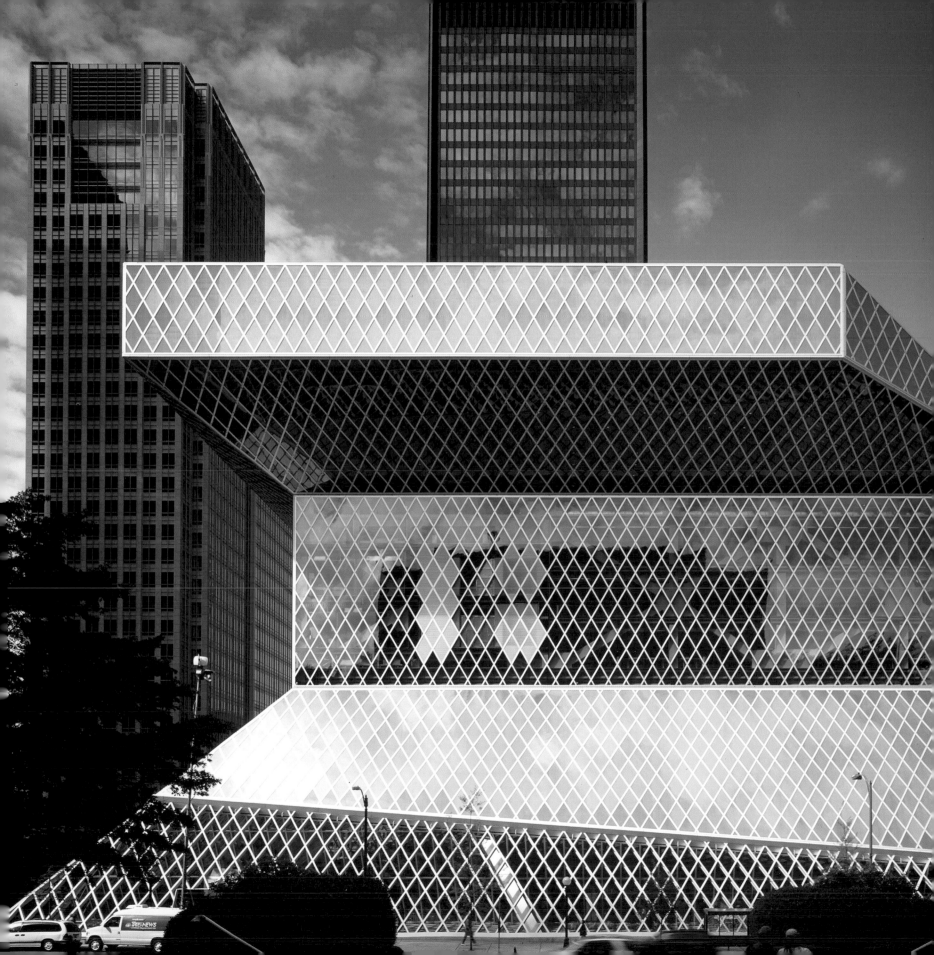

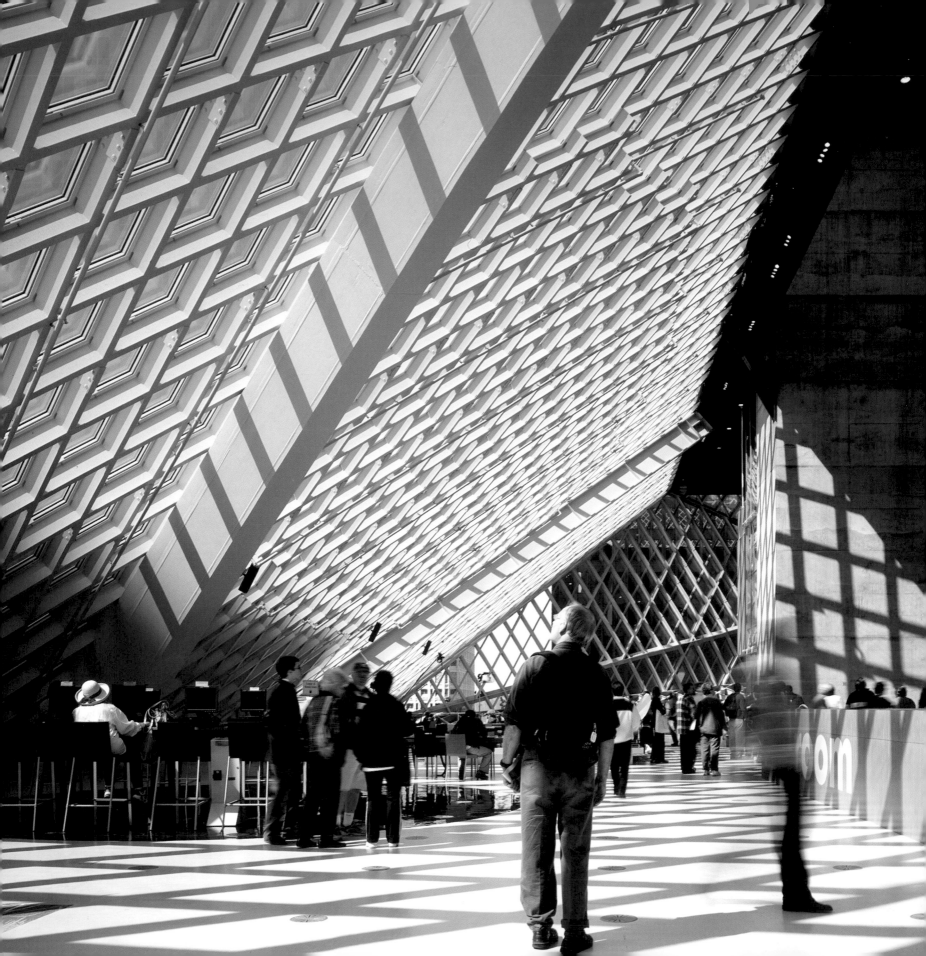

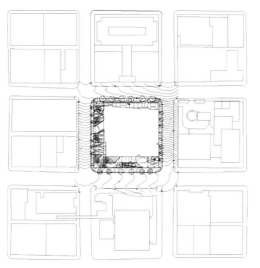

Site plan

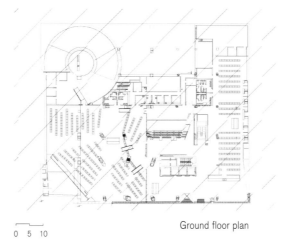

0 5 10

Ground floor plan

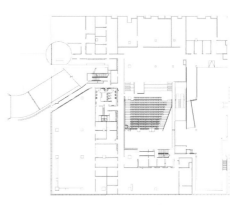

Second floor plan

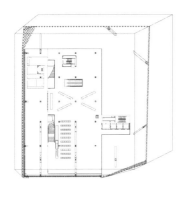

Fifth floor plan

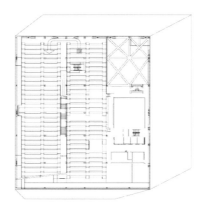

Ninth floor plan

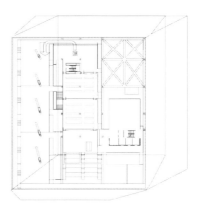

10th floor plan

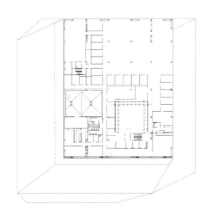

11th floor plan

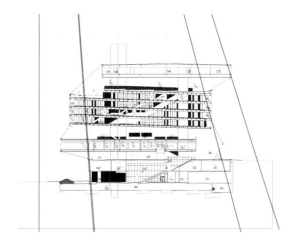

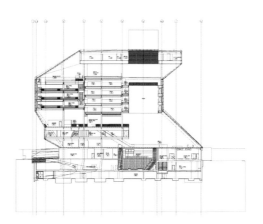

Sections

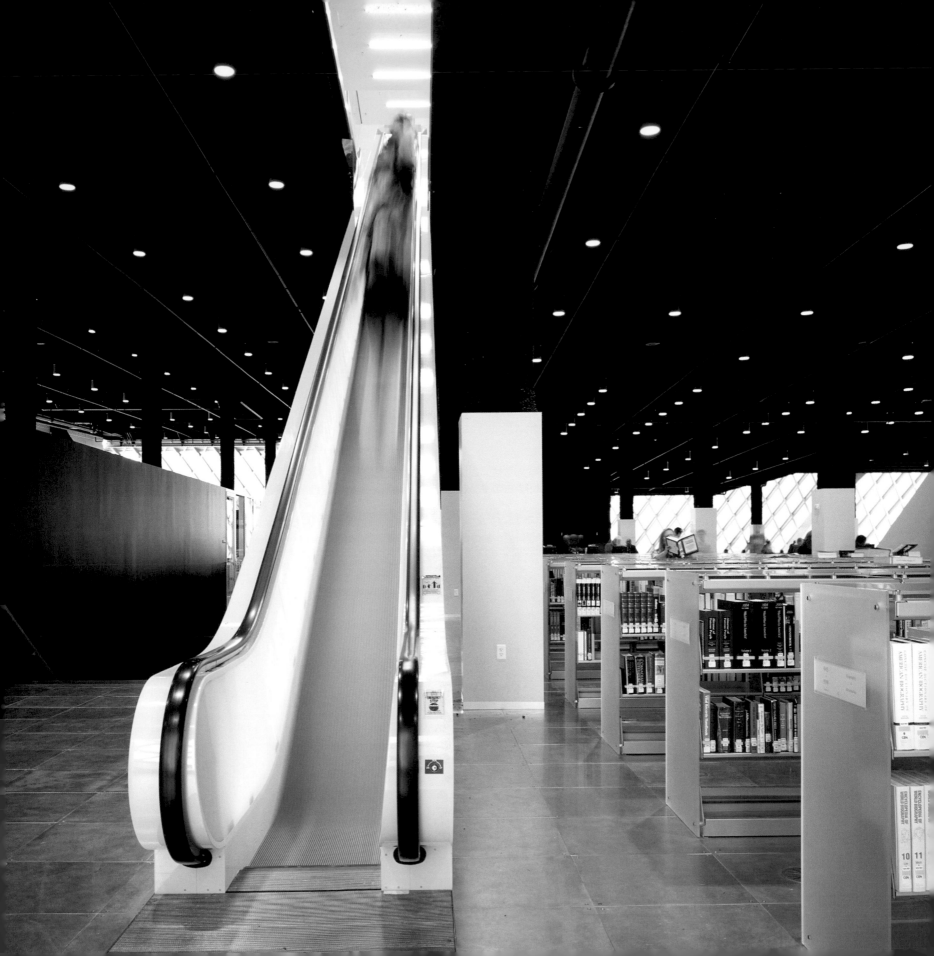

The circulation systems of the building's interior, composed of a series of diverse staircases and elevators, are clearly defined by chromatic variations. The different areas are clearly differentiated by an innovative mixture of materials and finishes such as metallic mesh, resin, and glass.

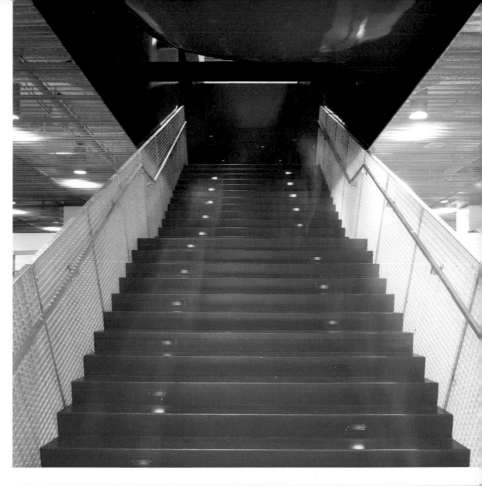

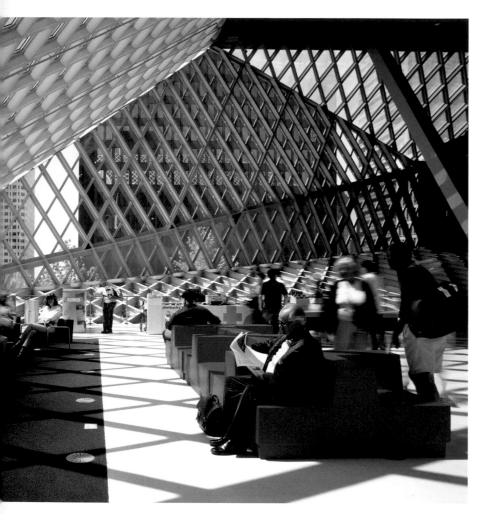
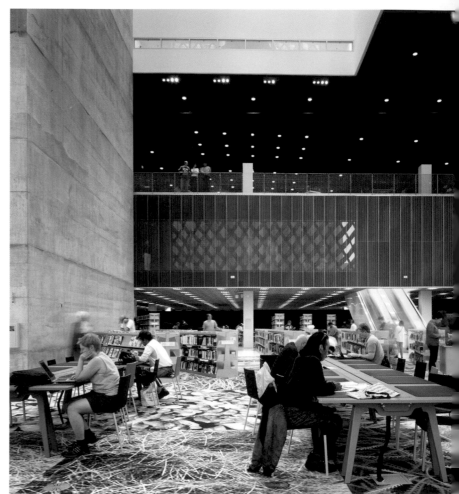

In response to the electronic age of information, which may be interpreted as a loss of order, tradition, and civilization, the project defends the nature of traditional, tangible information within an unconventional and contemporary program.

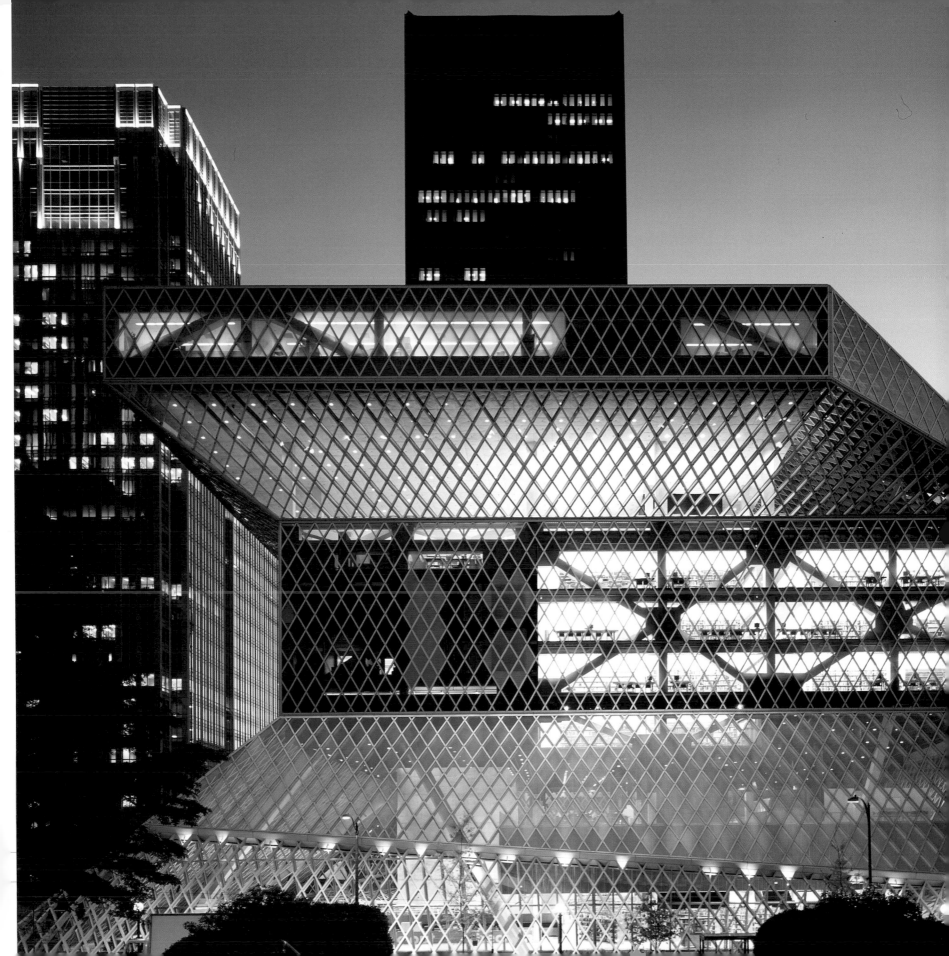

Selfridges Birmingham

Architects: Future Systems

Location: Birmingham, UK

Completion: 2003

Photography: Richard Davies

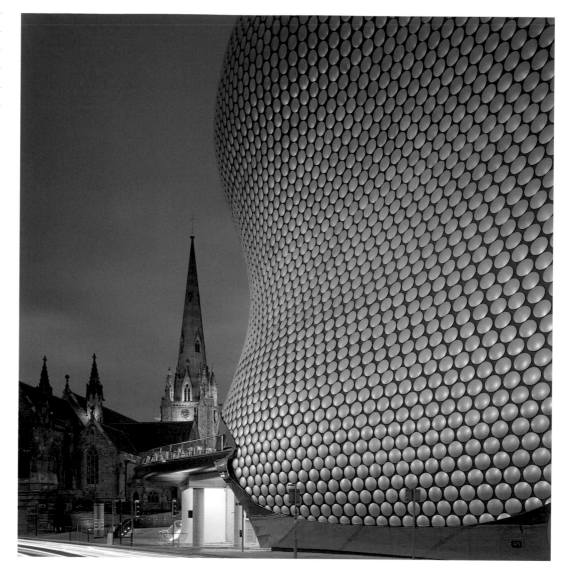

Set inside Birminham's redeveloped Bull Ring area and juxtaposed against the 13th-century/Victorian/neo-Gothic St. Martin's Church, the Selfridges building stands out as the largest and most prominent feature in the urban landscape. Its inconsistency in scale and appearance with the surrounding buildings is mitigated by the smooth curves and texture that characterize the structure, generating an unexpectedly harmonious relationship with its environment. Future Systems is noted for challenging traditional preconceptions of space with visually striking and highly practical designs inspired by nature and technology. The Selfridges store in Birmingham embodies this philosophy at its best, redefining the department store concept in an unconventional, functional, and highly aesthetic manner.

While most structures with curved façades undulate only in two dimensions, the Selfridges building curves three-dimensionally. Thus, the design makes no distinction between walls or roof, abstaining from abrupt angles that would break the organic, flowing lines. Wrapped in a waterproof skin covered with thousands of aluminum disks, the exterior boasts a fine lustrous grain that shimmers in the sunlight and gives the structure a sensuous, sculptural quality.

At the top of the building, a glazed free-form opening reveals only minimum support to maintain the highest level of transparency. The sheer membrane pours light down into a deep atrium, a dramatic inner landscape crisscrossed by glossy white escalators that recall the shape of a vast bone structure. The simplified interior design serves as a blank canvas for a variety of shops and venues.

Selfridges' singular design has the strength and singularity to make a landmark out of what could otherwise have been an ordinary shopping center. Future System's Matthew Heywood affirms, "We had a clear brief to design a landmark building immediately recognizable as Selfridges without the need for signage." The architects succeeded in reinterpreting the notion of a department store, not only by creating its unique appearance, but also by analyzing the social function such a building plays in contemporary society.

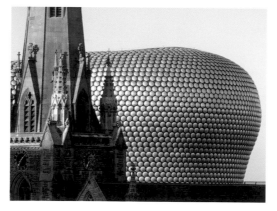

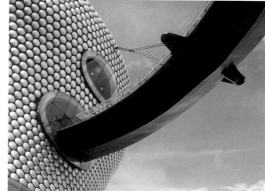

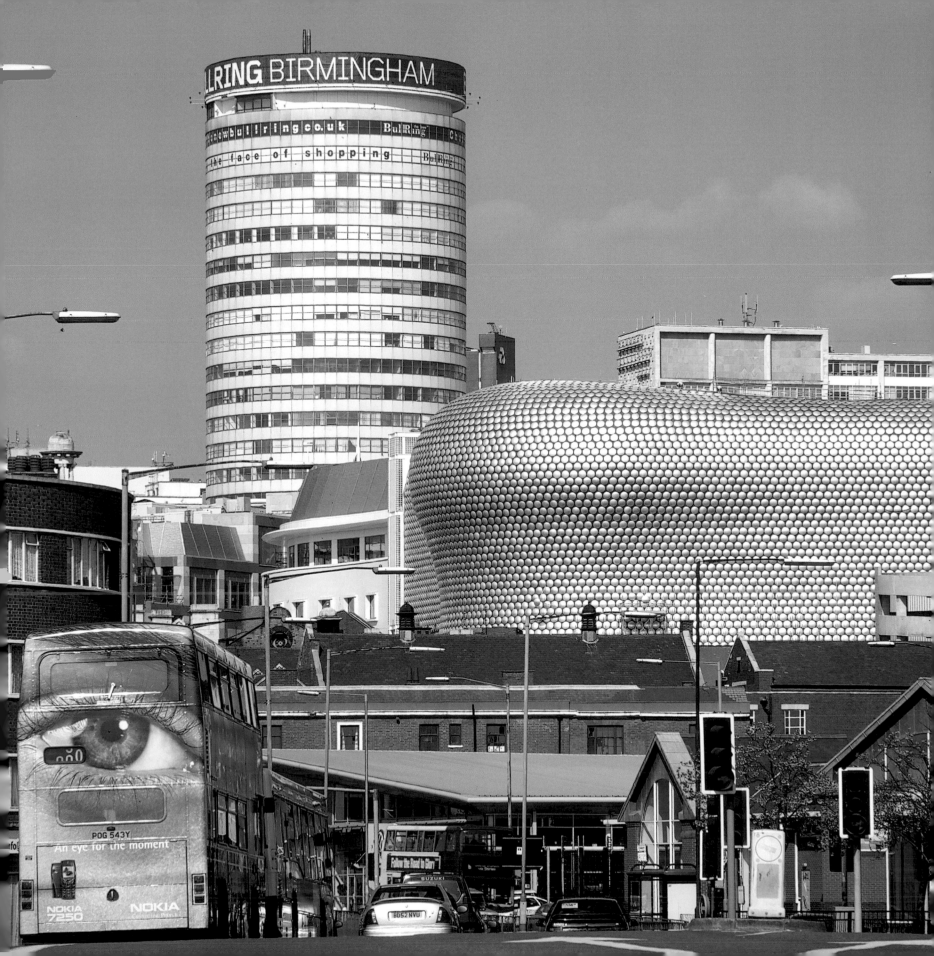

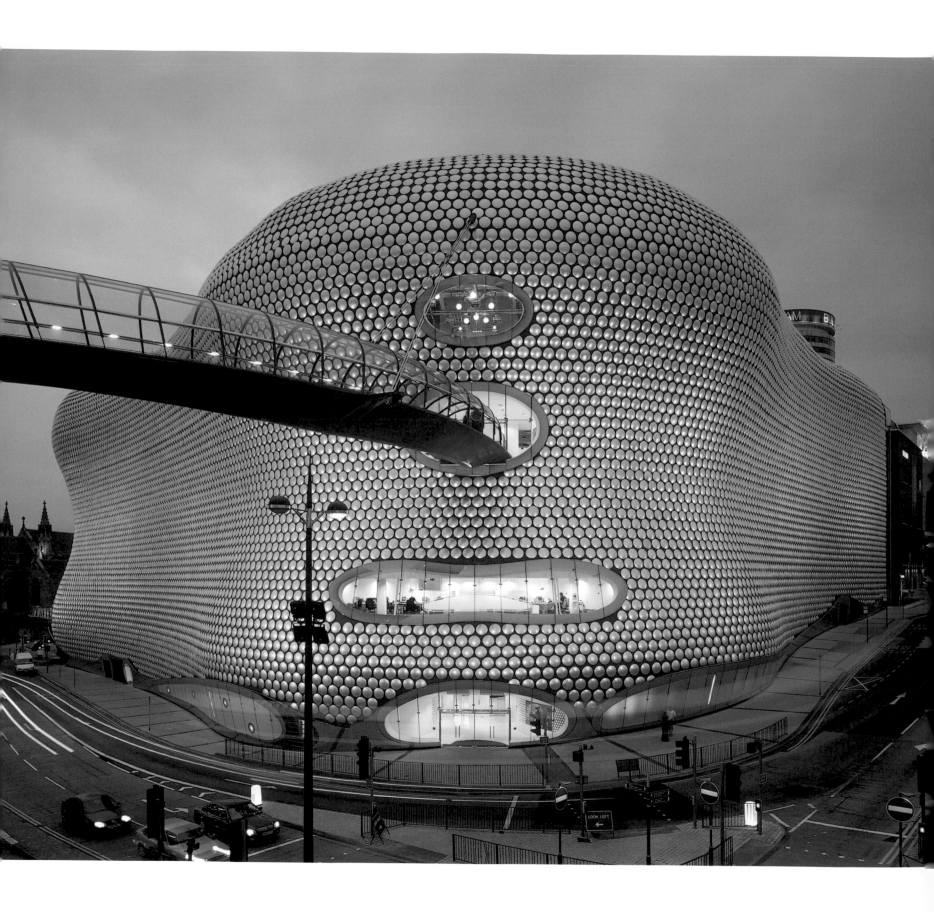

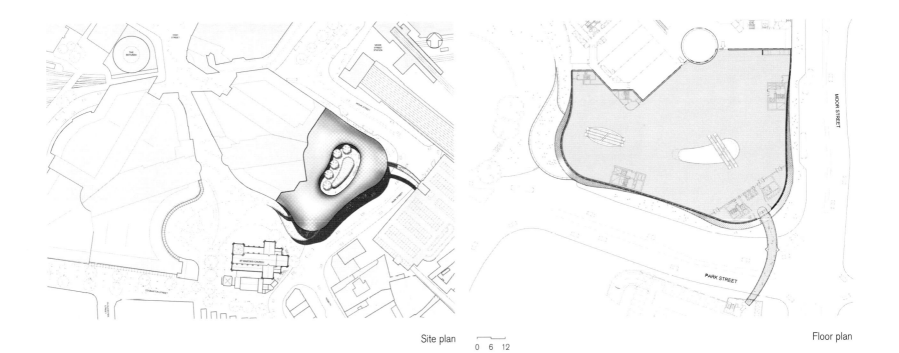

Site plan 0 6 12

Floor plan

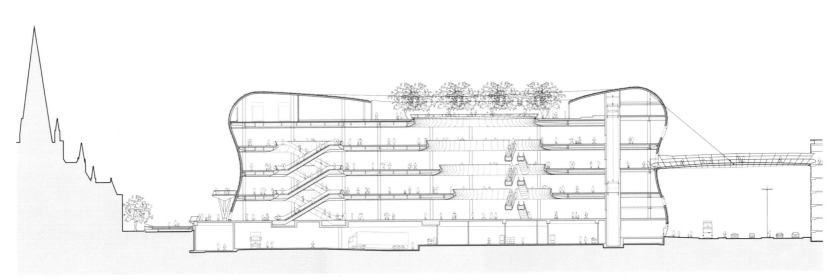

Section

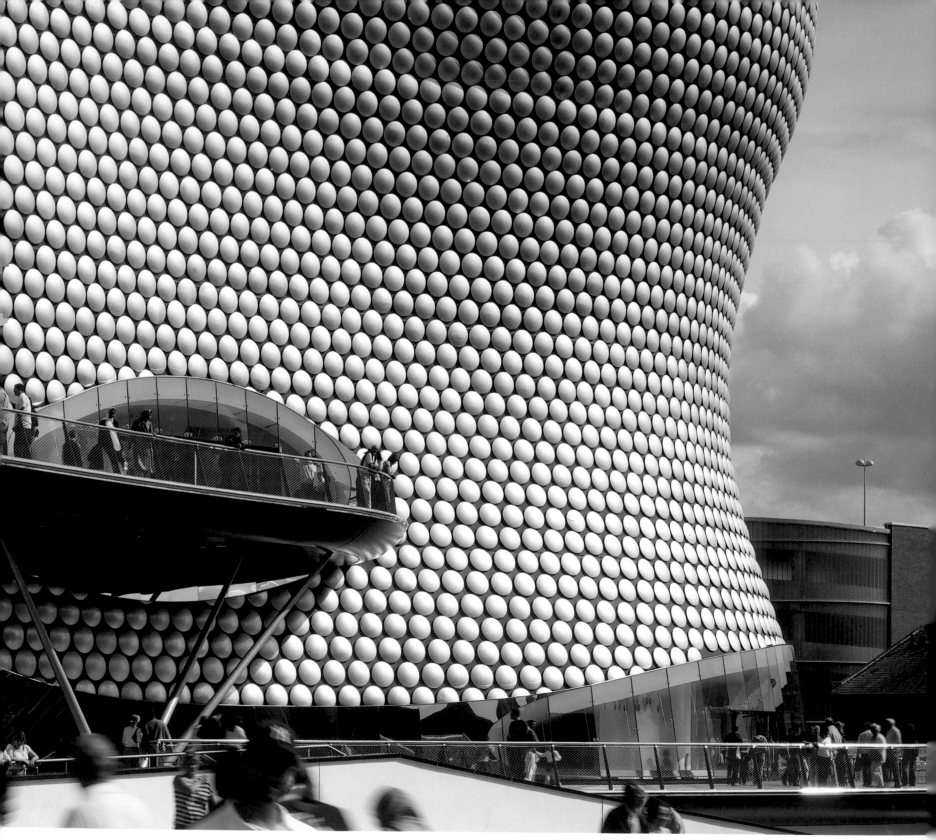

The shell is painted a deep Yves Klein blue. During the day, this shell is concealed by the smooth layer of disks, but at night the blue light from the street lamps causes the blue background to glow while the disks sit in shadow.

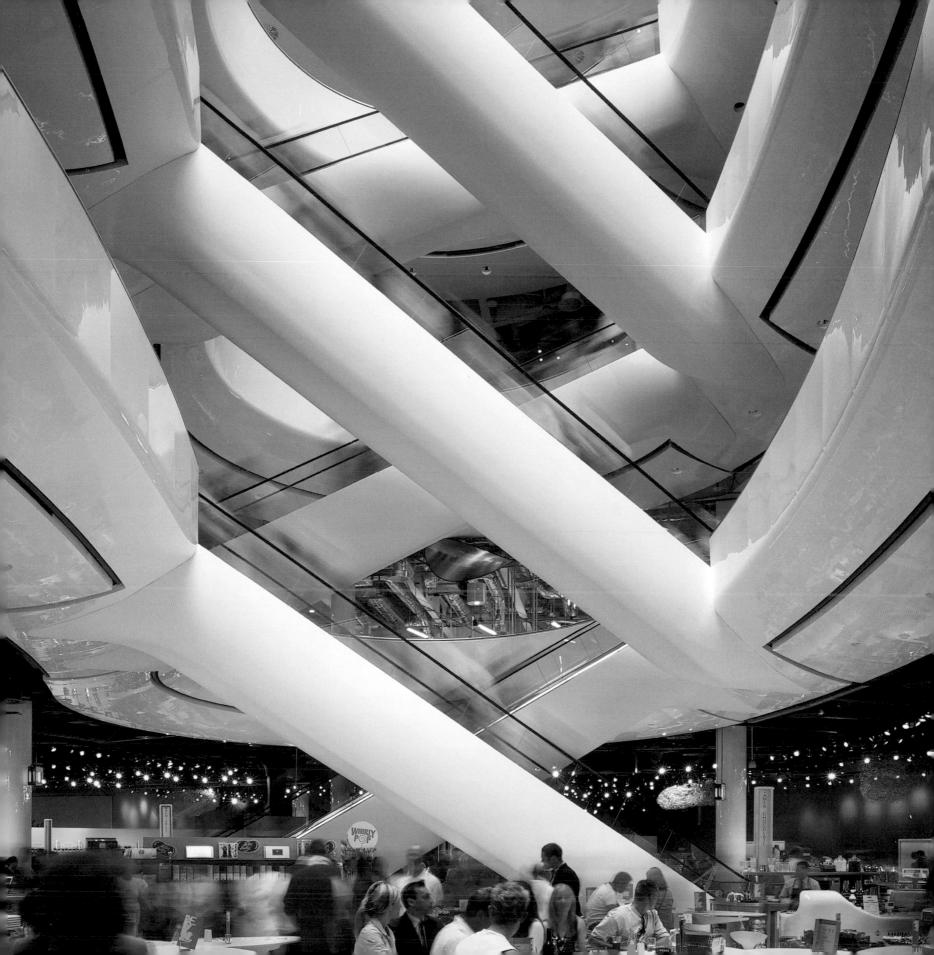

Although currently considered the tallest building in the world, Taipei 101 will be surpassed by several other buildings planned for completion before 2009, such as Union Square Phase 7 in Hong Kong, Shanghai World Financial Center, Burj Dubai, or the Freedom Tower in New York City.

Tenerife
Auditorium

Santiago Calatrava

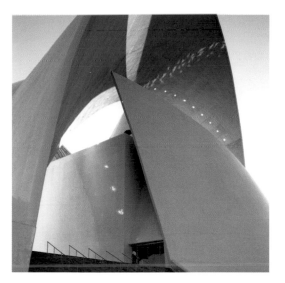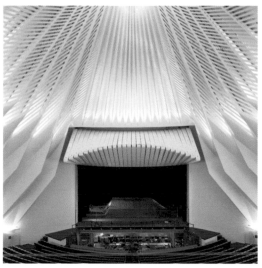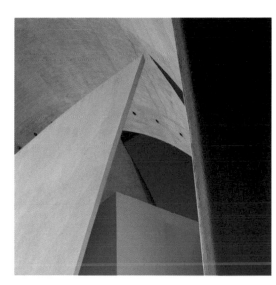

Tenerife Auditorium

Architect: Santiago Calatrava

Location: Tenerife, Spain

Completion: 2003

Photography: Stefan Müller-Naumann / Artur

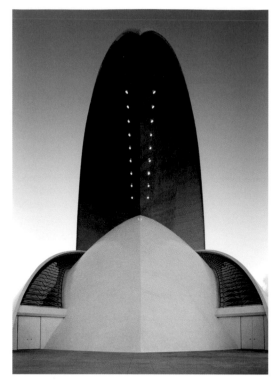

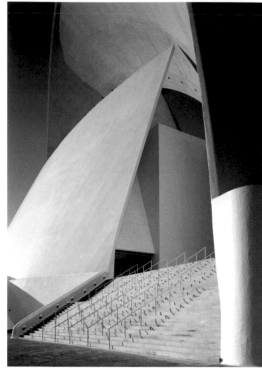

Dramatic, large-scale projects are not unfamiliar to Santiago Calatrava, and despite this being yet another of his spectacular creations, it is the architect's first performing arts facility. The curved white concrete shells—capped by a cresting, crashing wave of a roof—that characterize the new Tenerife Auditorium enhance a 5-acre waterfront site in one of the world's most popular vacation spots. The new addition to the ocean shore serves to connect the city to the ocean and establish a significant urban landmark.

The site comprises an innovative 1,660-seat concert hall, a 400-seat chamber music hall, a 140,000-square-foot public plaza, underground parking, and an annex building for the offices of the Tenerife Symphony Orchestra. The curved geometry of the main concert hall consists of a main cone-shaped body formed by a double layer of concrete casings: two inner, shell-like casings that enclose the main hall, and two outer casings resembling sails that enclose a perimeter hall and serve as a lobby, as well as an external sound barrier. The auditorium forgoes a conventional roof and instead projects a far more expressive element: a free-standing concrete structure, known as the Wing, rises from a base at the side of the building, sweeping upward into a curve nearly 200 feet high. Pointing toward the public plaza and ocean beyond, the Wing narrows and thins into a spear-shaped tip, 320 feet from the base of its arc.

The building's unconventional roof and overall structure make the auditorium acoustically unique. The design incorporates a series of overhead convex sound reflectors and sound absorbers placed behind a rectangular grid. To fine-tune the acoustics, the wood paneling of the interior takes on a crystalline form, which also contributes to the drama of the space. While the interior features the use of smooth plaster finishes, the exterior structure is inlaid with broken ceramic tiles—a traditional material in Spain—to create a gently polished surface. Calatrava's project can only add to the architect's acclaimed reputation for integrating technology and aesthetics in the creation of dynamic structural forms that challenge traditional practice in both architecture and engineering.

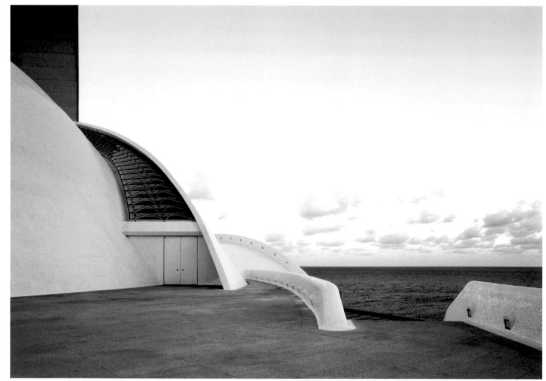

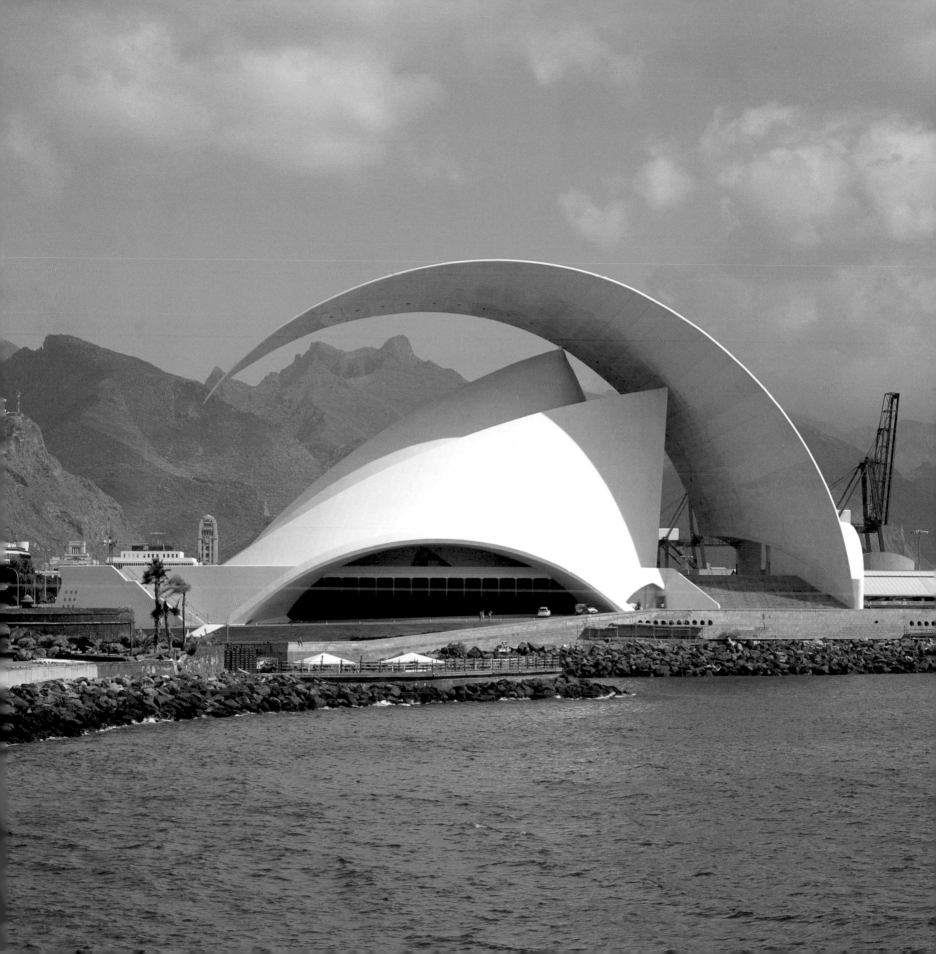

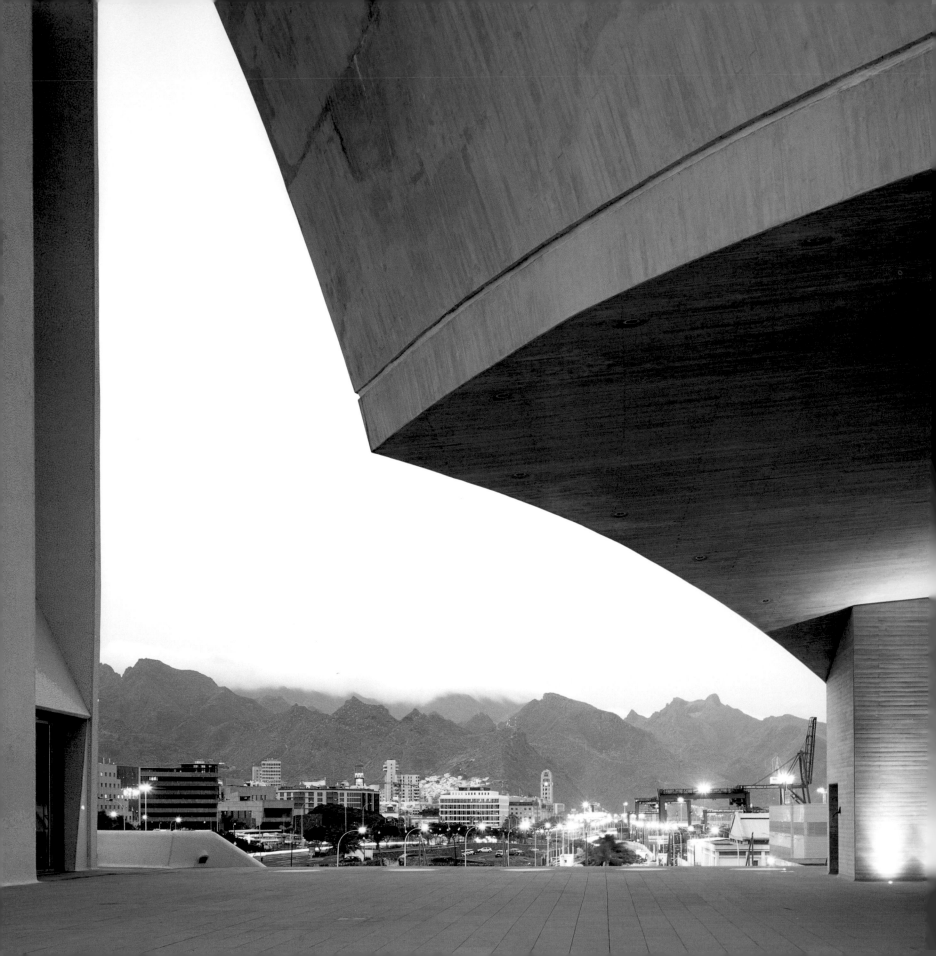

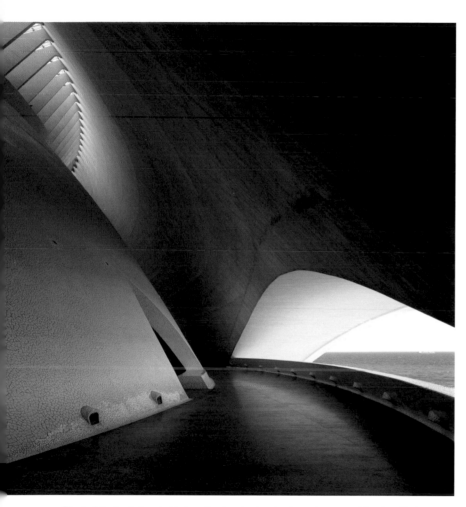

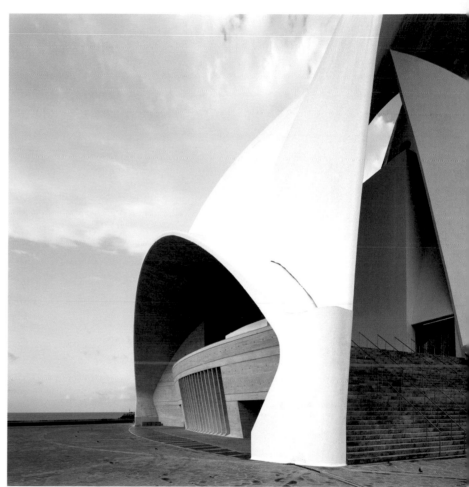

The building's plinth—clad in basalt, a local volcanic stone—forms a public plaza that covers the site and allows changes in grade between the different levels of the adjacent roads.

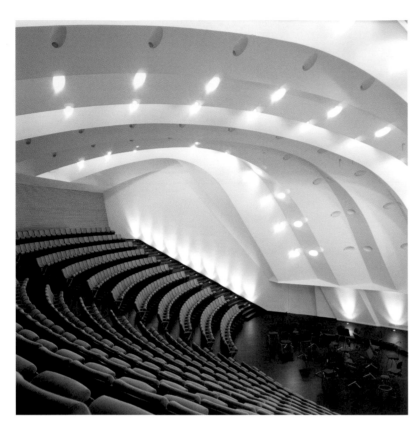

Public foyers and circulation areas benefit from the island's temperate climate, and are naturally ventilated through glazed areas beneath and between the building's concrete shells.

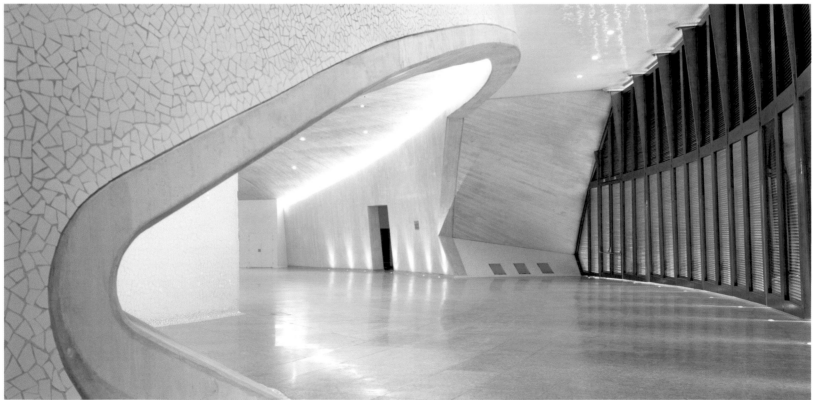

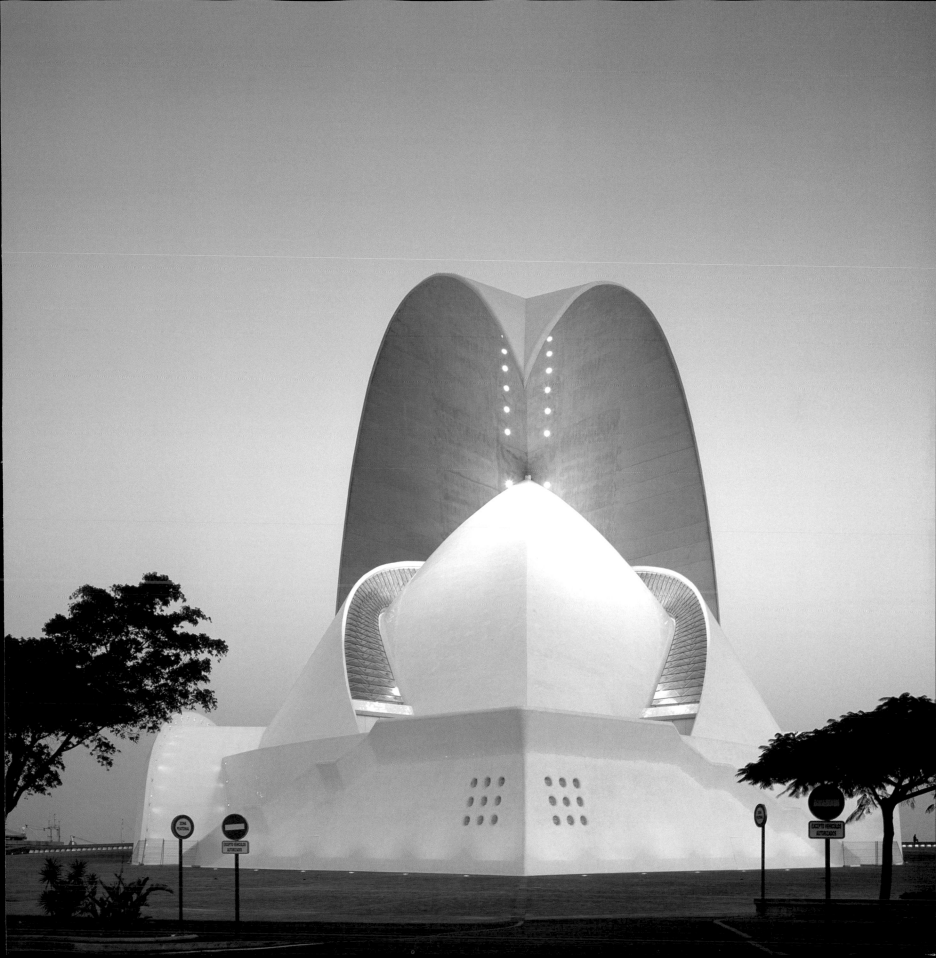

Yokohama International Port Terminal

FOA – Foreign Office Architects

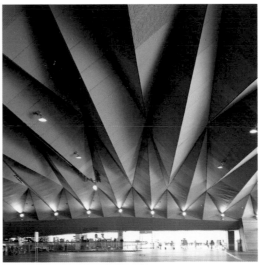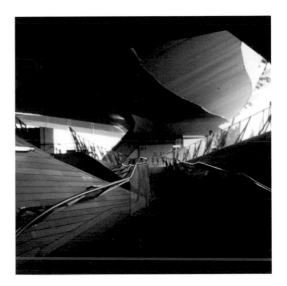

Yokohama International Port Terminal

Architects: FOA

Location: Yokohama, Japan

Completion: 2002

Photography: Satoru Mishima

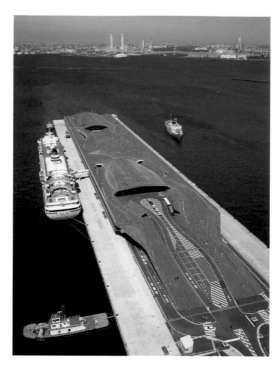
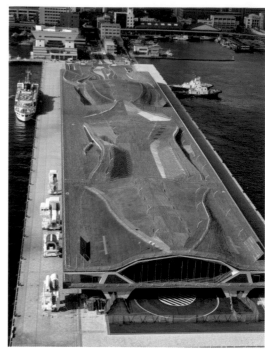

The concept that underlies the Yokohama International Port Terminal marks a decisive step forward in the notion of contemporary architecture. Whereas many of the large-scale buildings erected today acquire an iconic status as a result of a distinct aesthetic quality or representational theme, this project turns against form itself in favor of a mediation between the elements addressed by the program. This concept of differential mediation is derived from the term *ni-wa-minato*, and suggests an interaction between garden and harbor, and between the citizens of Yokohama and those from the outside world.

The project operates as a mediating device between two large social systems that define the new institution: the system of public spaces of Yokohoma and the management of cruise ship passenger flow. In an effort to counter the effects of rigid segmentation commonly produced by these social mechanisms, especially those in charge of maintaining borders, the architects devised what they refer to as a "no-return pier" that aims to create a fluid, uninterrupted, and multidirectional space, rather than a gateway to the flow of conventional, fixed orientation.

The traditional linear structure is subverted through a series of programmatically specific interlocking circulation loops, constructed as a systematic transformation of lines into an origami-like, folded, and bifurcated surface. The structure is intended as an extension of the urban ground, its boarding level seamlessly connected to the city's ground level. The building is also especially prepared to cope with the lateral forces generated by seismic movements known to affect the Japanese topography.

A reduced palette of materials, details, and finishes emphasizes the project's objective of performing a functional and conceptually innovative role in the creation of transitional spaces. Rather than a symbolic figure or object, the structure materializes a state of union between land and water. Described by some as "architecture without exteriors," the port terminal suggests a novel approach to building and challenges the norms of contemporary architecture.

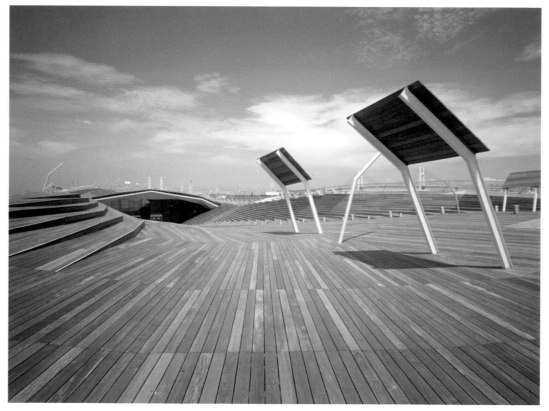

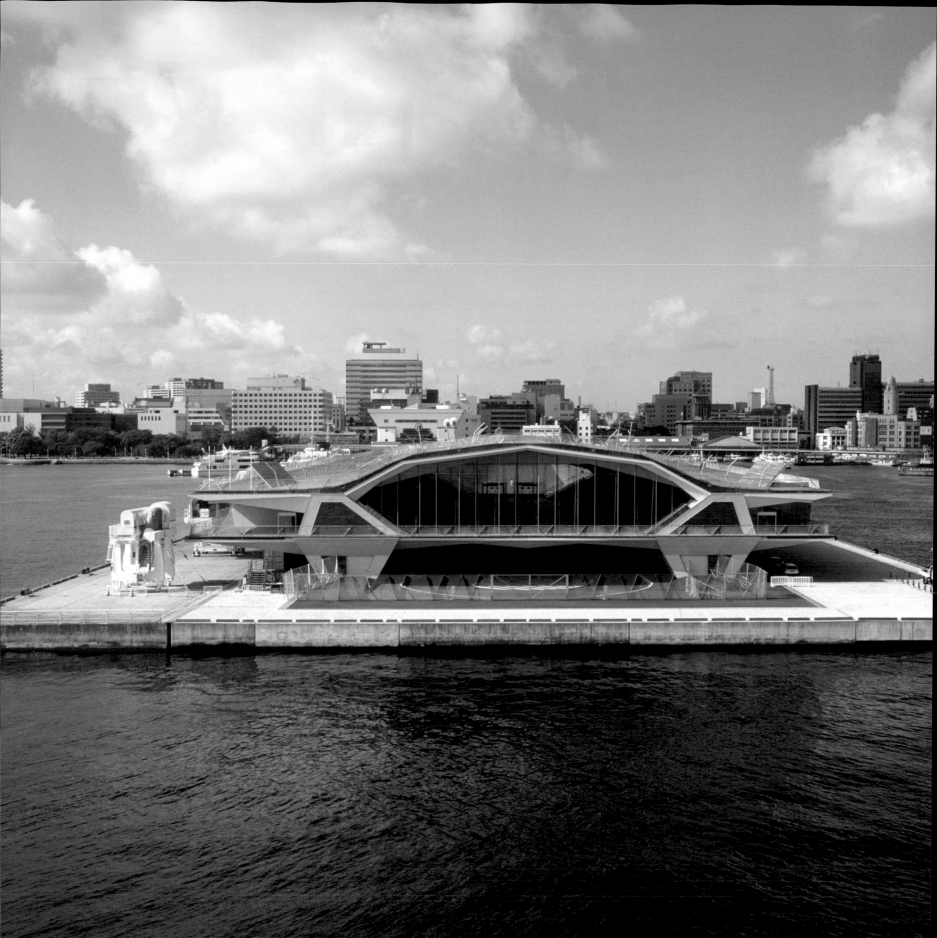

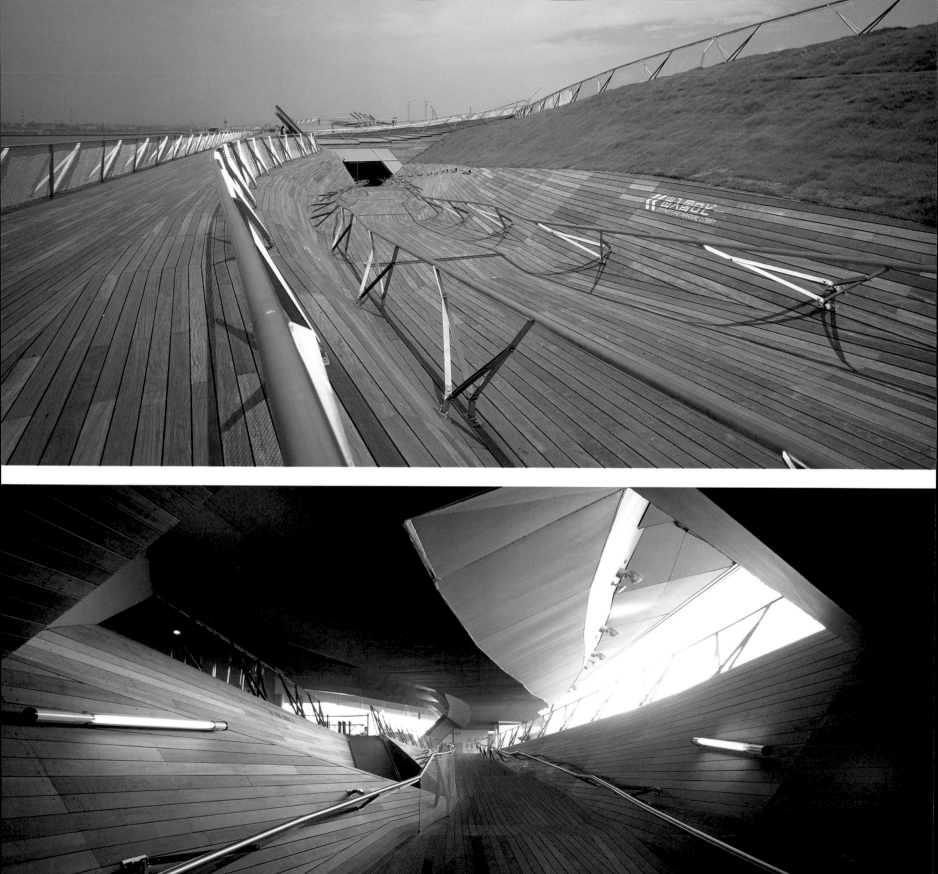

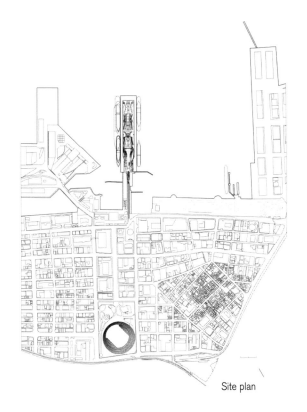

Site plan

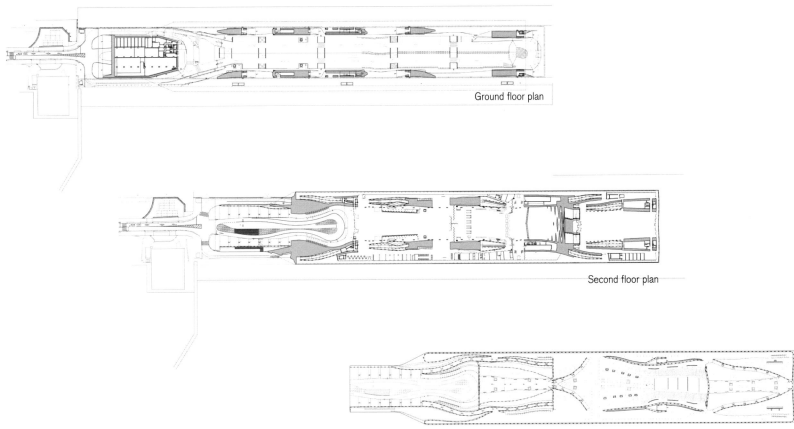

Ground floor plan

Second floor plan

Third floor plan

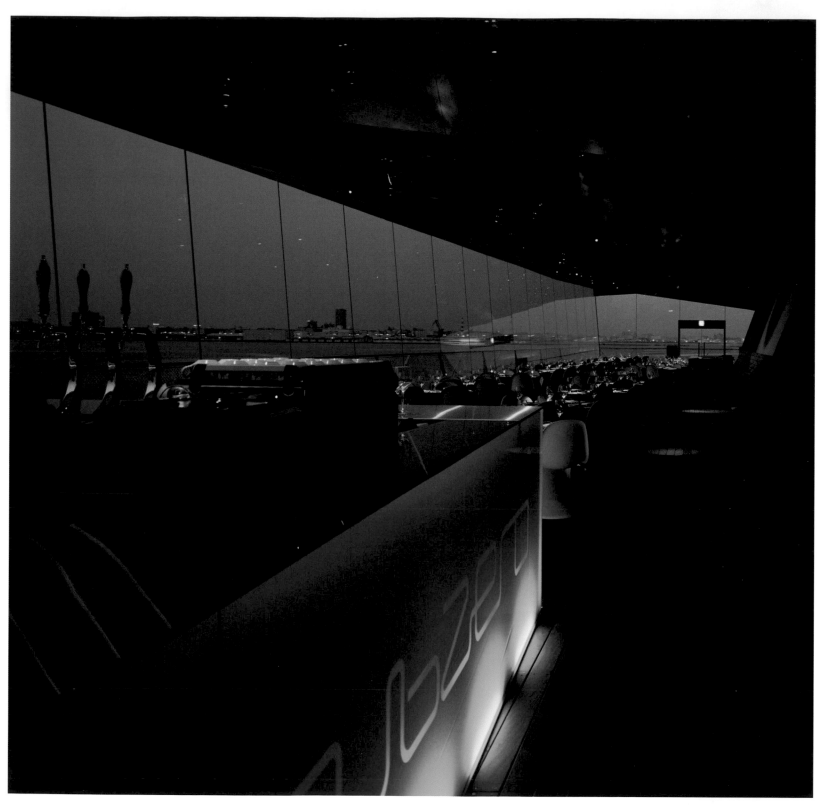

The bar and restaurant inside the terminal, contained within the continuous surfaces that
make up the project, feature a contemporary design and enjoy panoramic views of the harbor.

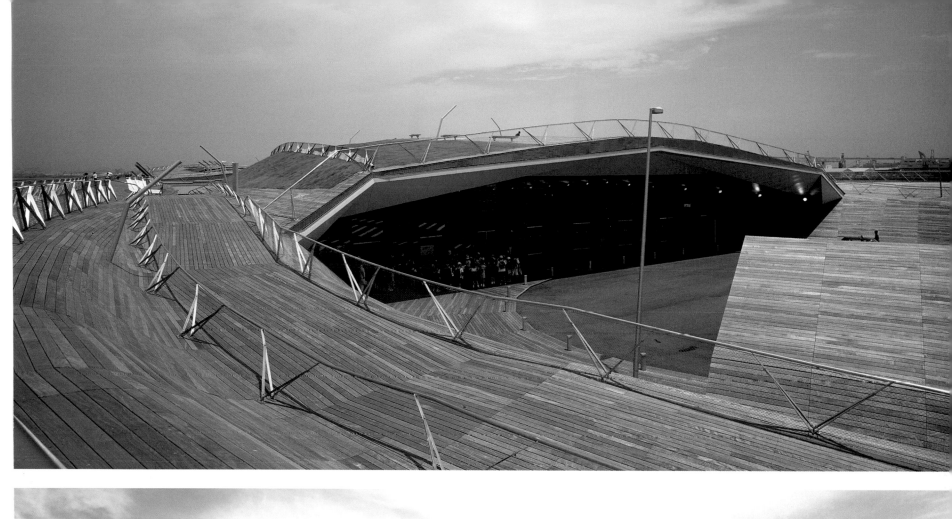

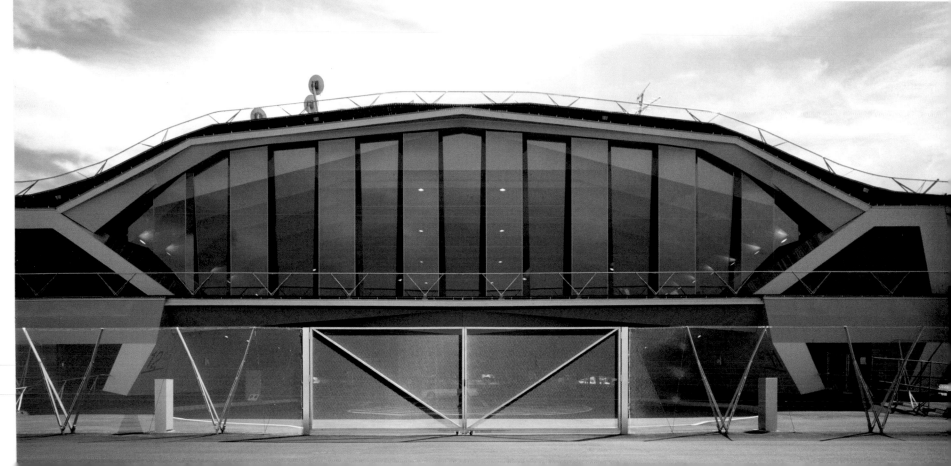

Udvar-Hazy Center

Architect: HOK

Location: Chantilly, VA, USA

Completion: 2003

Photography: Joseph Romeo Photography, Elizabeth Gill
Lui, and Alan Karchmer

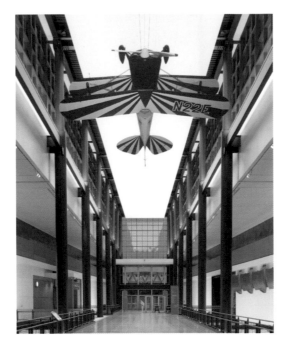
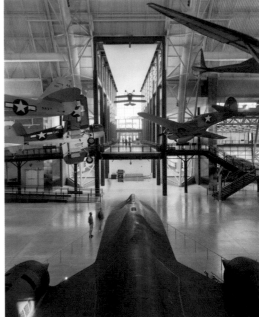

The project, named after International Lease Finance Corporation founder and Chief Executive Officer Steven F. Udvar-Hazy, who contributed $65 million for the facility, consists of an extension to the National Air and Space Museum belonging to the prestigious Smithsonian Institution. Having designed the original museum in the 1970s, HOK architects were challenged this time around with transforming the new center into an attraction for donations and a draw for revenue generation. Inspired by the very aviation roots it is designed to celebrate, the center will provide the museum with a second facility for the display and preservation of its collection of historic aviation and space artifacts.

Situated on the grounds of Dulles International Airport, the center embodies an aerospace theme that is immediately evident upon arrival to the facility. Featuring a fuselage-shaped entry lobby and an airport-inspired control tower element, the project in its entirety is configured like an airport terminal composed of a "landside" and an "airside." The land-side, designated as the realm of people, includes amenities such as the information desk, retail shop, food court, education center, administrative offices, IMAX theater, and observation tower. The airside features doors large enough to welcome airplanes and a floor able to withstand the weight of a space shuttle. Large-scale interior spaces incorporate the Main Hangar, the Space Hangar, the Restoration Hangar, and artifact storage.

In order to provide the most authentic viewing experience, the project's vast main aviation hangar replicates a sky, designed to be very high, light in color, cornerless, and lit only by electric light and supplemental reflected sunlight. Elevated walkways run parallel to the suspended aircraft so that visitors can experience the sensation of soaring along with the aircraft, as well as study the artifacts in greater detail. Following an extremely successful opening, the new facility continues to thrive and, like its founding museum, promises to be one of the most visited museums in the world.

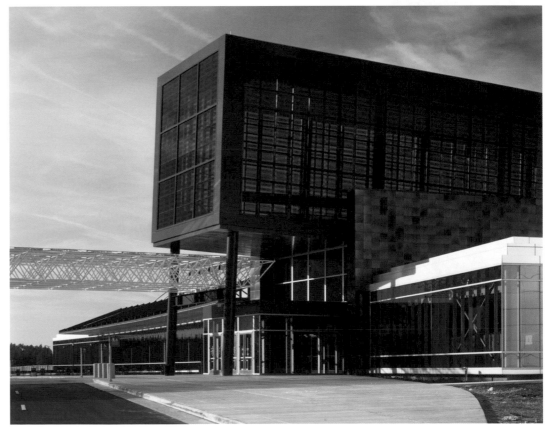

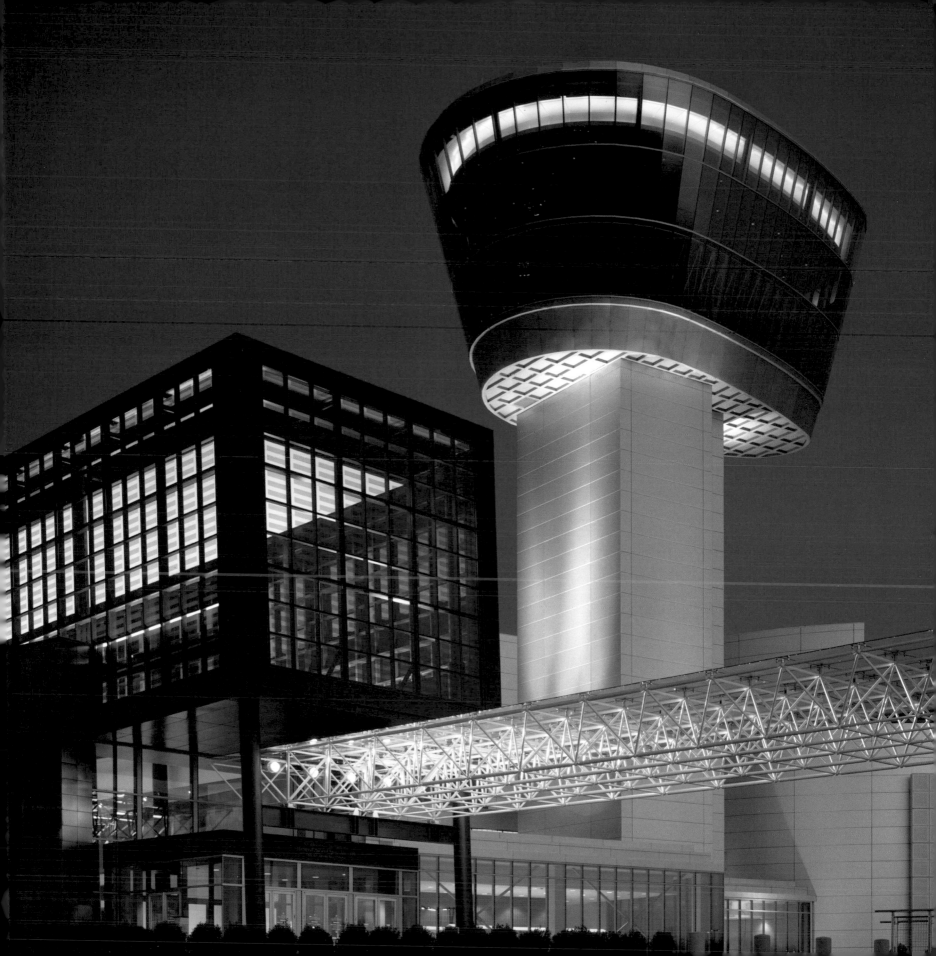

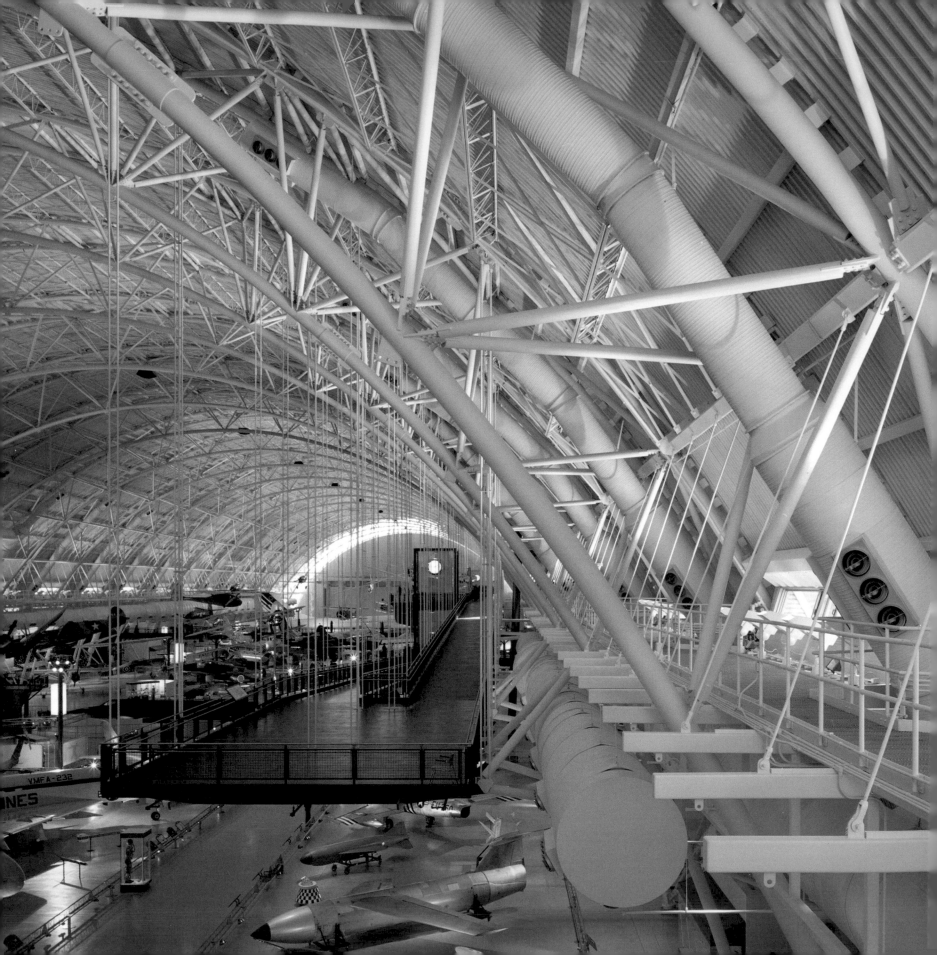

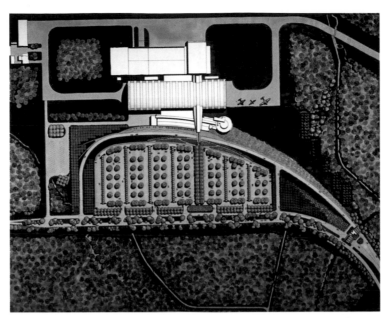

Site plan

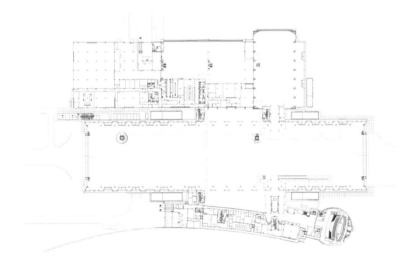

Ground floor plan

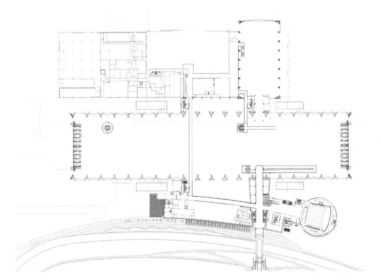

Second floor plan

0 6 12

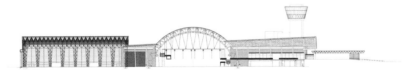

Section

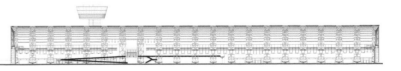

Elevation

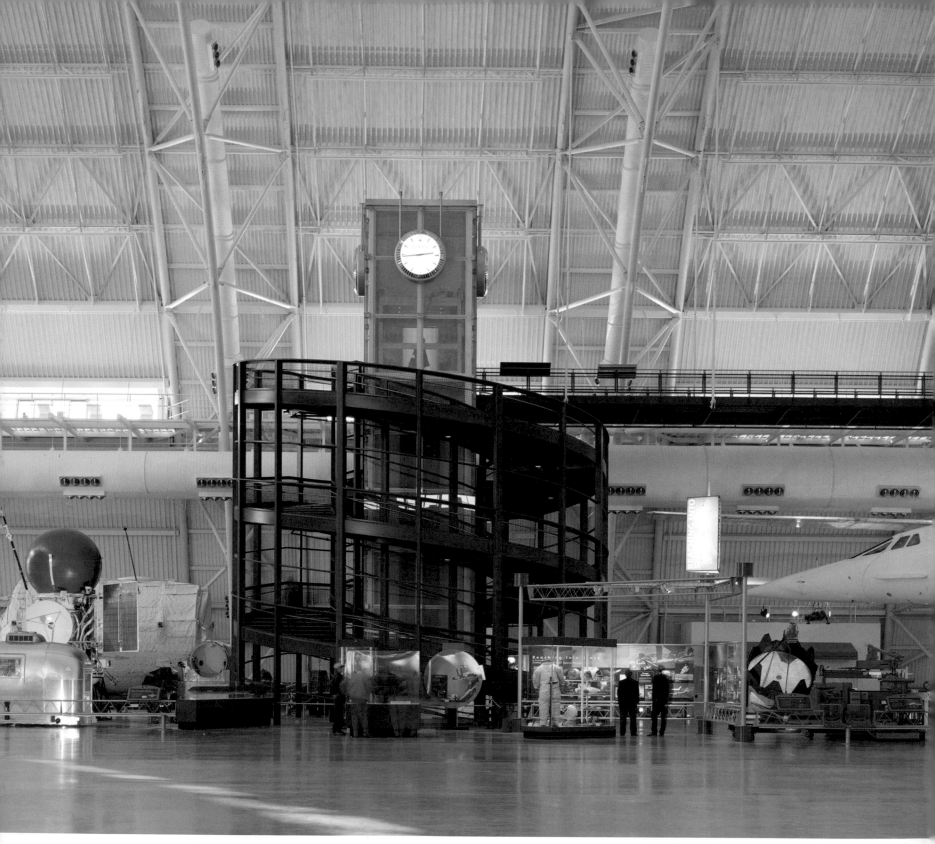

A spiral staircase leads to the upper walkways that provide a skylike view over the exhibited airplanes within the hangar. The restriction of skylights led to the implementation of artificial light and reflected sunlight.

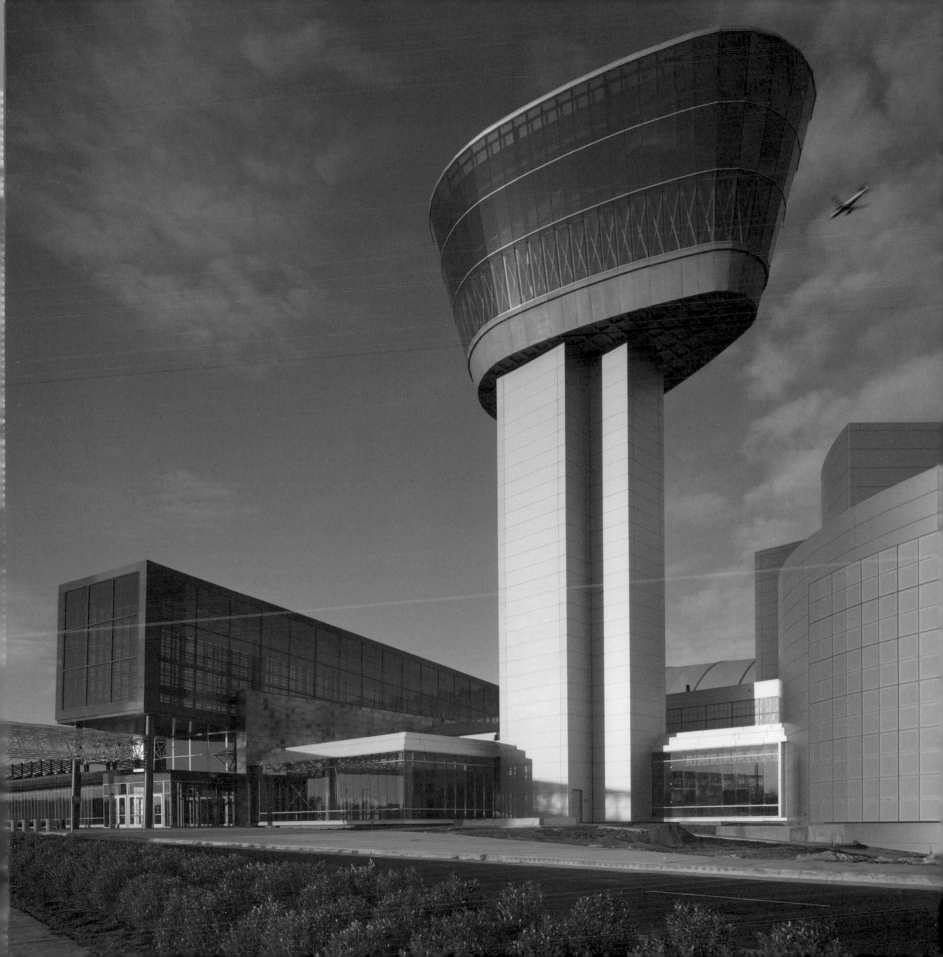